PIGSKIN RAPTURE

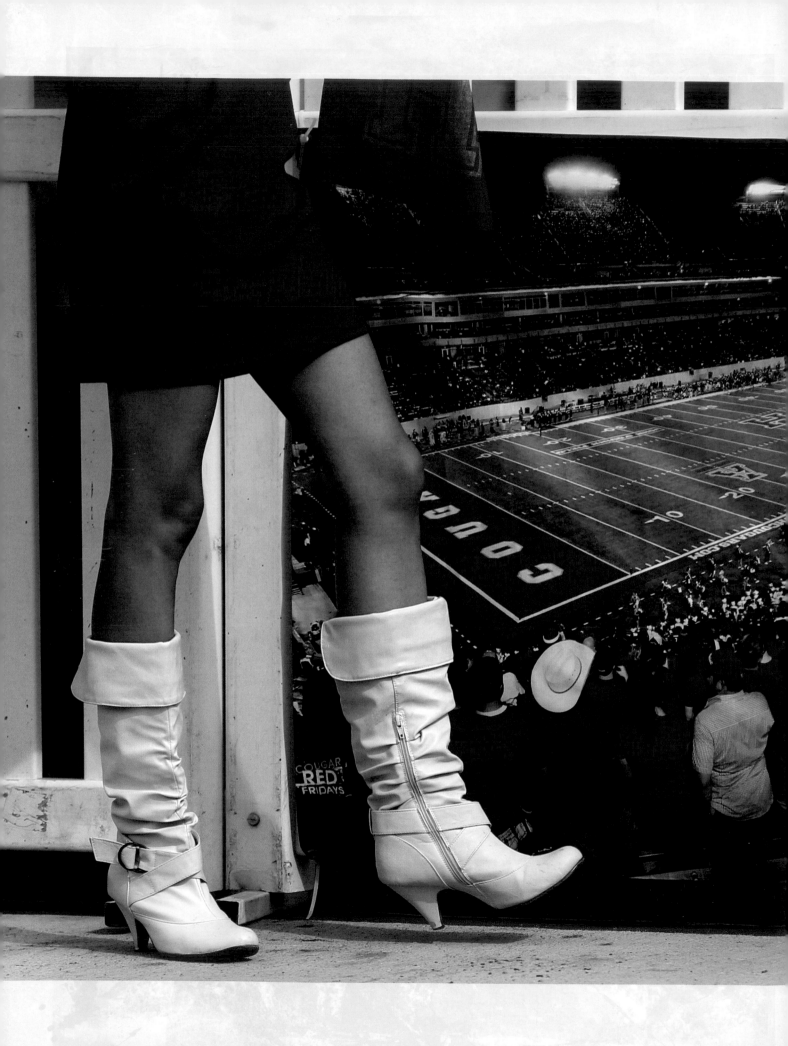

PIGSKIN RAPTURE

Four Days in the Life of
TEXAS FOOTBALL

FOREWORD BY TROY AIKMAN
MAC ENGEL

Photographs by
RON JENKINS

Assisted by
MICHAEL AINSWORTH

LONE
STAR
BOOKS

Guilford, Connecticut

An imprint of Rowman & Littlefield

Distributed by NATIONAL BOOK NETWORK

British Library Cataloguing-in-Publication Information Available

Library of Congress Cataloging-in-Publication Data

Names: Engel, Mac, author.
Title: Pigskin rapture : four days in the life of Texas football / Mac Engel ;
 photographs by Ron Jenkins.
Description: Guilford, Connecticut : Lone Star Books, [2016]
Identifiers: LCCN 2016013001 (print) | LCCN 2016016280 (ebook) | ISBN
 9781630762414 (hardcover) | ISBN 9781630762421 (e-book)
Subjects: LCSH: Football—Texas | Football—Texas—Pictorial work.
Classification: LCC GV959.52.T4 E64 2016 (print) | LCC GV959.52.T4 (ebook) |
 DDC 796.33209764—dc23
LC record available at https://lccn.loc.gov/2016013001

♾™ The paper used in this publication meets the minimum requirements of American National Standard for Information Sciences—Permanence of Paper for Printed Library Materials, ANSI/NISO Z39.48-1992.

For my favorite Texan, Vivian

And for my Dad, who advised me to pursue this line of work
because he thought it would be fun. He was right.
—Mac Engel

For Betsy, and to the collision of art and violence that is Texas football.
—*photographer and native Texan Ron Jenkins*

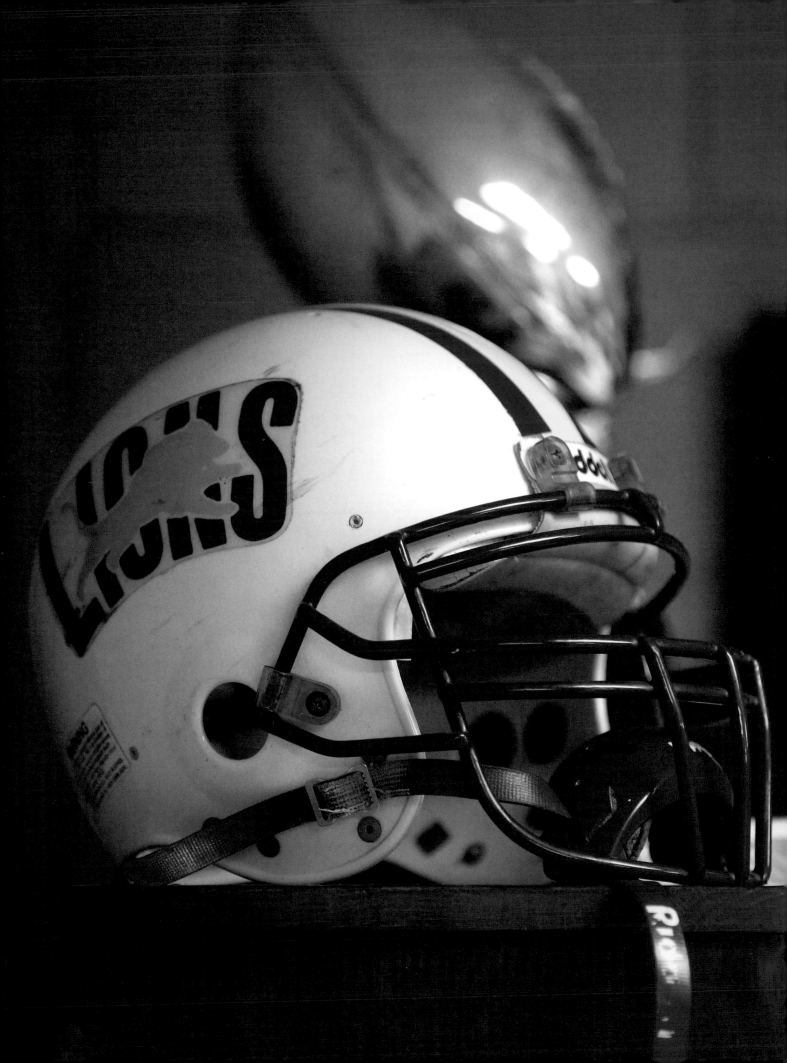

CONTENTS

FOREWORD

Ever since team owner Jerry Jones and the Dallas Cowboys selected me with the first pick of the 1989 NFL Draft, I have lived the importance of football to the city of Dallas and throughout the entire state of Texas. I did not know it when I arrived, but football is a vital piece of the fabric and the morale of everyday life here in a way that, because of the size of this state, no other place can match.

If you are a football fan, a football player, or a football coach, there is no better place to live than Texas. With all due respect to other cities, towns, and regions that consider football their favorite sport, nothing beats football in Texas. Even in the dormant months from March to June, we continually talk football. Then there is a different feeling in the air once practices begin in late July and early August. The social structure of life here changes in late August when the high schools seasons start, and in September when the colleges and pros begin.

That's when our real routine begins.

People deliberately avoid scheduling major events in their lives in the fall to prevent a conflict with a Texas, Texas A&M, Houston Texans, Dallas Cowboys, or any other big game. That happens in other places around the country, too, but not with the same frequency. Texans are sometimes expected to re-arrange their schedule based on the kickoff of their favorite team. People in Texas are known to pick watching an A&M game over attending a friend's wedding—and it is regarded as perfectly acceptable social behavior.

There is a volume, intensity, and scrutiny to football here that is irresistible. I can't imagine my life without football, and I can't be in a better place for it.

I recognize the irony now but my career actually began as an outsider here.

My family moved from California to Oklahoma when I was twelve, and shortly thereafter I learned that Oklahomans and Texans share a similar passion for football. Many of them also share a deep dislike of the other based purely on football. It's sometimes lost on my resume because I completed my college career and degree from UCLA, but my first experience with Texas football was not with the Cowboys but rather as an outsider at Oklahoma. Perhaps because I am from California I never did dislike Texas in the least. To me, Texas and Texans were good. I did, however, certainly want to beat Texas when I played at the University of Oklahoma during my first two years of college.

I played in two of the Red River Shootouts between Oklahoma and Texas at the Cotton Bowl, in 1984 and 1985. My college coach, Barry Switzer, would eventually become my second coach with the Dallas Cowboys. One of my Sooners teammates was defensive lineman Tony Casillas, and we would win Super Bowls in Dallas one day, too.

The second Red River game I played in we were No. 2 in the country and Texas was No. 17. More than 30 years have passed since that afternoon and I still vividly recall my pitch to teammate Patrick Collins for the game-winning touchdown. We won that game 14-7, and the experience is one of my fonder memories from college.

I transferred to UCLA after that season, but one of the reasons my time at Oklahoma was so special is because I had the chance to play in the Red River game. I had the chance to participate in a game in Texas and could feel the size and importance of a football game to people who live south of the Red River.

Of course, when I was drafted by the Cowboys none of that mattered any more. What mattered was turning the Dallas Cowboys back into America's Team again. When we finished 1-15 my rookie year, there was little mystique to the label of America's Team. Not many people were clamoring for the Dallas Cowboys when you're 1-15.

It was not until late in the 1990 season that the power and the magnitude of America's Team dawned on me. That was the year we began to show signs that we might be a good football team, and the fans in Dallas and all over Texas took notice. They had been waiting for this.

We just missed the playoffs that season when we finished 7-9, but you could feel that the team had the makings to be special. The fans were ready to support us in a way both locally and nationally that no one could properly prepare you for. Our teams in the '90s became the Dynasty Cowboys. We won three Super Bowls and that success created a level of popularity for that team unlike anything I had seen before. The 24-hour news cycle was beginning to overtake America, the framework of college football was changing with the inception of the Bowl Coalition Series, and football had firmly become the most popular sport in America.

Even when baseball was America's pastime, football was Texas's pastime. The Dallas Cowboys, Houston Oilers, and the Dallas Texans had about a 10-year head start before any other professional sport established roots here. Schools like Texas A&M, Texas, Texas Tech, Baylor, SMU, TCU, and so many others had already established long-standing football traditions before the creation of the pro teams that gave football a leg up on every other sport in the state.

Even when baseball was America's pastime, football was Texas's pastime.

All football has done is grow, expand, and become more popular. When we started to win, it exploded to the point where the Dynasty Cowboys were treated like A-list celebrity movie stars.

It was new to me then but something I have grown accustomed to now.

Whether as a player for the Cowboys or now as an NFL analyst for Fox Sports, I have been fortunate to travel the country to watch football in countless venues in every major city in America. Other places are great, too, but they're not Texas. The game is truly the common thread for people from all different backgrounds here—everybody speaks football.

It's a game, but it's a part of the Texas geography. I can't conceive Texas without football. It would be like taking the beach away from Miami, the Rocky Mountains out of Colorado, or removing the Empire State Building from New York City.

I can't imagine my life without football, and I can't imagine not living in Texas.

Texas is football and football is Texas.

—Troy Aikman

THE GAME PLAN

The intent of this book was always to do four games in four days, which in Texas is both exceptionally easy and endlessly difficult. The other intent was to prove whether or not the myth and perception of football in this state is as grand and important as it is perceived to be by outsiders, or if it's just an exaggerated view hyperbolized by pop culture and the media.

"It is not exaggerated at all," says veteran punter of the Houston Texans, Shane Lechler, one of those few who has played all three levels of football in Texas. He grew up in the state, playing high school ball in East Bernard before he was an All-American at Texas A&M, which led to a long career with the Oakland Raiders, and now, the Houston Texans.

Lechler was born into football. His dad was a high school football coach, and the first time Shane played a game at Kyle Field in College Station, it occurred to him that football was far more important than he had realized when he played in high school.

"The support here in Texas compared to others places is shocking to me."

Since being drafted by the Oakland Raiders in 2000, Lechler's routine every Friday night has been to attend the best high school football game in the area. "The only people at those games in California are the parents," he says. "The support here in Texas compared to other places is shocking to me."

For so many Texans, Lechler has led the ideal life: all football, all of the time.

"You know, it's kinda sad, but it's true—all I know is this game," he says. "I have been around it my whole life, and I understand it inside and out. I feel like I would not be doing justice if I did not carry it on, which is why I'll go into coaching when I'm done playing."

If proving that the myth surrounding Texas football is as grand as the reality, the "endlessly difficult" part was to knowingly exclude teams from these four days. Unfortunately, there's just no way to include them all. The goal was to find a "big" game on Thursday night, and then to cover as much ground as possible, including all three levels—high school, college, NFL—in four days. There was the matter of logistics, and traveling the extensive distances between the major football destinations in this state. Texas spans nearly eight hundred miles from north to south; Corpus Christi in the south is closer to Cuba than it is to Denver. This project required punctual planes, cooperative weather, and not falling asleep while driving.

When all of the schedules were released by the end of May 2015, a four-game stretch was discovered: the Houston Texans on Thursday night, Odessa Permian on Friday night, the University of Texas on Saturday, and the Dallas Cowboys on Sunday. This meant that Texas A&M, Baylor, Texas Tech, and so many others would either not be given a larger platform, or left out altogether.

The plan was to cover as much football in ninety-six hours as logistically possible, from the games to the stadiums, the tailgates to the cheer-leaders—everything that embodies the greatness of Texas football.

"If you look at the state of Texas, it's a blue-collar state and that is what foot-ball is—it is the ultimate, blue-collar team sport."

"If you look at the state of Texas, it's a blue-collar state, and that is what football is—it's the ultimate, blue-collar team sport," Lechler says. "You have to get eleven people on the same page every snap. The game represents this state, and I think the state represents the game. It goes both ways. Without football, I don't know . . . I think Texas would just be blah."

FIRST QUARTER

THURSDAY, OCTOBER 8, 2015

Indianapolis Colts at Houston Texans, NRG Stadium, Houston

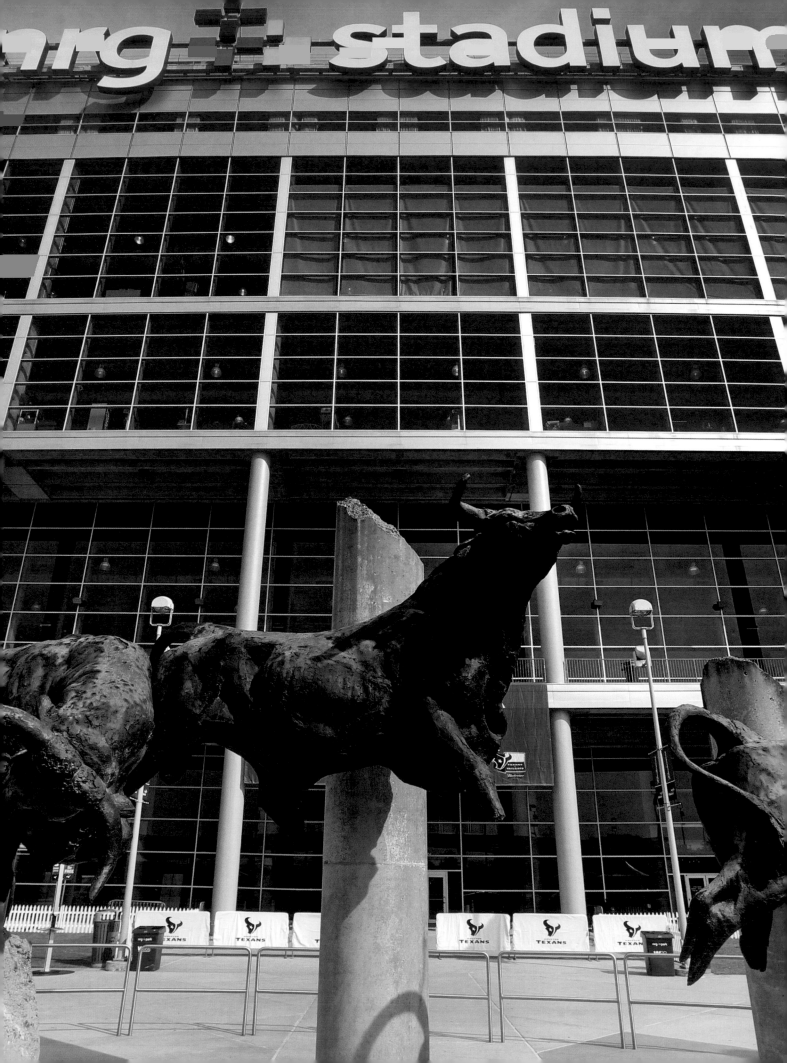

The popularity of football has grown, along with the US population, meaning football can no longer fit the Friday-, Saturday-, Sunday-, Monday-night routine. The role of television has played a large role in the expansion of football, moving it beyond the traditional time frames and pushing it to include Thursday, as well.

There are sixteen games from all three levels—high school, college, NFL—scheduled for tonight in the concrete jungle that is the sprawling Houston area. To play these games requires a cast of thousands, from the players, coaches, and parents, to the volunteers, extra police officers, the people who drive the team bus, and on and on. The games are woven almost subconsciously into the daily fabric of life here, and schedules are adjusted accordingly to accommodate a football game on a Thursday night.

8:06 A.M.

Astrodome main concourse

The Eighth Wonder of the World needs to be torn down, but the city of Houston cannot let go. The Houston Astrodome, once one of the biggest and most elaborate structures in the world, is now a dusty warehouse closed to a curious and sentimental public.

A tall chain-link fence surrounds the circular, 1960s-style stadium, giving it a ghostly, haunted look. From the outside, the Houston Astrodome looks like it hasn't been touched in decades. It appears to be covered in a layer of dust, if not quite neglect. The last time it was open for business was for a George Strait concert in 2002.

Houston grows faster than a bed of weeds, with countless buildings razed to create space for newer, sleeker, and prettier places to do what this city does best—business. Few places in America are as unregulated and business-friendly as Houston. If the Astrodome was any other outdated building in this city, it would have been demolished years ago. The land it sits on would have become a natural gas site, a condo complex, a strip mall with a Starbucks and a Gap, or a parking lot.

This building provides a tangible connection to the city's roots of outer space, open space, and football—of the run-and-shoot, the Phillips's 3-4, Bum, Luv Ya Blue, and countless other links to Texas football and Houston's ascent as a major US city.

This is the *Astrodome*, however. This building provides a tangible connection to the city's roots of outer space, open space, and football—of the run-and-shoot, the Phillips's 3-4, Bum, Luv Ya Blue, and countless other links to Texas football and Houston's ascent as a major US city.

In approximately eight hours, in the same endless parking lot at NRG Park, some of the football fans who cheered for the Houston Oilers in the Astrodome will arrive early to support the Houston Texans. Once one of the largest indoor buildings in the world, the Astrodome looks like a backyard woodshed compared to the cavernous

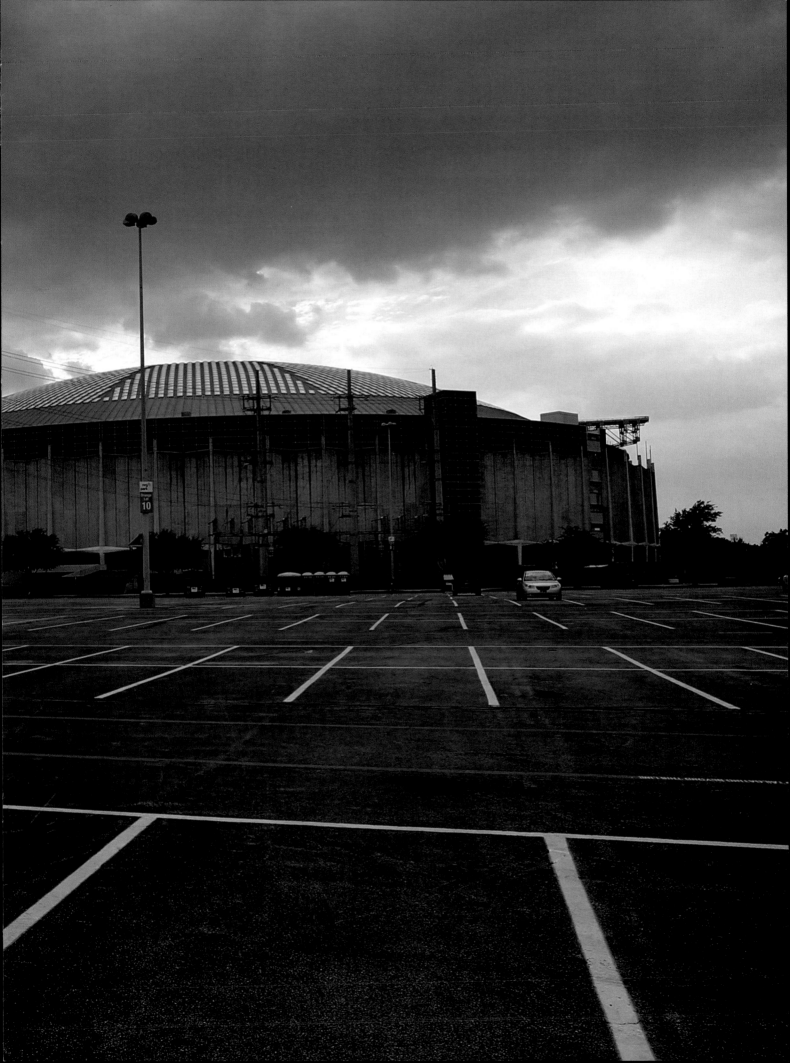

size of NRG Stadium next door. Yet the Astrodome remains one of Houston's most recognized and celebrated landmarks. It was the first building in this city of more than five million that became uniquely and internationally famous. It was Houston's Empire State Building, White House, or Sears Tower. The stadium is forever historic, yet in its current abandoned state, is a bit sad.

Once one of the largest indoor buildings in the world, the Astrodome looks like a backyard woodshed compared to the cavernous size of NRG Stadium next door.

"I'm from Houston and I do have an attachment to it," says Houston city councilman Larry Green, whose District K includes the Astrodome. "If it was up to me, I'd keep it. I'd like to see it as a mixed-use park with a hotel and a parking garage. That would be really cool."

NRG Park, which operates the Astrodome, makes it clear that *no one* is allowed inside the building. Not even Houston's de facto mayor and longtime acclaimed *Houston Chronicle* sportswriter John McClain can gain access. This has not stopped people from trying to take a look at the first place to embrace professional sports and big-money entertainment in the same venue, in a way that had never been done before it was opened in 1965.

The only spot that appears to offer any view inside the dome is down a service ramp for freight access. There are a few doors, all of which are locked. A small hole exists in one of the large garage doors, covered from the inside with duct tape and cardboard. This hasn't stopped people from pushing through the hole to take a look at this museum.

Immediately above the service entrance on the outside is the plaza where patrons formerly walked through the double glass doors to enter the building. To walk through these doors is like entering a time machine that leads back to 1965. To 1975. To 1985. To 1995. This isn't just another warehouse. It's all right here: The Oilers. UCLA versus Houston basketball. Luv Ya Blue. Hurricane Katrina refugees. Bum Phillips. Elvis Presley. Bobby Riggs versus Billie Jean King in the Battle of the Sexes. Heisman Trophy winner Andre Ware and the Houston Cougars. Nolan Ryan's no-hitters. Muhammad Ali. Earl Campbell running over the Miami Dolphins on Monday Night Football in 1978 for four touchdowns. Buddy Ryan punching

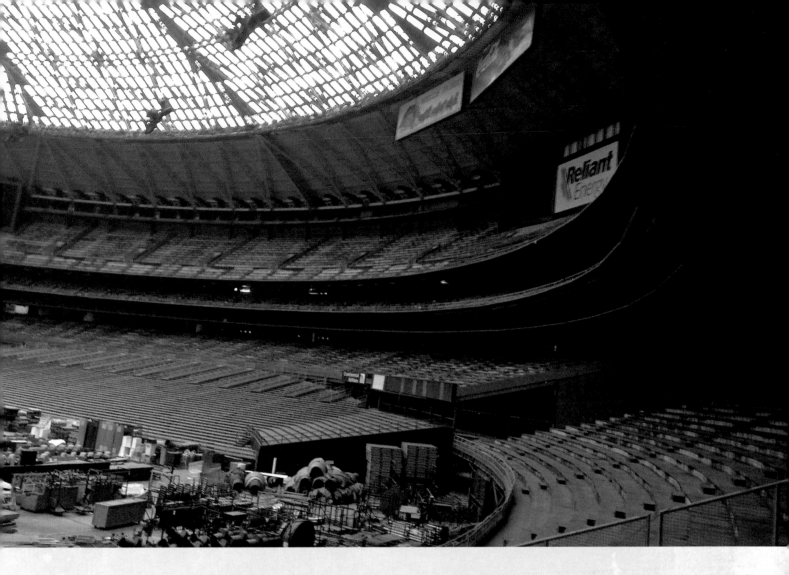

Kevin Gilbride. Billy Graham. Jerry Glanville. The giant cockroaches that roamed the field. The run-and-shoot Oilers with Warren Moon. Texas high school football play-off games. Evel Knievel. The giant scoreboard that featured steers and cowboys. The awful Astroturf and its infamous seams that barely held the thin carpet together over the concrete floor. The Houston rodeo. Billy Hatcher's home run in the bottom of the fourteenth inning to tie the game against the New York Mets in the 1986 National League Division Series.

They're all gone now, yet they still float around this dormant stadium. For multiple generations of Houstonians, of Texans, of sports fans, the Astrodome is their childhood.

Later in the NRG Stadium parking lot, Gayle Hogwood of Kingwood, Texas, will wear her pink-colored Texans' gear, but a sliver of her heart remains in the Astrodome.

To walk through these doors is like entering a time machine that leads back to 1965. To 1975. To 1985. To 1995.

She was a kid when she was a "Spacette" in the early days of this place. She had the Jackie Kennedy pillbox hats famous in the 1960s when the Dome opened, and the gold lamé outfits with the white boots that all of the Spacette ushers wore.

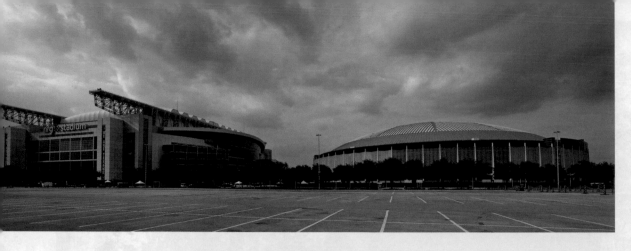

"I worked the first baseball game they ever had here, and it was just amazing—that's when they had grass inside," she says. "It was great until the grass died." That dead grass was replaced by a synthetic product called Astroturf, which ruined athletes' knees and ankles for decades.

Unlike other stadiums across the country that have been razed—Yankee Stadium, Texas Stadium, Three Rivers Stadium, Candlestick Park, the Orange Bowl, Fulton County Stadium—the Astrodome remains upright. Cutting down this tree house is difficult; Houston just can't decide what to do with it. There have been plans to demolish it, as well as pitches to turn it into a giant, indoor park. Both plans involve millions of dollars, and no one can make up their collective mind, or pass the necessary measure, to move forward beyond the status quo.

"It is a [Harris County] property, so [they] have jurisdiction and control over it," councilman Green says. "You have two major factions—one is a contingent that wants to see it torn down, and the other is a lot of old-timers that don't want to see that. There is a struggle there."

On this day, it is a storage shed. A row of port-a-potties stands across the floor from the industrial-size dumpsters in the vicinity of the 35-yard line. Rows of empty bleacher seats sit on the floor. The regular seats are gone. A few stacks of pallets are in the end zone. The unmistakable lights give the place a soft, dull glow, a reminder that the Astrodome was always a rather dark place even when all of its lights were burning brightly.

The Astrodome's importance to the city, the state, and even to football, has never effectively been replaced. NRG Stadium may be expensive and pretty, but it's just one more in an endless stream of eponymous theme parks all over the country. It's not the Astrodome, nor are the Texans the Oilers. The Astrodome changed sports, and America, whereas NRG is merely part of the trend. The Astrodome was the first domed stadium in America, and the first to start the relationship between high-dollar amenities and sports; since this place opened, these features have become standard at nearly every venue in the nation.

Four hours to the north on Interstate 45 is the latest shrine to professional sports excess and football: the AT&T Stadium in Arlington. It is this generation's Astrodome.

The Astrodome was years ahead of its time, and remains close to the hearts of the hundreds of thousands who walked through her doors. That's why letting go is so hard. There is a reason why it closed, and a reason why the NFL came back here after the Oilers left. Between walking around the Astrodome at dawn and coming back here before tonight's game is to traverse a diverse city that is bonded by football.

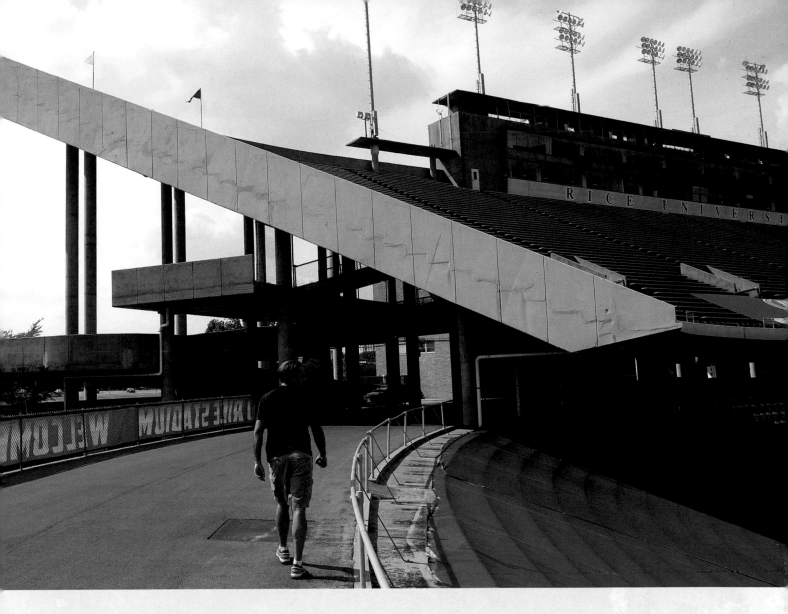

8:14 A.M.

Rice Stadium light platform

A key to sanity in Houston is to know the side streets. Roughly fifteen minutes north of the Astrodome on Fannin Street, which avoids Highway 10 or Loop 610, is the eternally shaded and swank Rice neighborhood. This is close to the home of fictional heroine Aurora Greenway, created by Texas's most famous author, Larry McMurtry, in his novel, *Terms of Endearment*. (Or at least the film version's producers shot the movie—which won Best Picture in 1983—here, around this small school and in the shadows of its disproportionately large football stadium.)

Rice University is Texas's version of an Ivy League school. While it shouldn't care about football, in Texas it has no choice. Rice's enrollment is roughly 6,600; its reputation is permanently glued to academics, and its relationship with the most popular sport in the state is historic, cordial, and downsized.

Since 2000, eight schools in Texas have either built new football stadiums or updated their old digs to the tune of more than $1 billion. Rice has raised more than $31 million for improvements to its football stadium, which was built in one year and opened in 1950, but there are no signs that the school is in a hurry to join the college football rat race. When the Southwest Conference broke up in 1996, Rice was one of the schools left out. Unlike the other Texas schools that were initially left out of the Big 12—Houston, Southern Methodist University, and Texas Christian University—Rice never appeared to care as much as the rest.

The school commissioned a study in 2006 that concluded the university should drop athletics completely—that it wasn't worth the money. One of the higher-ups insisted that to drop sports would be to remove a part of Rice's soul, and that it would hurt its national brand and the number of applicants. Rice remained in football, but at its own pace.

All of it was downsized, including what used to be the most famous part of its team—the band. The Rice Band, affectionately known as The Mob, bears a modest resemblance to the group that used to rival Stanford for creativity and brashness. The Mob still proudly proclaims that it does *not* march, and that anyone can join, but membership here has waned considerably in recent years.

"I've been in it since 1973, and it's just a lot different now. Raising money for it is much harder," said trumpet player John Gladu, who did not attend Rice.

For years The Mob was nationally renowned as The Onion of college bands. In 2007 The Mob's director wrote a special script for the return of former Owls coach Todd Graham. In the previous season Graham led Rice to a 7-6 season and an appearance in the New Orleans Bowl. You would think that because Graham led Rice to its first bowl appearance since 1961 there would be gratitude when the former coach returned to Houston in 2007. The rub was, the day after he signed a new contract with Rice, he left to accept the job at Tulsa University.

Instead of a touching tribute, The Mob roasted the coach with a rendition of "Dante's Inferno." At the end of the performance, the announcer read aloud over the public address system, "You know, that reminds me of a joke: A priest, a nun, and a rabbi walk into a bar. Now, I forgot how the rest of it went, but I think in the end, Todd Graham is a douchebag. Ladies and gentlemen—the 2007 Marching Owl Band. Please send all of your complaints to your mom at Rice dot e-d-u."

"That was a top ten, for sure," Gladu says. "He would deny this, but the president of the university had tacitly signed off on it. He couldn't say anything about Todd Graham, but he was not going to stop The Mob from doing it."

The whole thing smells more like Harvard, but it is decidedly Rice.

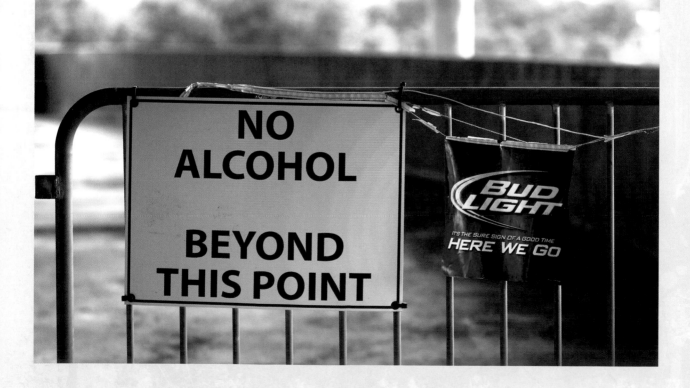

9:51 A.M.

Stallworth Stadium, west bleachers, Baytown

Without a helicopter there's no way to avoid the highways necessary to reach Houston's blue-collar belt, and Baytown. Depending on traffic, to reach Baytown from Rice can take forty-five minutes, or an hour and forty-five minutes. Baytown is one of many towns in East Houston that represent the manual labor portion of Houston's industrial relationship with the Gulf of Mexico: It's there to be extracted and pumped to provide jobs.

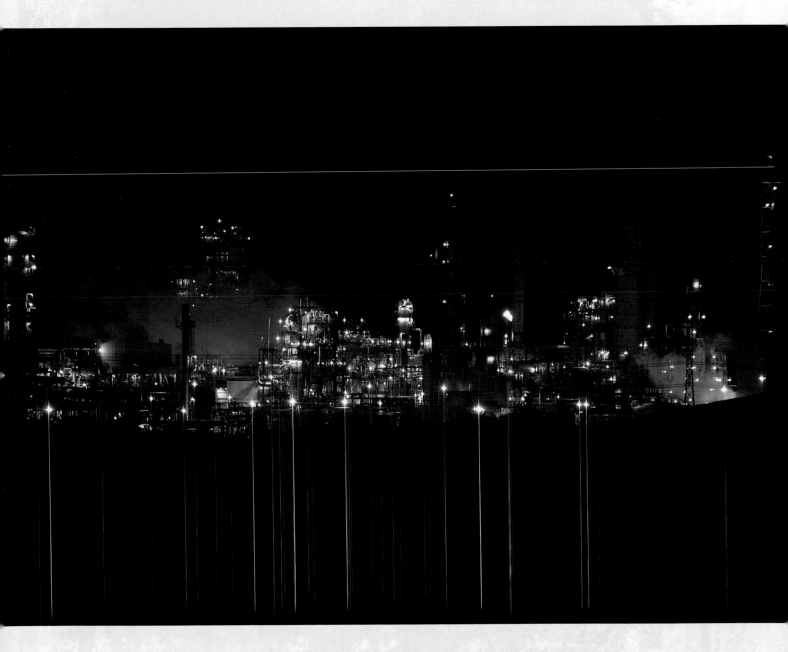

Baytown is near the end of Houston's ship channel, and oil and chemical refineries hum and grind twenty-four hours a day in this region, from Kemah to Texas City. Baytown is not a tourist destination for vacationers or Greenpeace members, but it is a place to find a job and raise a family.

"A lot of the parents here work in the plants," Baytown Sterling football coach Pete Gareri says. "They are working all hours. Some people will commute an hour or so just to work in those plants. It can be tough work, but you can make a good living doing it. The refineries and the oil fields are just a way of life here."

Gareri grew up in this region, and has been coaching high school football for twenty-three years. He has a Class 6A, District 21 game here at seven p.m. tonight against Port Arthur Memorial. With a capacity of 16,500, Stallworth Stadium is the biggest high school venue in East Houston, and while it's more than adequate, it's nothing compared to some of the plush palaces in other Houston suburbs like Katy, Stratford, and The Woodlands.

(In November 2014, the Katy Independent School District was approved for a bond package that includes a $60 million football stadium. In May 2016 the Dallas suburb of McKinney approved a new $62.8 million high school football stadium. When completed, it will be the most expensive high school football stadium in America, eclipsing the one built in Allen, a suburb of Dallas, finished in 2012. "I've seen the drawings, and they spent some money on that. It's going to be incredible," said one of Katy's most famous football alums, Cincinnati Bengals quarterback Andy Dalton.)

Gareri is well versed in the realities of coaching in East Houston, and Texas. Just because you are coaching Texas high school football does not automatically mean you win; someone has to lose. When Gareri arrived at this job in 2012, Baytown Sterling had won a total of three games in three years—well out of any discussion to play in the Texas high school playoffs.

His team is nearly halfway through the season, and with a 4-1 record, he believes it can finally return to the postseason. Tonight is the type of game Baytown needs to win to reach the playoffs for the first time since 2008.

In recent years the state of the Texas University Interscholastic League playoffs has been a point of contention for all Texas high school coaches and administrators.

In recent years the state of the Texas University Interscholastic League playoffs has been a point of contention for all Texas high school coaches and administrators. Following the lead of nearly every single major sports league in America, more teams are admitted to the playoffs in Texas than ever before. In 1991, the Texas UIL increased the number of playoff teams from each district from two to three. Since 2012, every classification added playoff teams to four per district. The argument was that the numbers justifies expansion. In 1990, the estimated population of Texas was a little more than 17 million. By 2015, it was 27 million.

Critics killed the playoff expansion because it potentially rewards the mediocre down to the bad, and enhances the perception that kids are handed trophies for nothing. In 2014, Houston Scarborough finished the regular season 0-10, but made the playoffs because its district had just four teams. In its playoff game against power West Orange–Stark High School, officials went to a running clock in the first quarter with the score 35–0; by the end of the game, Scarborough gained one yard, lost 64–0, and extended its losing streak to fifty-eight games.

"You have to remember—we are here for high school," Gareri says. "More playoff teams makes sense. Kids to get play another game. Everybody involved gets one more game. The state has gotten bigger over the years, and it's proportionally right. This is about high school kids; this is not college. I know there are more teams, but, of course, it's still a big deal to make it."

Even if it is "easier" to make the playoffs, and Gareri's team just needs to finish fourth in a seven-school district, he won't be apologizing if they qualify for the postseason. Gareri is like every other high school coach or high school player in Texas—they just want to get in.

12:14 P.M.

Stratford High School principal's office

Highway 10 cuts a horizontal line through Houston and is the main automobile artery that connects the east to the west in this city. At least an hour is required to drive from the area's blue-collar region of Baytown to the white-collar suburb of Stratford and the "energy corridor."

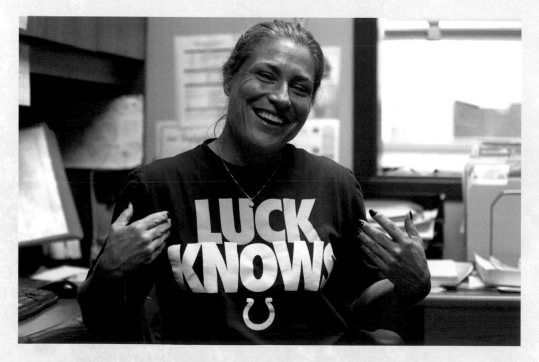

Directly across the street from Tully Stadium in the suburb of Stratford is the one place in all of Houston that has a conflicting interest in tonight's Texans game against the Colts. Immediately above the desk in the front office at Stratford High School is the unbridled pride and joy of this school—an autographed, framed NFL football jersey of its most famous alum, Andrew Luck, the starting quarterback of the Indianapolis Colts. Luck played here from 2004 to 2007, and the most visible sign of his career at the school is not at the Tully Stadium across the street but at the principal's office.

Houston is loaded with current and past football celebrities from nearly every single decade—from Pro Football Hall of Famer Lance Alworth to Cliff Branch, Mel Renfro, Gary Kubiak, Thurman Thomas, and on and on. Luck is currently Stratford's most famous alum, topping former running back Craig James, who along with Hall of Fame running back Eric Dickerson formed the "Pony Express" on the well-paid SMU teams in the 1980s. James played for five seasons in the NFL, and for many years served as a lightning-rod analyst for ESPN, but he never achieved the level of celebrity or revered cult status as Luck. James, who unsuccessfully ran for a US Senate seat in 2012, forever remains a divisive figure, while Luck is hailed as an angelic saint.

There are few things Texans love more than to claim they knew a guy in high school before he became The Man in college or the pros. Julie Gibson is an assistant administrator at Stratford, and two of her sons played with Luck. On this Texans' game day, she proudly wears her Colts' Luck T-shirt.

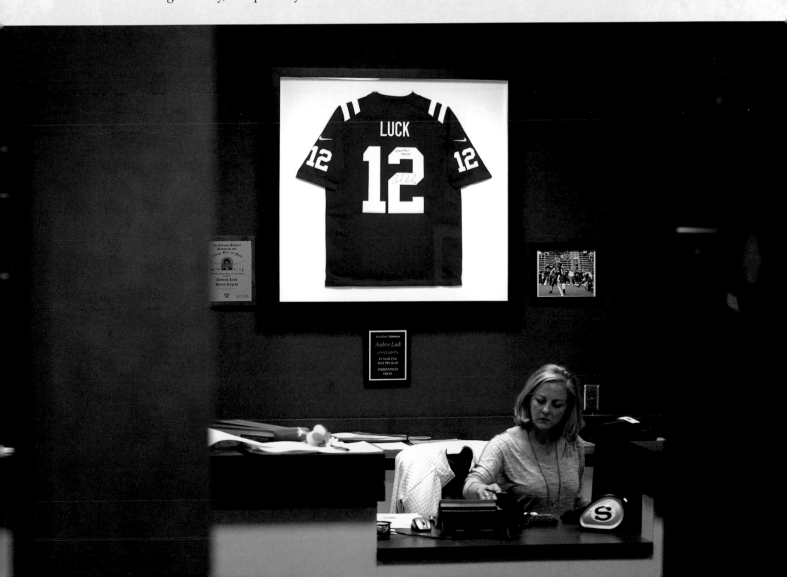

"You are talking about one of the nicest, hardest-working guys you'd ever want to meet," she says. "My sons just loved playing with him. When he was a senior, everyone would say to him, 'When you are in the NFL,' and he would always say, 'No, no, no.' He just hated the attention. It made him so uncomfortable."

Andrew's father, Oliver, was drafted by the Houston Oilers in 1982 and spent his four NFL seasons in this city. Andrew was born in Washington, DC, in 1989, but he spent his early years in Europe when his father managed two World League of American Football teams. The Luck family returned to Texas when Oliver was hired by the Harris County–Houston Sports Authority, where Andrew attended Stratford High School and began his own football career.

Yes, of course these welcoming people want to see their Texans win, but deep down, they'd rather see their friend succeed.

Everybody here at Stratford seems to know Luck, his mom, his sister, or his dad—or someone that knows Luck. Maybe the guy who cuts his hair. Everyone here seems to have, or claim, a direct or distant tie to the former Stanford quarterback who became the number-one pick of the 2012 NFL Draft. They can all claim they are his friend, even if he may not be able to remember all of their names.

Yes, of course these welcoming people want to see their Texans win, but deep down, they'd rather see their friend succeed.

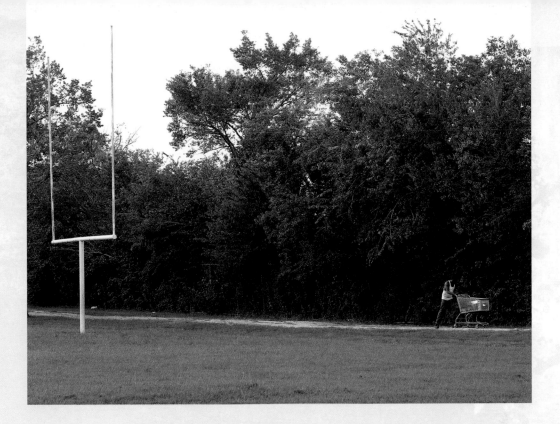

1:58 P.M.

Beech-White Park, Houston

Rodney is fifty-two, and at the moment he is high on crack cocaine. All of his worldly possessions are in a blue shopping cart, which he currently sits in as he takes a hit from his crack pipe. He is missing two of his front teeth, and his blue jeans come up to just under his buttocks. He is a picture of mental illness and homelessness—of the racial and financial inequality that plagues Houston and all of America's inner cities.

Rodney lives about twenty miles west of Stratford—"inside the loop," which is considered the most desired real estate in Houston. Some parts are better than others. He has nothing to do with football; he only knows that his home features a pair of pristine and immaculate football fields that boast four bright yellow goalposts. If there is one criticism of Texas from outsiders, and even from some in the state itself, it's that sometimes those associated with football receive more care, attention, time, and money than those who are not.

What Rodney has to say is mostly incoherent; he tries to make sense despite the limitations the drugs put on his speech.

What Rodney has to say is mostly incoherent; he tries to make sense despite the limitations the drugs put on his speech. He says he stays here most days, and when the weather is bad he walks to a nearby shelter. His daytime home is a football field. The opponent protests that Texans, or Americans, spend millions on football players, equipment, and stadiums, and yet people like Rodney spend their days homeless in the shadow of the expensive goalposts. It's an odd sight that in Texas is part of the landscape.

2:49 P.M.

Field House, Jack Yates High School, Houston

North on Scott Street and across the muddy Brays Bayou waterway, a group of young teenage boys stands inside the weight room of Houston Yates. The room features pretty new equipment. A few of the guys are playing with their phones while others try to nap, or talk quietly among themselves.

The school, built back in the 1950s, is tentatively scheduled to be demolished and rebuilt, but many of the alums and neighbors don't trust the plan, so a fight ensues. Opponents of the plan with the Houston Independent School District want to ensure that the school—alma mater of so many in the area, as well as actresses Debbie Allen and Phylicia Rashad—doesn't simply go away.

None of the young men in the field house look too concerned about it. They weren't even born when their school won the state title back in 1985, and most don't know who "The Booker Boys" were. Head coach Luther Booker's team was the last Houston ISD team to win a state championship when they defeated Odessa Permian, the team that made *Friday Night Lights* a thing.

Texas high school football—and the world—has changed since then, but the one constant at Yates is the no-nonsense coaches who do not suffer fools gladly, or have time for excuses.

"Get off your feet," assistant coach Marshall Lawson says sternly to his kids. "We've got a game. I want you off your feet."

This is not a request.

Head coach Jeffrey Caesar reclines in a chair in his office, waiting to go out to address his team. In less than five hours they will play Houston Lee High School in a Class 5A, District 20 game.

Yates is located in Houston's Third Ward—a predominantly African-American neighborhood, where life looks little like the world of Stratford, or Katy, the largely white suburban Houston area schools that have come to dominate Texas football. Yates is the inner city, where resources are stretched, and the priority placed on sports and football fluctuates depending on the political bent in the local government. The realities that the coaches here face are nothing like those in Stratford. Players routinely transfer, the Houston ISD must account for far more people than suburban schools do, and budget shortfalls are routine.

The realities that the coaches here face are nothing like those in Stratford. Players routinely transfer, the Houston ISD must account for far more people than suburban schools do, and budget shortfalls are routine.

Yates won the Texas Negro High School state championship title in 1930. When it won the state title in 1985, it became the first high school—historically, all-black—to win a Texas UIL championship at the then-5A level (the largest classification).

Yates is also the school that produced former Oklahoma State and Washington Redskins defensive end Dexter Manley, one of the sport's most dominant defensive players when he played for the Redskins in the 1980s. He was also the kid shuttled through the system because he was good at football. Manley was functionally illiterate, but that

didn't prevent him from receiving thirty-seven scholarship offers to attend college. Manley eventually learned how to read, well into his pro career.

This isn't an indictment against Yates; the same thing could have happened to Manley at a number of big high schools, because he was good at sports. This is the reality of inner-city high school football in Texas, and other places in the country. There are those who judge, but sports do provide a way out of the challenging economic environment some kids are born into. It's why some players no longer play football, not even in Texas. Yates is one of the schools in Texas where if the kid is good at basketball, he's not playing football. Assistant coach Lawson worked at Fort Worth Dunbar High School, a place where the legendary boys' basketball coach Robert Hughes insisted that if you wanted to play basketball for him, your football career was over.

The Yates basketball coach doesn't want his best players to play football, and Coach Caesar agrees. He does not want to threaten a kid's health, or standing, in a sport that could be a ticket to college. At Yates, the best athlete in school is not sitting in this locker room preparing for tonight's game. The best athlete is Jacob Young, a guard for the basketball team who has signed to play at the University of Texas. He is the son of Michael Young, who graduated from Yates and was a member of the famous "Phi Slama Jama" basketball teams at nearby Houston University—the national runner-up teams that had Basketball Hall of Famers Clyde Drexler and Hakeem Olajuwon in the early 1980s.

Before youth sports changed into more of a one-track system, Jacob Young would have been a quarterback, wide receiver, or running back who would have played basketball when football season was over. Today, the decision to play one or the other is made well before the athlete ever steps onto the Yates campus.

The man sitting in the office with the blue cast on his right forearm and lower right hand is okay with all of it. He's not one to complain, to bitch or yell. He is too grateful to care about such relatively trivial concerns. On May 13, 2013, Caesar's car was struck at a red light. The oncoming driver did not stop, and the ensuing collision nearly killed him. He suffered an "incomplete spinal injury" and was unable to walk for two weeks. When he did regain the ability to walk, he required a cane, no longer needed today. That year was the first since he was in second grade that he wasn't around football. After extensive physical therapy, he returned to Yates to coach.

"It meant the world to me," he says. "To be around the kids again. To be around all of it. My whole life has been football. To lose that was to lose everything. That's why I keep doing it."

He can't run the way he once did, and his right hand still requires the cast; he may never regain full function of that hand. The other driver was fine. Despite their physical limitations, both Caesar and Lawson look like old-school, kick-ass football coaches.

Caesar is the product of one of the fiercest, most independent, and successful football coaches that ever lived—Eddie Robinson. Caesar played for Coach Robinson at Grambling State, long before the man died. No black coach in this country ever did more for his sport, or his race, than Coach Robinson.

"When I was there, Coach Robinson was still on point," Caesar says. In the final years of Coach Robinson's career, it was no secret that Eddie Robinson's daily involvement in running the football team was limited.

"What he taught me was about being accountable. About how to present yourself," Caesar says. "We were the only team that wore suits and ties. You'd see us walking through the airport, and everybody would stop and look at all of these big guys dressed in suits and ties.

"All of the discipline he dealt with himself. He got me one time. I was late, and he made me run stadium steps—and if you don't know, those steps at [Eddie Robinson Stadium] were *steep*. And he would run them with you. The thing I always remember him saying was that you know football is going to be in trouble when football is not run by football people. We are at that day."

All football coaches in Texas and elsewhere fight this. Caesar stands up and heads to one of the squat racks. The kids put down their phones, wake up, take off their headphones, and circle around their head coach. Yates is 2-3, and tonight's game is a district opponent. Whatever problems or challenges that may exist outside this locker room will have to wait until the game is over.

4:11 P.M.

Spirit Squad Room, TDECU Robertson Stadium, University of Houston

One block east from Yates High School on Cleburne Street and halfway down Scott Street, the University of Houston Band at TDECU Stadium rehearses and prepares for tonight's game. The Houston Cougars are 4-0 and will play SMU at seven p.m. in an American Athletic Conference game.

As the trumpets, tubas, and rest of the band warm up on the field, inside one of the buildings attached to the stadium, Chelsea Villars sits in front of a mirror. She and many other members of the UH spirit squad are preparing for the production that's a

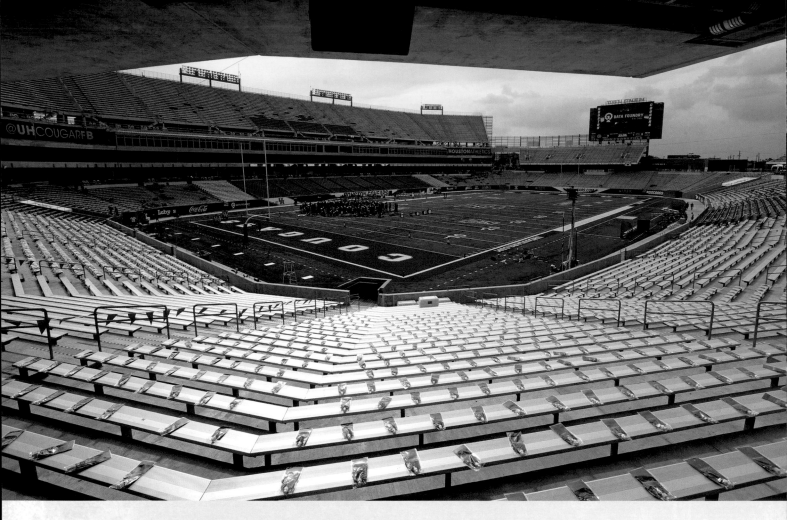

vital part of a football game's entertainment value. Villars uses a hair straightener to address what Houston humidity routinely does to her hair. It's October, and the city's level of humidity is as reassuringly constant as its traffic.

"Yesterday was great," she said. "Today, it's awful." (To those unfamiliar with Houston humidity, both days were awful.)

Villars, twenty-two, is too young to remember when Houston football was irrelevant and left for dead when the Big 12 formed. Like all of her classmates, she is too young to know about the famed run-and-shoot days of David Klingler, Heisman Trophy winner Andre Ware, or the Cougars that made running up the score in the Astrodome fashionable back in the 1980s and early '90s. She's too young to know that this school in the '80s, like so many in the Southwest Conference, was ravaged by NCAA sanctions. She's too young to know much about the statue she walks by outside of Gate 1—of former UH coach Bill Yeoman, the man who created football's "Triple Option," and the first coach to recruit a black player to his team in Texas.

Villars *is* old enough to recognize that her school is following TCU's plan, and SMU's and Baylor's, and so many others: pour millions of dollars into the athletic department with the hope that a successful football team will result in increased attendance, donations, and applicants. It is risky and has zero to do with education, but it can work. Baylor and TCU, both of which have top-ten football programs, are enjoying all-time highs in donations and applications.

Houston spent $120 million for a new stadium that was completed in 2014. The school also reportedly subsidized its athletic department with more than $100 million between 2008 and 2014. Whatever money the athletic department lost, or needed, the school paid the difference.

A few hours before its game against SMU, and apparently the plan is gaining traction. The inner-city school with an enrollment of more than 40,000 is focused on its football team, and this mostly commuter-based campus shows vitality and life.

"It has completely changed the atmosphere here, and it's continuing to grow," Villars says. "I cannot believe the difference one year has made. The students are excited about attending games, and involved in UH's sports."

First-year head coach Tom Herman is doing what Art Briles and Kevin Sumlin did before him. Briles and Sumlin both used their success at Houston to land top-tier jobs—Briles at Baylor, and Sumlin at A&M. UH paid Herman a school-record amount of $1.35 million to leave Ohio State and come back to Texas. Herman is a Californian by birth, but a coach raised in Texas; his coaching roots began at Texas Lutheran, extended to Texas, expanded to Sam Houston State, and then to Texas State and Rice, too.

In his first season the Cougars have not lost, averaging 46 points per game, and the success of the football team is validating the school's plan. The idea is not complicated: Win, and the fans will come, followed by the students, and then the money. Perhaps this time Houston can also hang on to its head coach.

"The perception of UH is that it's a commuter school," Villars says, "but the university has created and accomplished an H-Town takeover."

5:13 P.M.

NRG Stadium Parking, Coors Light Blue Lot 22

Driving approximately eight miles from the University of Houston to the home of the Houston Texans, it's hard to miss that the player this town loves the most is J. J. Watt. Nearly all of the Texans' signage in this town, from the sides of city buses to billboards, is of their All Pro defensive end from Waukesha, Wisconsin, who has made Houston his. Houstonians love Watt, and he loves Houston right back.

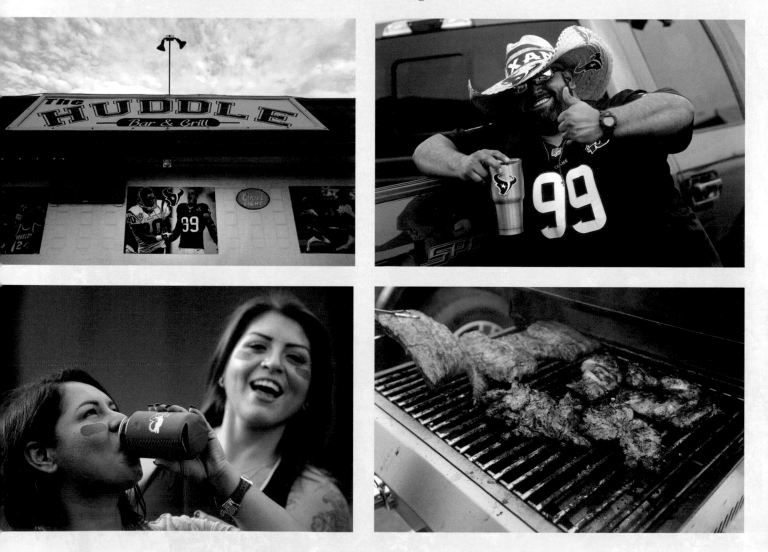

South of the stadium sits an RV where a large group of young professionals is sitting in chairs, pouring beer from a keg, playing outdoor games such as bag toss or throwing a football, watching ESPN's *SportsCenter* on a satellite TV. The topic of conversation seldom veers from football, or the current state of the Texans.

"We've got the worst GM in the league" is a common phrase.

This is Brad Spradlin's party, and it functions as a way to entertain clients as part of his job at Triton Equipment Services. Amid this group of young male professionals, nearly all of whom grew up together, is a man with his own "Watt story" that makes the man's relationship to his city so endearing.

Nathan Poe is twenty-seven, and when he takes a break from sipping his beer or ripping the Texans for failed drafts, he shares one of the great moments of his life. As part of his wedding celebration, Poe had a little statue of J. J. Watt made for the top of his groomsmen's cake. Not long after the wedding, Poe's buddy tweeted a photo of the Watt figurine atop the cake to veteran ESPN business reporter Darren Rovell. Rovell then retweeted the picture, which eventually found its way to Watt. Watt contacted Rovell to say he wanted to meet the newlyweds. Rovell eventually found Poe's wife, Stephanie, and told her in a phone call, "No guarantees—can you be home at five?"

Sure enough, J. J. Watt knocked on the door of the Poe residence at five p.m. When he greeted Stephanie in her house, he noticed the two large TVs in the living room, positioned there so the couple can watch two games simultaneously. A local ABC TV station was there to cover it, although Watt asked not to be on camera. Watt simply wanted to meet the people who were supporting him, and the Texans.

Just one problem: "I wasn't even there," Nathan Poe says. "I was offshore. They couldn't reach me because I was drilling in the Gulf of Mexico."

Luck would have it that Poe and his wife went to a charity event later that year, which Watt also attended. Poe was finally able to meet his sports icon. Watt remembered, and said, "You were the ones that had the two TVs in your living room!"

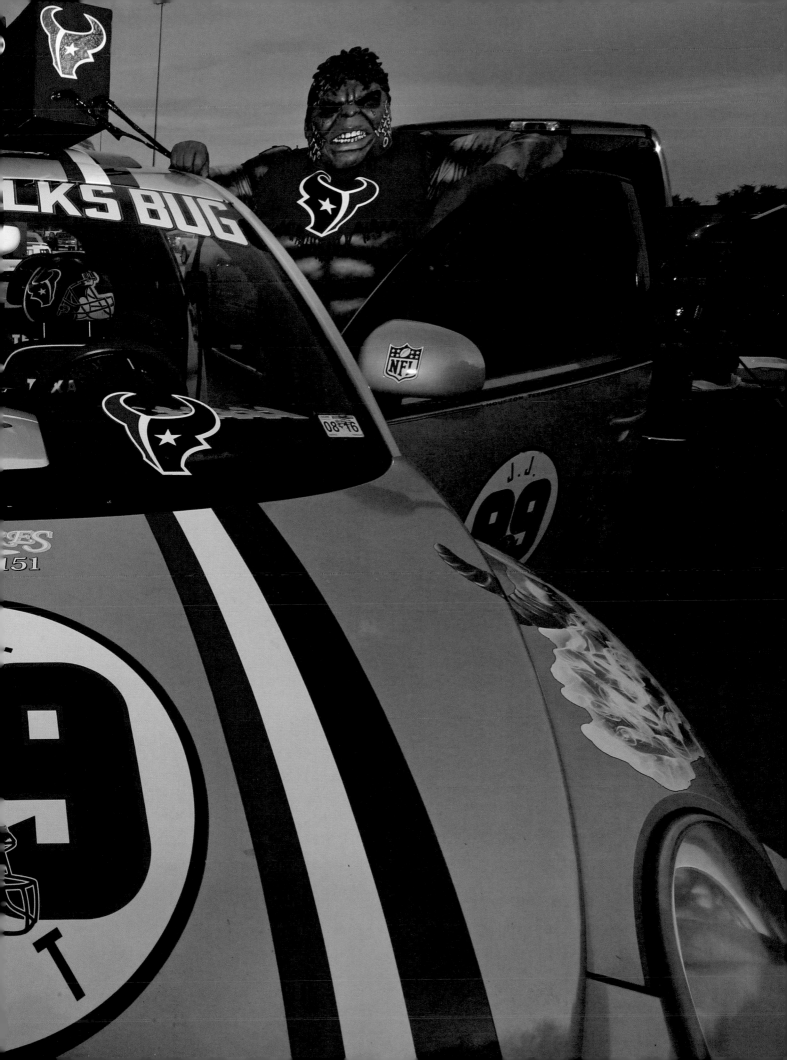

6:13 P.M.

NRG Stadium, Bud Lite Plaza

At a small radio booth directly outside of the stadium, a curious crowd of Texans fans approach the announcers as they introduce their special guest: Houston Rockets center Dwight Howard. He is one of this city's biggest sports stars, mentioned in the same breath as teammate James Harden, J. J. Watt, and Astros pitcher Dallas Keuchel.

Howard is a ripped, six-foot-eleven specimen who commands a crowd. He is a favorite among his fans, primarily because he chose to be with them. This is the man who rejected a bigger contract from the Los Angeles Lakers to sign with the Rockets in the summer of 2013. The Rockets are the only team that has given this city a pro sports title—in 1994 and '95—and Howard helped to make the franchise nationally relevant again.

Fans here feel that their Texans are on the precipice of terrible, yet the NRG Stadium parking lot is still packed with tailgaters, despite the fact the Houston Astros are playing an American League Division Series playoff game in Kansas City at the same time. NRG is sold out because these people love football.

The Texans exist because billionaire Bob McNair personally made sure the team would return to Houston rather than Los Angeles. In 1999, McNair paid a record $700 million to the NFL to create the expansion Texans; he personally beat out a pair of bids from LA by roughly $200 million. The fans love McNair for this, and hate Bud Adams, the former owner of the Oilers. Adams is still reviled for angrily taking his team, and its name, in 1996 to Tennessee because the city refused to help him build a new stadium. It took until 2016 for the NFL to finally land a team, and a stadium, to return to Los Angeles.

Fans here feel that their Texans are on the precipice of terrible, yet the NRG Stadium parking lot is still packed with tailgaters, despite the fact the Houston Astros are playing an American League Division Series playoff game in Kansas City at the same time.

Houstonians who remember the Houston Oilers are not as plentiful any longer, but the devotion to that time and some of the colorful characters from that team is undying. Bum Phillips, who coached the Oilers from 1975 to 1980, had the misfortune of running right into the dynasty of the Pittsburgh Steelers in the '70s. Bum and his Oilers exist in a state of Greek-like myth around this region. Bum never did reach a Super Bowl, and no Houston team ever has.

Regardless, the *Bum Phillips All-American Opera* ran for one night in Houston the month before this game. Based on Phillips's autobiography, *Bum Phillips: Cowboy, Coach, Christian*, the opera made its debut in New York City and actually received positive reviews from the notoriously difficult critics of the *New York Times*. The "Luv Ya

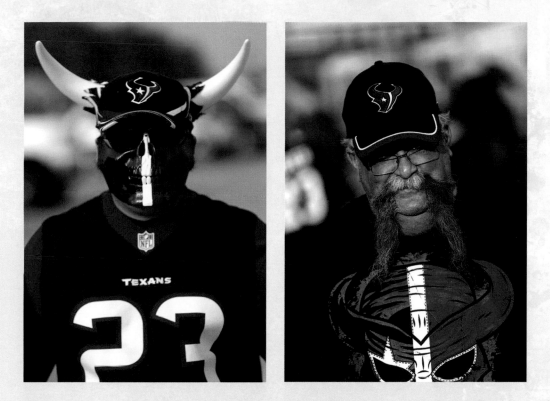

Blue Days" from the Oilers teams of the '70s that included Hall of Fame running back Earl Campbell built a bond with its city that few teams ever achieve.

Tony Sherrill stands in the plaza waiting to go inside. He's a Texans fan, yet there's no mistaking the fact that his passion for this team originated when he was a kid watching those Oilers. He was at the Astrodome when the city held a pep rally for the Oilers after they were blown out in Pittsburgh by the Steelers in the 1978 AFC Championship game.

"We had a love affair with that team," Sherrill says. "It was a family then."

Sharon Havemann graduated from Pearland High School in 1968, and she has an undying loyalty for Houston football, whether it's the Cougars, Oilers, or Texans. "Football is a religion here," she says, "and we will follow a team no matter how bad they are."

Despite Houston's size and robust economy, its football team's lack of success compared to that of the Dallas Cowboys has created and maintained an inferiority complex that exists to this day. The Cowboys won Super Bowls while the Oilers could never reach that pinnacle. Former Dallas Cowboys team president Tex Schramm famously said of his team in the '70s that the Cowboys were "America's Team." After an Oilers win against the Cowboys in '79, it was Bum Phillips who said, "The Dallas Cowboys may be America's Team, but the Houston Oilers are Texas's team."

Passionate Oilers fans can recite that quote from memory. On this night it's clear that not many remember this anymore. The tailgate scene is all Texans. For the older generation of Houstonians who still remember the better days of Bum Phillips, Jerry Glanville, Warren Moon, and others, it doesn't matter. The Texans are theirs, and their loyalty to them is as strong as it was to the Oilers.

6:58 P.M.

NRG Stadium tunnel

The Houston Texans cheerleaders hurriedly walk into their dressing room for last-minute preparations before they run out to the sidelines. It is impossible *not* to stare. From afar, professional cheerleaders are a group of women in perfect physical shape, able to wear outfits only the bravest could pull off. Their makeup is extensive, their hair, heavily managed, yet neither are necessary. Oftentimes they actually look better in person than they do in their Photoshopped pictures. They are in enviable shape, and they are professional, often more so than the football players they stand to applaud for three hours every game. This is a collection of pretty young girls whose job it is to do just that: be professional, look good, and cheer.

Among this cast of beautiful young women is one that stands above the rest in a way that is decidedly rare for a cheerleader. Lesha is five-foot-eleven; wearing the uniform's knee-high pink boots, she is well over six feet tall.

"I was in the sixth grade when I hit my growth spurt, and I would cry myself to sleep and ask my mom, 'Why am I so tall? Why don't I stop growing?' " she says. "In my sophomore year in high school I started modeling, and those girls were six-foot-two. *That's* when I wished I was taller."

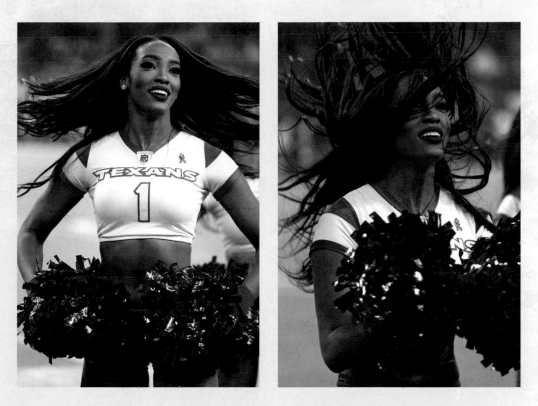

She is black, with long hair, and beautiful. She towers over her teammates, and looks like she belongs more on a Paris runway than an NFL sideline. She is graceful, athletic, and hard not to notice. During middle school and high school she was the target of interest for the basketball, volleyball, and track coaches. At the time competitive cheerleading remained more of a club activity. (In 2015–2016 the Texas University Interscholastic League did add a "spirit" category competition.)

Lesha has the perfect build to play sports, but cheerleading is her thing.

"When I got to high school, I had to pick one activity," she says, "and I really didn't want to play basketball. I wanted to do something more meaningful, and for me, that was cheerleading."

Cheerleading doesn't necessarily fit the conventional Girl Power paradigm, where a woman is lauded more for her mind and intellect than her appearance, but to the cheerleader, that doesn't matter. To cheerleaders in Texas, what they do is every bit as critical as the game.

Texas cheerleading can be a blood sport, or a national joke. In 2008, Lifetime Television produced the highly entertaining *Fab Five: The Texas Cheerleader Scandal*, which chronicled the inane real-life antics of five teen cheerleaders in McKinney, near Dallas. Their behavior was nothing compared to the internationally famous story of Wanda Holloway, the famous "Pom-Pom Mom," which happened twenty-three miles from Houston, in Channelview. Holloway was sentenced to prison in 1991 after trying to hire someone to kill the mother of a girl who had made the middle school cheerleading team while her own child did not. Holloway's hope was that the child would be so sad that she'd quit, thus creating a spot for her own daughter to make the team. This story would eventually be told in a book and two movies.

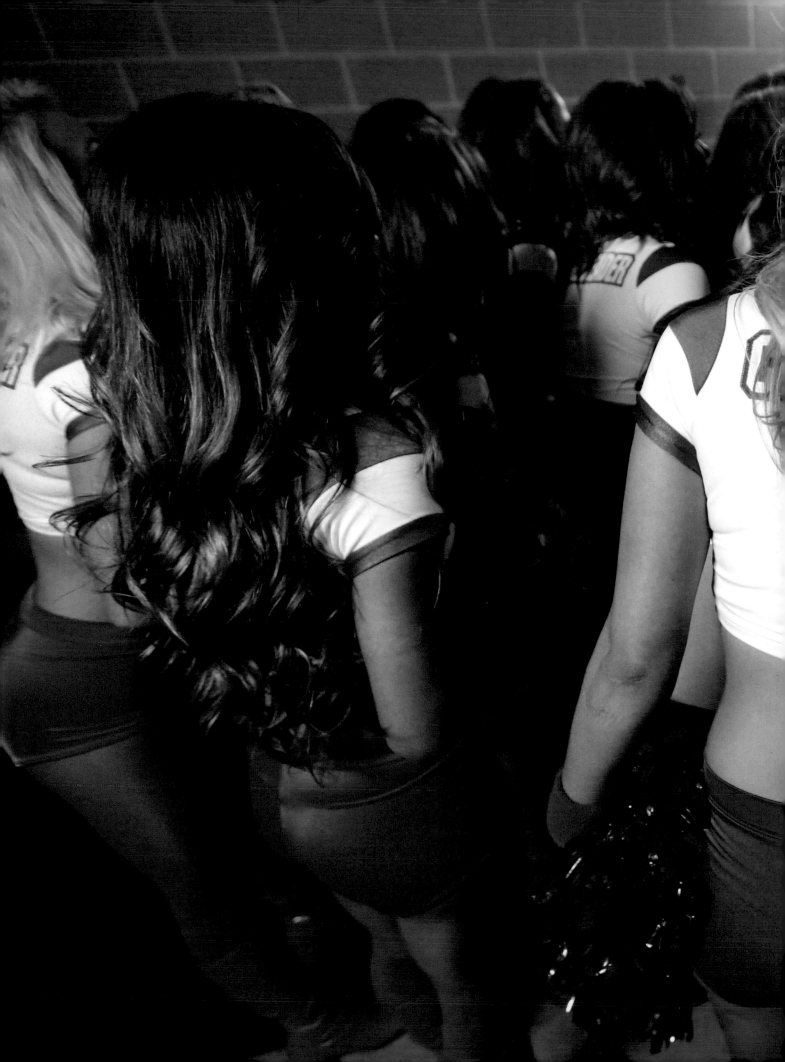

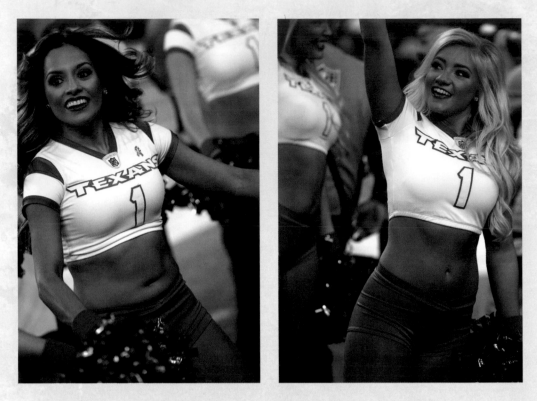

These tales are outlandish and hyperbolized exceptions that help to construct an image of Texas football as a bunch of blind, flesh-eating zealots with one mission in life: to play football, or to cheer for football. The cheerleading Fab Five and Wanda Holloway did happen, but they are not the norm. Nonetheless, cheerleading here *matters*.

Football is a game, and a show; there is no separation between church and state in this equation. A female may not fit into a football game, but she does in a football show. Lesha is not sure how long she will be part of this show, but she loves it, and is as impossible to ignore as the players themselves.

FIRST QUARTER, 8:50

Texans' ball

Hometown boy Andrew Luck wears a Colts hat and stands on the sidelines. He is hurt and out for tonight's game; starting in his place is forty-year-old veteran Matt Hasselbeck. His counterpart is a fellow native Texan that this fan base is praying can be their version of Andrew Luck.

The Texans take the opening kickoff, and with Ryan Mallett as their starting quarterback, they move the ball down efficiently. Mallett has been this team's starting quarterback since week two, when head coach Bill O'Brien made him the starter over Brian Hoyer. The Texans have just completed the thirteenth play of the drive, and are at the Colts' 19-yard line when CBS color analyst Phil Simms says during the telecast, "How about the confidence of Ryan Mallett? Different-looking quarterback than we saw last week."

Clockwise from above: CBS sportscaster Jim Nantz, Houston Texans owner Bob McNair, and Andrew Luck

When the New England Patriots traded Mallet to Houston in the off-season, the Texans' fan base nervously hoped he'd be the answer to this team's problems at the game's most important position. No position has stymied the progress of this team more than the quarterback. David Carr was the number-one overall pick of the team when it was created in 2002, but he never panned out. His replacement, Matt Schaub, was an upgrade, but never good enough to lead them to great success.

Mallett grew up in Texarkana in the northeast corner of Texas, along the Arkansas border. He is big and strong, and can throw a ball to the moon. He looks the part of a star NFL quarterback, with all of the tools and similar physical skills to Luck. Like Luck, Mallett elected not to play college football in Texas. He went to Michigan, and then transferred to Arkansas. Unlike Luck, the rap on Mallett is that he is immature.

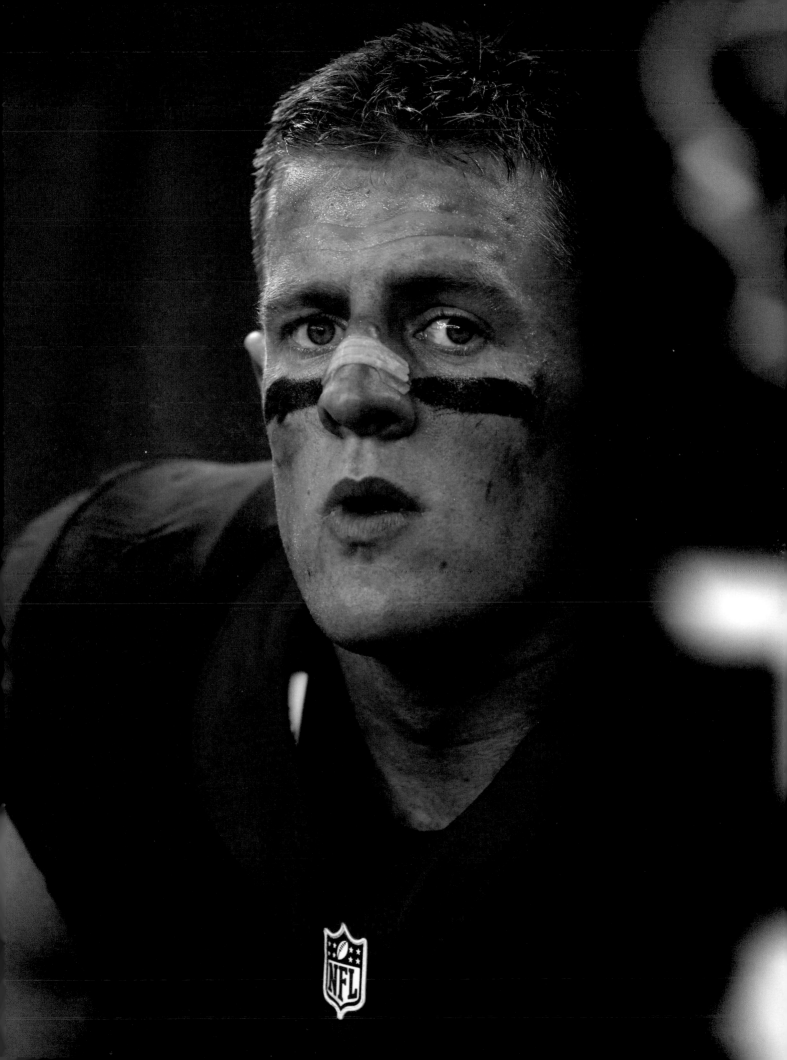

Two plays after Simms gushes about Mallet's confidence, on a third-and-five, he throws a pass over the middle to open running back Arian Foster. The ball is on target, but it goes through Foster's hands and is intercepted by Colts safety Mike Adams.

"What else do you want me to do? Throw the ball better?" Mallett asks.

Mallet is disgusted as he walks to the sidelines. Foster sits next to his quarterback and points to his chest, saying, "It's my fault."

SECOND QUARTER, 6:56

Texans' ball

A team's season comprises thousands of plays full of timing, bad luck and good luck, nuance and interpretation. Thus far the Texans' season has been full of bad luck and bad breaks.

His team trailing 13–0 and facing a third-and-three from their own 27-yard line, Mallett stands in the shotgun. His pass attempt is incomplete, but he takes a nasty hit from Colts linebacker Sio Moore, who is penalized for "roughing the passer—leading with the crown of the helmet." Replays show that Moore's helmet is down as it slams into Mallett's ribs. Before the NFL's rulebook expanded to try to protect more players from injury, this would have been a clean hit. Now it's a 15-yard penalty and automatic first down for the Texans.

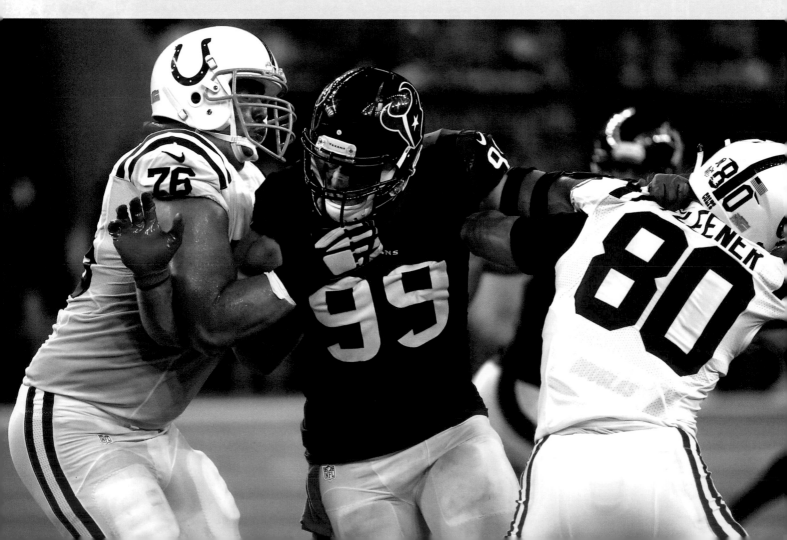

Mallett is unable to stand up immediately, and looks like he had the wind knocked out of him. He walks slowly, gingerly, off the field, and Hoyer replaces Mallett. As the Texans run two plays, one of which is an incomplete pass from Hoyer, Mallett puts his helmet on as a signal to the coaches that he's ready to play. The ancient football adage that a player can't lose his starting job because he was injured does not apply here. O'Brien stops Mallett from going back in. He is staying with Hoyer, and Mallett is pissed. He just lost his starting job.

SECOND QUARTER, 00:01

Texans' ball

Under any other circumstance, all eyes here at a local sports bar—Coaches' Pub on Louisiana Street—would be on the Texans–Colts game. Instead, the majority of the TVs here are showing the Houston Astros game against the Kansas City Royals. Sports bars represent a large, multimillion-dollar machine in Texas, and normally the football game would trump a baseball game, but this is a special situation.

The sports-bar experience is part of the fabric of the social scene on game nights—a place where fans wear their team jerseys and settle in for the night to watch a load of games on Saturday, or all day Sunday. This particular circumstance demands that more eyes in Houston be on baseball than football. The reason? This city has been dying for a winner, and the Astros have never won a World Series. This season snapped a string of six consecutive losing years, three of which included a hundred losses.

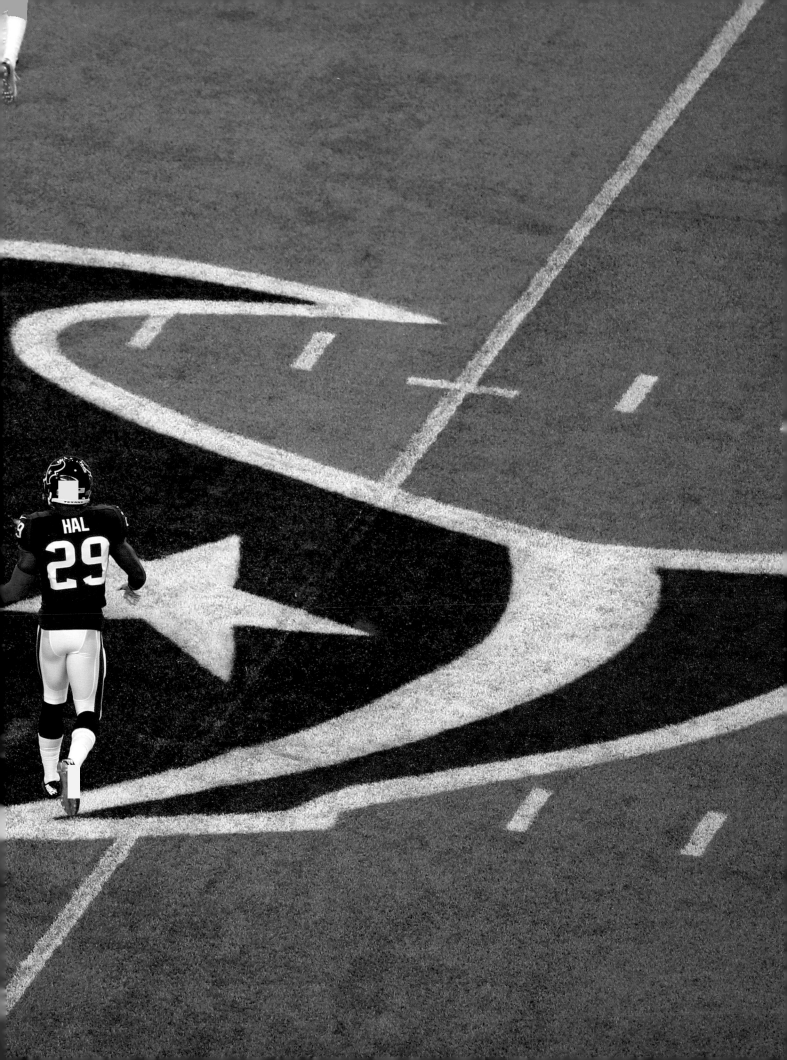

The Astros scored four runs in the first four innings against the defending American League Champion Royals, and are primed to take a 2-0 lead in this series. It doesn't help that the Texans are losing 13–3 when Hoyer takes the snap at the Colts' 42-yard line, with one second remaining in the first half.

So far this game has been a bad night for Texans fans. The former pride of the Texans—wide receiver Andre Johnson—has scored a touchdown for his new team, the Colts. The Texans' starting quarterback has been benched.

In the final play of the first half, Hoyer drops back to pass and launches a Hail Mary—a moniker made famous by former Dallas Cowboys quarterback, Roger Staubach—into the end zone. For the first time tonight, something goes right for Houston: Texans rookie receiver Jaelen Strong out-jumps the Colts defenders and catches the ball in the end zone, for the Texans' first touchdown of the night, and the first touchdown of his career. The few Texans fans watching the football game rather than the baseball game rejoice, and eventually those watching the Astros also celebrate the football team's good fortune.

Maybe the Texans game is not over.

FOURTH QUARTER, 1:37

Colts' ball

Andre Johnson has scored two touchdowns tonight, but the Texans have found his quality replacement in DeAndre Hopkins. He has caught eleven passes tonight for 169 yards, and in his third year out of Clemson looks like a stud. The problem for the Texans is that Hopkins is not a quarterback, and he can't play defense.

The favored Texans trail 27–20, and the Colts have the ball at their own 20-yard line on a third-and-six. If the Texans can force the Colts to punt, they will have a good chance to tie the game. They feel like they should have tied it on the previous possession, but Hoyer's pass was intercepted in Colts' territory.

It is just past ten p.m., and most of the fans here have to wake up early tomorrow to go to work; if the Texans can get a stop here and score, the lack of sleep will be worth it. All the Texans need to do is to stop a likely running play and they will have a chance. NRG Stadium is loud, the team has momentum, and there is the sense that the Texans are going to do this.

With five seconds remaining on the play clock, Hasselbeck takes the snap and actually drops back to pass. The Texans fans are shocked and giddy. If they can force an incompletion, they won't even have to use a timeout. Hasselbeck looks to his right,

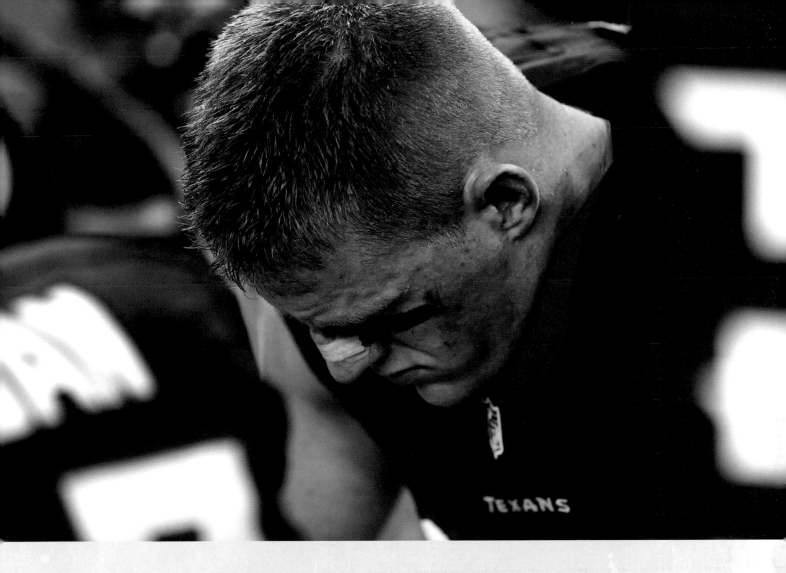

but stops and lofts a deep pass in the direction of his favorite receiver, T. Y. Hilton. Texans defensive back Kareem Jackson runs stride for stride with Hilton, who at the last second uses his right hand to gain a fraction of separation and actually catches the ball, for a 43-yard gain. The fans immediately are silent, and Hilton waves good-bye to the crowd. Luck celebrates on the sidelines as if he threw the ball.

It is an NFL record, sixteen consecutive wins for the Colts in the division, and a painful kick to the Texans.

At least the Astros won.

11:03 P.M.

Houston Texans locker room

Disgust hangs in the air of the Houston Texans locker room as players slowly dress, or hurriedly move to leave. Everyone here knows the score: The Colts had no business winning. Mallett actually left the field before the end of the first half, although he says he did this because he didn't realize the half was over. After the game he tersely addresses the media with answers such as "It's a long season. We still have a lot of

games left to play. What we gotta do is get on the right track," and "The only people that matter to me are in this locker room."

Directly across from Mallett's locker is the Texans' other moody, but far more productive, player—running back Arian Foster. He dismisses the idea that this season is the lowest point in his seven-year career with the Texans.

While Foster talks, 325-pound veteran defensive tackle Vince Wilfork slips on his jeans without saying a word. No one bothers to ask the man who won multiple Super Bowls with the New England Patriots his thoughts. The Patriots cut him during the previous off-season because they thought he was finished. He is here in Houston, playing out the string.

Disgust hangs in the air of the Houston Texans locker room as players slowly dress, or hurriedly move to leave. Everyone here knows the score: The Colts had no business winning.

There is one guy in this locker room who has seen too much of the NFL, and of football, to be too negatively affected by one game's outcome. He is thirty-nine years old, has been in the NFL for sixteen years, and should be set for life. Only the die-hards know the name Shane Lechler.

He was born in nearby Sealy, his parents played sports at Baylor, and Shane is a former All-American at Texas A&M. Shane is a Texan—a Houstonian—and if any member of the Houston Texans understands the plight and frustrations of this team, and, more specifically, this fan base, it is this man.

"I have been around it my whole life, and I understand it," he says. "Losing the Oilers when we did, and how we did. I still remember when Bud Adams took them. I had all of the 'Luv Ya Blue' stuff. I loved the Jerry Glanville and the all-black he had the team in. When Bud took them, he took the heart away from this city.

"This is a new organization, compared to most of the rest of the league. It is one that the city adopted quickly. I think ninety-nine percent of the people here adopted us when Mr. McNair bought the team. I know how badly these people want it. It is frustrating. We know we are better than this."

11:15 P.M.

J. J. Watt's locker

Watt is the last person to talk to the media. He could decapitate a reporter with a glare. Hasselbeck, who two days before this game needed an IV drip and did not practice during the week, beat him. Watt is a perfectly sculpted hulk who has become an even better version of the All-American he was at Wisconsin.

A female publicist stands in front of his locker stall as a buffer from the media. Watt is the face and voice of the team, the only defensive player in the NFL whose voice is the most important in his locker room. The staffer moves out of the way, the media scrum pushes up to him, microphones and booms about twelve inches from his mouth.

"Guys—can you back up a little bit?" Watt asks.

This is not a request. He's pissed. That smiley, happy figure that goes out of his way to interact with fans on social media, or in person, is somewhere else. His team is 1-4 and there is nothing he can do about it. He is a defensive end, not the quarterback.

"I don't judge frustrations. It's just frustrating," he says.

"What do you want me to do? Beat a triple team?" Watt says tersely. "What kind of question is that?"

Watt played all sixty-five snaps on defense and was credited with assisting on two tackles. The Colts sold their soul to block him and his teammates did not make the plays. In an effort to get the short-answering Watt to say anything beyond a five- or six-word response, a reporter nervously fumbles through a question by asking, "Are you staying within yourself?"

"What do you want me to do? Beat a triple team?" Watt says tersely. "What kind of question is that?"

It is a desperate question for a desperate team that at this moment has no answer.

TRAVEL LOG, DAY 1

Photographer Ron Jenkins and I arrived in Houston on Wednesday, October 7, to ensure that the first of the four days could start in the morning. Flying from Dallas / Fort Worth International Airport to Houston Hobby was not a problem, which allowed us to start basically at dawn. The trickiest part of Houston is, by far, its traffic from hell. The only place in America that may rival Houston for bad traffic is Los Angeles, although it's close.

The day was mapped around trying to drive to places at off-peak hours, and making sure we arrived in plenty of time for the start of the Texans versus Colts game. How we all managed to navigate this planet before interactive and real-time maps on our phones is a mystery.

Ron and I drove mostly from A to B to C by design, except for the stop at Beech-White Park. Talking to Rodney, the homeless man, next to those football fields and taking his picture was not by design. Neither was meeting some of the other men who approached Ron wanting his money.

The night ended at roughly 1:00 a.m. The flight to Midland–Odessa was scheduled for 7:30 a.m. Day 1 was long, but not a problem.

11:56 P.M.

Seabrook

A few minutes shy of midnight, the city of roughly 6.2 million is relatively quiet. Only the cleanup crews and staffers from NRG Stadium remain at the stadium. The nearby Astrodome is dark. There is a fading amount of traffic on Interstate 10. Loop 610 moves. Most of the restaurants are closed. The city's outstanding and underrated cultural district is dormant. The chemical plants from Baytown to Texas City to Seabrook to Pasadena continue to run.

Of all of the football games today, ironically the highlight of the day in the city is not football, but baseball. The Houston Astros defeated the Kansas City Royals 5–2 in Kansas City in Game 1 of their best-of-five American League Division series. At this moment, this football city is an Astros' town, but one football team is gaining serious traction.

The University of Houston blew out SMU by 21 points, and is on the verge of cracking the Associated Press Top 25 ranking. People here are beginning to notice, albeit slowly, that the hometown team is legit.

Tomorrow is nearly here, which is the official start to the football weekend. It's almost Friday; time for high school football.

DINING LOG, DAY 1

Houston is actually a favorite among chefs, considered one of the best food cities in America. The city is stacked with solid options, and has nearly every cuisine imaginable. Here are a couple of favorites:

Danton's Gulf Coast Seafood Kitchen. Located in the arts district, Danton's offers a wide array of seafood choices, most notably dynamite, fat oysters plucked from the Gulf of Mexico. It has gumbo, as well as a large Sunday brunch. (4611 Montrose Blvd., Houston; dantonsseafood.com)

Bellaire Broiler Burger. H-Town has plenty of burger options, but few are going to top this place. The broiler is in the front window. Don't come for the ambience, but the burger. This is the ideal greasy-cheeseburger-and-fries experience. (5216 Bellaire Blvd., Bellaire)

MIDLAND-ODESSA

Before the Dallas Cowboys, Dallas Texans, Houston Oilers, or Houston Texans, the roots of football in Texas are in the kids who play the game and support the system that makes it all possible. Because of the state's population and single-minded focus on one sport, high school football in Texas is bigger than in any other state, including Ohio, Florida, or Pennsylvania.

Media outlets cover high school football in Texas like it's the NFL or the Texas Longhorns.

Media outlets cover high school football in Texas like it's the NFL or the Texas Longhorns. Communities spend millions of dollars to build palaces to watch high school games. Fall schedules are built entirely around a ten-game high school football regular season. Texas high school football is a lifestyle that affects legions of citizens, from the players to the band members and cheerleaders, from the trainers and coaches to the teachers, boosters, and fans.

There are 1,064 public high schools that play eleven-man football, and an additional 138 that play six-man football. All of that adds up to more than 166,000 students playing high school football, and more than 121,000 in the marching band. These figures do not include the private schools or the growing number of charter schools that play football.

Basically, if you live in Texas, you're either playing football or watching it.

9:08 A.M.

FM Road 191, Midland

The annual average rainfall for this area of Texas is about fourteen inches per year, which makes the fresh splash of rain that fell the previous night and this morning an unexpected but most welcome anomaly. Unlike the many other climates of Texas, way out here it can be dry and hot, the kind of heat where the air refuses to move. In the Petroplex the wind howls. With nothing to stop it, a good thirty-mile-an-hour breeze is not uncommon, and it can cut into your teeth and eyes. Those gusts are typically felt more in the spring than the fall.

This morning a cold front has blown through, giving the whole area a crisp autumn feel—nothing like the humidity that circles Houston. Midland is about 460 miles from H-Town, but it may as well be on the other side of Mars. Houston and Midland–Odessa are in the same state, but life in Houston feels nothing like life here in West Texas. There is one Starbucks in Odessa—two, if you count the one inside the local hospital, which you don't want to because it closes at five p.m.

Midland is about 460 miles from H-Town, but it may as well be on the other side of Mars.

The ability to buy a Grande Nonfat Blah-Blah-Blah is far from the only difference between Houston and Odessa. There is no hurry out here, which is simultaneously its appeal and its drawback. The idea of a traffic jam is comical. Compared to the state's metropolitan areas like Austin or Dallas, there's not much to do out here, but the hassles are also far fewer. People come here to find a job, to make some money, raise a family, and enjoy a slower pace of life. Folks here live at the pace of a tortoise and not a hare, and about the only commonality they thrive on is the health of their natural resources—oil, gas, and football.

9:37 A.M.

Midland Lee High School, Odessa

Inside the main office at Midland Lee High School is an autographed picture from this area's most famous ex-residents, and this school's most famous alum. Former first

lady Laura Bush graduated from Lee in 1964. For a long time both she and George W. Bush lived in Midland. On the picture with a black Sharpie, the president wrote, "To Lee High School," and the famous couple signed their respective autographs.

When Dubya left the White House in 2009, the first place he went was back to West Texas. Air Force One actually flew the First Family to Midland. He and Laura were greeted by twenty thousand of his people at nearby Centennial Plaza. This is the town where the two met, and where Laura was born, in 1946. After leaving Midland the two officially retired to Dallas. Despite the national criticism George W. received during his eight years in office, this entire state remains a safe harbor for the former

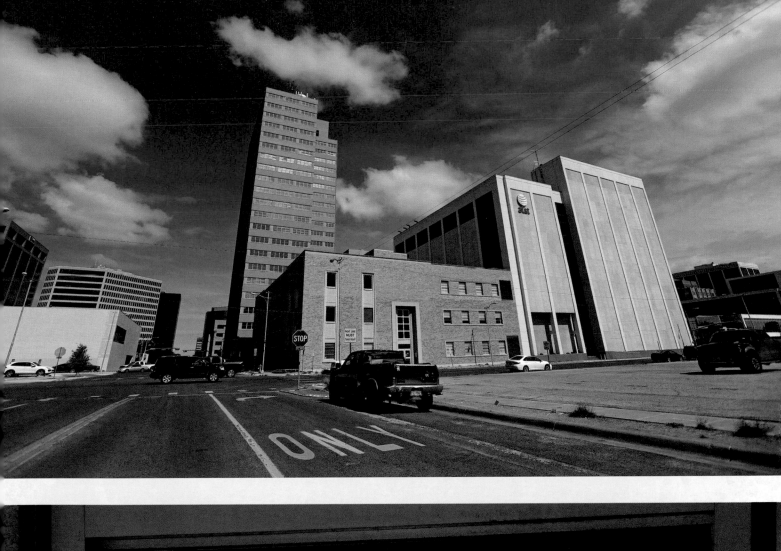

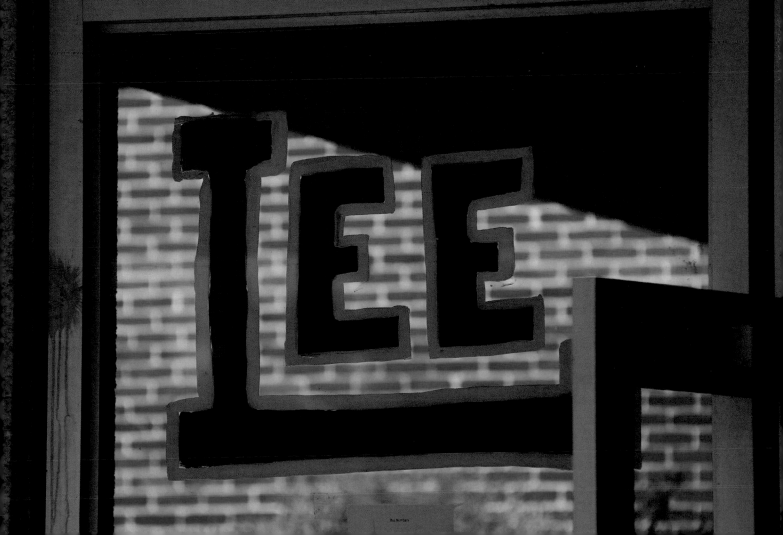

president and first lady. He seldom misses a chance to profess his love for Midland, and for Texas.

The love that folks in Midland, and most Texans, feel for Bush is not only about politics, although the vast majority of the people here share his beliefs. Their love and devotion for him is rooted in the values this community professes—small-town, Christian conservatism born from Sunday services, football games, backyard barbecues, and neighbors that know everything about everybody, and despite their private judgments would do anything for them. To knock George W. is to knock their neighbor, their friend, their uncle. *They* can do it, but an outsider cannot. Midland has a growing population of a little more than 120,000 people who cling to any national identity that a community this small can possibly offer. In this case, it's oil, gas, George W., and high school football.

Despite the national criticism George W. received during his eight years in office, this entire state remains a safe harbor for the former president and first lady.

This morning Midland Lee High School is draped in decorations, celebrating the upcoming game. At seven p.m., Midland Lee will play its more-famous rival, Odessa Permian.

9:43 A.M.

Midland Lee, football coaches' office

The season is halfway complete, and the Midland Lee Rebels are an erratic 2-3. The players are still mostly in class, and the team will not make the twenty-minute drive west to Ratliff Stadium for tonight's game for several more hours. Head coach James

Morton sits at a table just outside of his office with an older, white-haired gentleman named Mac Gilliland, talking football.

West Texas is full of characters, represented by the men right here at this table. It's game day, and the head coach chats with a fan. The meeting between these two is not part of the written job description of the Midland Lee Rebels head coach, but it's as important as any game plan or defensive scheme. The job of head football coach at any high school in these communities is not for everybody. The pay may be six figures, but coaching here is like working in a zoo. These are the towns where community involvement can be the best, and worst, element of the job.

"Coming from Lubbock, it's entirely different," Morton says.

Lubbock has only about a hundred thousand more people than Midland, but the presence of Texas Tech University changes things between the West Texas towns. In Midland, Midland Lee High School is Texas Tech University.

"People have been respectful. I have not had any issues. I enjoy people, and I know that is part of my job," Morton says. "The people here, it's a workmanlike mentality."

Morton leans back and recites a quote from the most famous football coach this region ever had—Spike Dykes. Spike coached at Texas Tech for thirteen years, and before that coached here at Midland Lee from 1980 to '83. Spike remains the weathered face and twang of West Texas football.

"Coach Dykes said it best about life out here: 'If the farmers don't have a good crop, they didn't get the rain and God held out. In Midland and Odessa, people learn at an early age—you get up early, you go to work, and if you work hard enough, you will be successful,' " Morton says. "The part that makes this place fun are the people and the tradition."

Morton grasps the culture and the people of West Texas, and these jobs. All schools have fans, but not many have the type of fans that make Midland Lee, or Odessa Permian, so special in a state full of rabid followers.

Part of the tradition includes school district lines gerrymandered to ensure that certain areas where the better players live will end up at Midland Lee rather than Midland. Families will move from one part of Midland to another—which can be a matter of a few blocks—so their son will be a Rebel and not attend Midland High.

Mac Gilliland never went to Midland Lee, yet on his finger he proudly wears a Midland Lee state championship ring.

Lubbock has only about a hundred thousand more people than Midland, but the presence of Texas Tech University changes things between the West Texas towns. In Midland, Midland Lee High School is Texas Tech University.

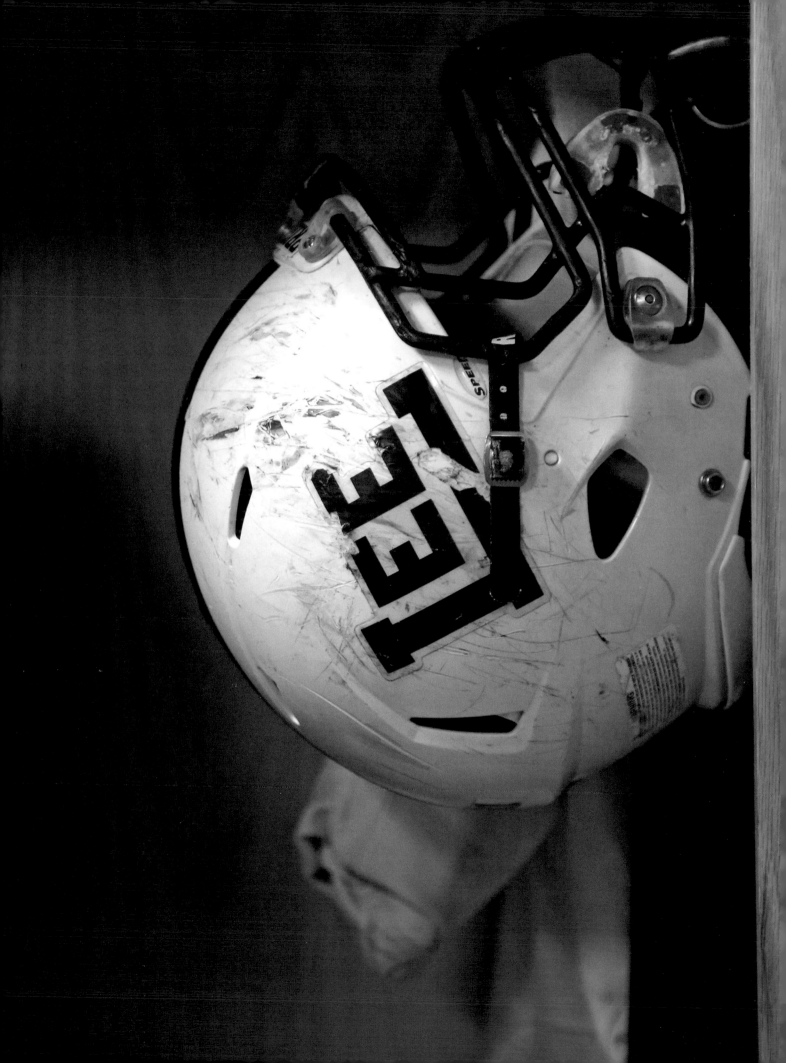

"There is more community support [at Midland Lee]. I think more people know what is going on in the program," Gilliland says in a soft drawl. He pauses, and leans in: "The difference is this—the people that don't have kids in the program. That is what separates West Texas from other parts of the state. There is still a passion and a following just from the community."

Gilliland played high school ball in the 1960s in a place called Big Spring, which is not big. He lived in a handful of other places before he settled here in the early '70s, and became a faithful fan to the point where he bought himself a state championship ring.

"Got it made after we won the last title," he says.

That last title was in 2000.

Gilliland is part of a group of elderly gentlemen who watch practice together, go to all the games, and prepare lunch for the coaches once a week during the season. This football team is a large part of the social structure for many people who have no direct affiliation with the school, other than the fact that they're fans of the local team.

"I think the biggest difference between the fans in West Texas and big-city fans is that big-city fans will go for the team in general, whereas in West Texas, they know individuals," Gilliland says. "They know each kid and what each kid is capable of. You get that kinda thing in West Texas that I don't believe you get on the I-35 or I-45 corridors."

Gilliland's group makes a calendar, and every week a different person brings lunch for the guys and they sit around and jabber. About their lives. About football. About the next game. About the weather. About the kids on the team.

There is something undeniably sweet, innocent, and perfectly logical about this if you're from West Texas.

10:31 A.M.

Midland Lee, football locker room

No one around here is quite sure if the team is better than its record, or if this is what they are—average. The Rebels begin their District 3-6A schedule tonight against a team that will reveal just how good they are, or are not. Lee does not have the national name recognition of Permian, but they all know there was a time when theirs was the best football team in the state, even though the famous Hollywood team to the west received all of the attention.

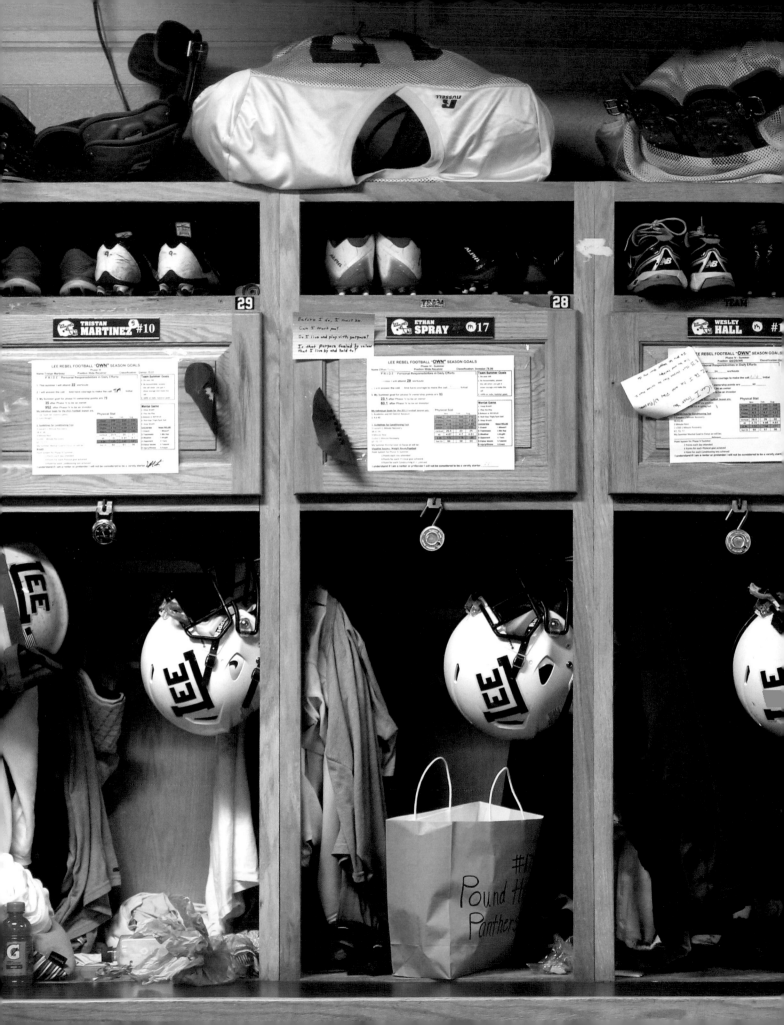

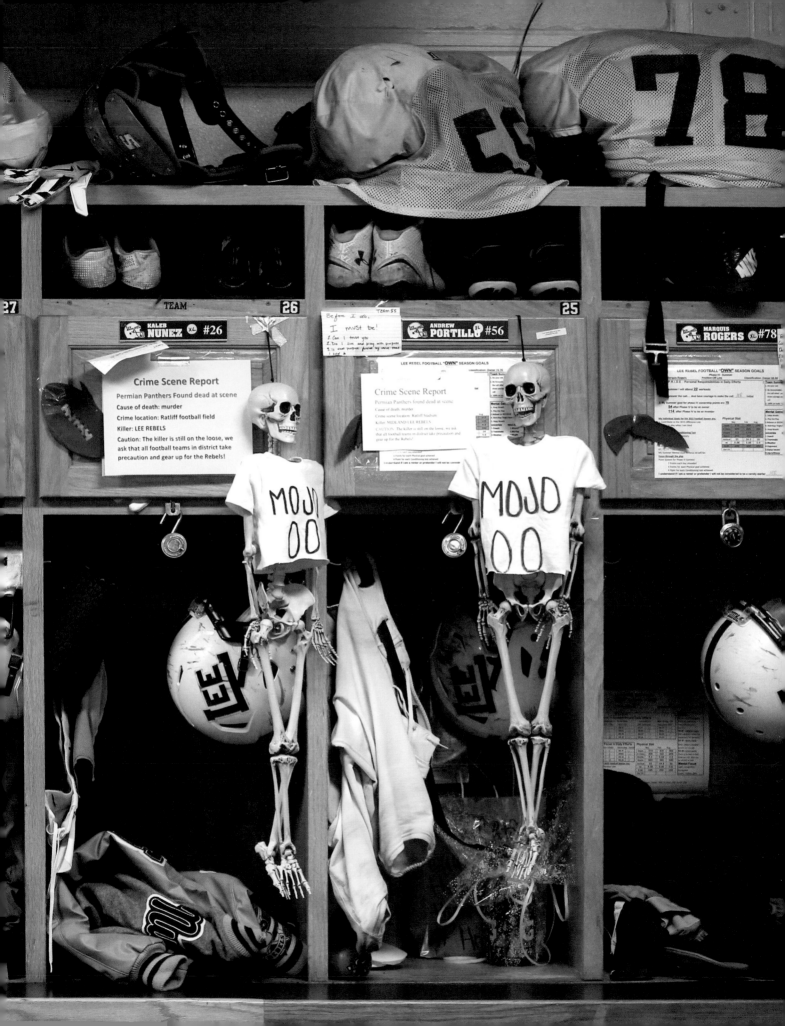

Lee won state championships in 1998, 1999, and 2000, in what was then the largest classification in Texas—5A. The Rebels had one of the best players in the history of the state, running back Cedric Benson. He was one of those special players that come along only so often, and a perfectly unstoppable kid on the field. Benson played at the University of Texas, was a first-round draft pick of the Chicago Bears, and played eight NFL seasons in Chicago, Cincinnati, and Green Bay. He doesn't come back here much anymore, but these people claim him nonetheless.

Lee does not have the national name recognition of Permian, but they all know there was a time when theirs was the best football team in the state, even though the famous Hollywood team to the west received all of the attention.

Since Benson left—along with former lineman and future Houston Texan, Eric Winston—the Rebels have not been the same. The power and domination of West Texas football, lionized by the best-selling 1998 book *Friday Night Lights*, has changed considerably in the past ten years. No team from this region has won a state title since Lee. No one will come out and say why, because we're too PC for that, but a quick look

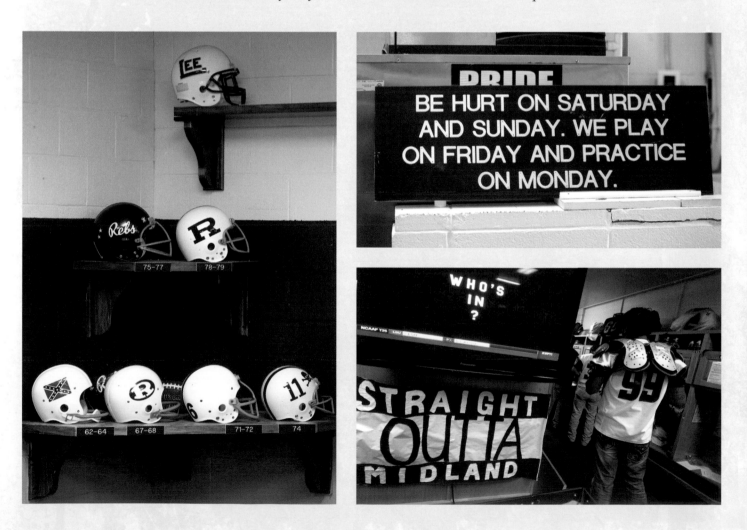

at the names on the lockers inside this room, and the reason for the drop is apparent: The demographics of Midland–Odessa and West Texas have changed dramatically. Midland is now 37 percent Hispanic—more than half of the Lee roster reflects this—and the number is growing. For whatever reason, a predominantly Hispanic football roster has not yet achieved the success the region was known for in the 1980s and '90s.

Assistant football coach Mike Connelly has lived here long enough to see this slow change to both Midland Lee and Permian. He coached at Permian for five years before taking the offensive-line job at Lee. Connelly prepares the team's classroom for the noon meeting. Most of the team will be here shortly for final-hour reminders for tonight's game, which includes a visualization exercise.

Connelly has been at Lee long enough to know what outsiders think of West Texas football, shaped mostly by *Friday Night Lights*. He knows the stereotype slapped on both teams: Priorities are askew, and football-mad parents drive the team bus. The emphasis placed on football and the money spent here is undeniably large, and it can be quite disconcerting to an outsider.

Both Midland High and Midland Lee share a beautiful 15,000-seat stadium on the western side of town that opened in 2002. Midland was one of the first to enter the race to court a corporate sponsor for its high school stadium, signing a naming-rights contract with Grande Communications for twenty-five years, at $1.2 million per year. This only enhances the perception that football in this part of a football-drunk state is somehow different.

"It's the same passion at both schools. Everybody cares," Connelly says. "Everybody thinks we are all too wrapped up in this. It's really not that. I've seen the homes of some of these kids—single-parent homes. Kids need this. It's a positive outlet. People don't realize just how much football helps some of these kids out. It gives them a purpose, and it does keep them focused on school."

11:24 A.M.

The Bar, Midland

The term *downtown* is applied liberally when it comes to the Midland skyline. While there are a couple of "larger" office buildings, everything else is just one or two stories. But don't let the modest appearance of these buildings, or the blue-jean-and-cowboy-boot-clad citizens, fool you into thinking this is some dead-broke town living off welfare. Real

Boom or bust is a way of life here.

money is moved in these unassuming offices. When the price of oil is over $70 a barrel, silly money flows out here. When the price of oil is $40 or lower, life isn't quite so carefree and fun. Boom or bust is a way of life here.

Midland is known as the area where the employers live, while Odessa houses the employees. Their collective existence fluctuates based on the price of oil and gas. At the moment the price of oil is just a tick under $60. These people recognize the impact that $2-per-gallon gas has on the rest of America, but residents here agree that life is just a bit better when it costs about $2.80.

THE BAR
EST. 1979

This region has gone bust before. In the 1980s, cash flowed freely; it was common for people to fly aboard their own planes to New York City in the morning for a shopping trip, returning home again that night. Then the market went bust and all of that excess was repossessed.

A couple of blocks away from the office "towers" is one of the more popular spots in town—The Bar. Not a bar, but *The* Bar; that's its name. On the walls are hundreds of pictures of football players from all over the state—high school, college, and pro. This is not some chain franchise, but rather a decidedly Midland establishment. At the far end of the bar in The Bar stands manager Judy Farris, who has lived here forever. As the lunchtime crowd gathers, she looks over the customers, most of whom she knows on a first-name basis.

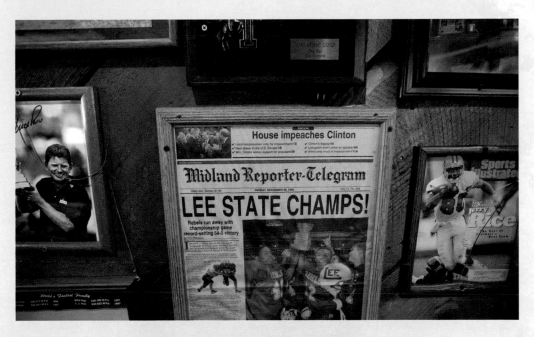

"Right now it's the drilling that is suffering, not the production," she says. "What's different this time, unlike in the '80s, is that people did not buy their own planes or their own Jet Skis. That's the older crowd."

The two communities are only twenty minutes apart on Interstate 20, but there is a dividing line. "We hate Odessa, just on general principal," Farris says, tongue firmly in cheek—or maybe not. "The saying goes, 'You raise hell in Odessa, and you raise your family in Midland.'"

Right now a good portion of the older crowd is here eating at The Bar, with the father of former Houston Texans offensive lineman and Midland Lee Rebel, Eric Winston, in the thick of the discussion. He's here, as are dozens of former Midland Lee Rebels, who gather round to talk about the price of oil, and tonight's game against Odessa Permian.

The two communities are only twenty minutes apart on Interstate 20, but there is a dividing line. "We hate Odessa, just on general principal," Farris says, tongue firmly in cheek—or maybe not. "The saying goes, 'You raise hell in Odessa, and you raise your family in Midland.'"

The two towns disagree on this point, and on football, but they wholeheartedly agree on a desire to see the price of oil go back up.

12:14 P.M.

KD's Bar-B-Q, Midland

Kansas City, North Carolina, and Tennessee all have their own take on how to do barbecue—that their way is the *right* way. They're wrong. There is a romantic, nostalgic quality to firing up a barbecue in Texas those other regions lack. Plus, Texans agree it's a mathematical fact that no barbecue tops a Texas barbecue.

The reputation of football in Texas is not too dissimilar from a piece of brisket here; there's just something different, and better, about it.

Dwight Freeman has been the owner of KD's Bar-B-Q for the past eighteen years. Known for his goatee and slow drawl, he's as pleasant as a gentle breeze, and genuinely happy that his loyal customers love his barbecue. His restaurant is jammed with Texas culture all over its walls. A roll of paper towels provides napkins for the table, and the smell of smoked brisket, sausage, and other meats from the giant smokers outside permeates the wooden walls. Even if you are a die-hard vegan, it's a good place to sit and enjoy the aroma.

ROCK

Freeman's theory about why Texans, and Americans, love his barbecue and romanticize it more than other places feels spot-on: "It's back from the old cowboy days of the Old West," Freeman says as he stands outside the giant smokers that run day and night to prepare the sausage, brisket, chicken, and tenderloins that his restaurant is famous for. "It's about the cowboys cookin' up for a wagon train, or just for themselves, over wood coals. It's been that way for over a hundred years."

Freeman has not been cooking it for over a hundred years, but at this point it feels that way. When he was a kid, his dad, Garth, worked the oil fields in Loveland, Texas, and the two of them would stay up all night to prepare a pit and slow-cook meat. "Hell, I hated it," Freeman says. "I really did hate it, but I learned how to do it. He would put the mesquite wood in a giant fire pit that he built."

The recipes for the rubs that he applies to the meat about thirty feet from his restaurant are not too different from the ones his dad used. KD's is spacious, the fare is plentiful, and it leaves a lasting impression. This is the type of place that feels, smells, and tastes like Texas barbecue.

1:34 P.M.

Stanton High School football field

Midland and Odessa are not big, but they feel bigger because each is flanked by smaller towns that are hard to find on a map. Even with a map, there's a chance you would miss these places. You don't find but rather stumble into little Texas towns. If you miss an exit on Interstate 20 out here, settle in; you're going to be driving for a while. Maybe you'll wind up in Stanton, Texas, population 2,765.

This town west of Midland enjoyed a population boom when the price of oil and gas shot up and people flocked to Stanton for jobs. When the price dropped, the jobs vanished, but the people stayed. Texas is loaded with these little towns, a great many of which teeter on the edge of extinction. Small towns across America continually shrink because of changes in the economy, and because the younger generation prefers to live in a more active, larger community. The suburbs surrounding Dallas, Austin, and San Antonio are all growing, while places like Stanton just try to hold on.

Compared to many other small towns, Stanton is actually doing well. In fact, from the looks of the high school football field, this place is thriving.

"People came out here for the jobs and they've stayed even after the jobs went away," says Stanton High School principal Mark Cotton. "I'm not sure what a lot of these people are doing for work, or whether they are living on government assistance. It will be fine once oil goes up and there are jobs again. [In the meantime, we're] growing, and I don't know why."

People genuinely like Stanton. Cotton came out here to teach and coach in 1990, and promised his wife the plan was to stay for two years and leave.

> **Midland and Odessa are not big, but they feel bigger because each is flanked by smaller towns that are hard to find on a map. Even with a map, there's a chance you would miss these places.**

Then he was named head coach, and led his team to a state title in 1997. (Stanton's 2A title was the last unified 2A title before the Texas UIL split the division into two classifications.)

"You know, we had three kids here," Cotton says. "Stanton has been real good to us, so we just decided to stay."

A lone oil derrick pumps quietly just outside the football stadium's encircling fence. Built in 2014–2015, the field and field house are big, clean, and pretty. These facilities don't look like they belong in some quaint town where its citizens can't find work. The field turf and the track cost $2.5 million. The field house cost $1.6 million, and the restrooms, locker rooms, and everything else, about $1 million.

A few young kids are throwing a football on the field that in a few hours will be open for business, becoming the epicenter of Stanton. Members of the football team sit inside one of the offices at the field house, watching game film of tonight's

opponent—Colorado City, which is one hour and forty-five minutes to the east. That's not the longest distance schools out here have to drive to play a district game; the farthest would be Coleman, two hours and thirty minutes away.

The high school parking lot is full of pickup trucks, nearly all of which are encrusted in a layer of mud and dirt, giving them an authentic, rough look. The high school football players wear their team jerseys and blue jeans, and most of them wear cowboy boots.

In about twenty minutes, the whole school—plus the elementary school—will convene in the high school gym for a pep rally.

2:00 P.M.

Stanton High School gymnasium

The Stanton High School hallways are clear and the classrooms empty for this weekly fall event. From the hallway leading into the gym, the cheerleaders can be heard, and there are the unmistakable high-pitched screams and laughter of young schoolchildren. The boys that compose the high school football team all begin to line up outside the gym, waiting to be introduced to the rest of the school. They're so young, and they simply cannot wait to play this game tonight.

Austin Luna is a junior who plays both ways—wide receiver on offense, and strong safety on defense. He chats with his friends as they wait to be introduced.

"This is going to be a *really* good game tonight," he says.

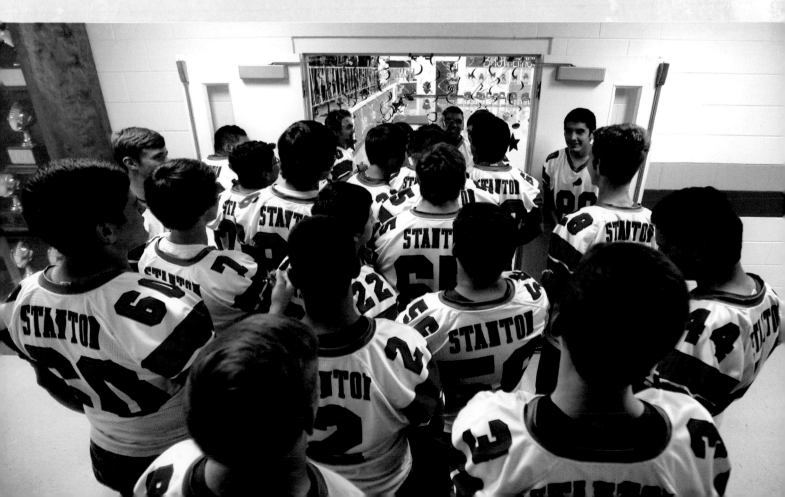

At this moment, football is everything. Playing these games with his buddies and teammates is a high point in Luna's life—an experience to be savored rather than mocked or belittled.

The team walks in as the band plays a few songs and the cheerleaders do their

At this moment, football is everything. Playing these games with his buddies and teammates is a high point in Luna's life—an experience to be savored rather than mocked or belittled.

routines. It is not professional. It does not look as good as the highly coordinated and comparatively sophisticated groups and bands at Midland Lee or Odessa Permian, but it's perfect in its imperfection. Much of the music is off-key, and some of the horn instruments limp along. The trombone players don't seem to have enough oxygen. The cheerleaders do their best, but all of it has a small-town feel.

A banner reads CLEAR EYES, FULL HEARTS, CAN'T LOSE. The line is taken directly from the television version of *Friday Night Lights*, and this mantra is present in every school all over Texas.

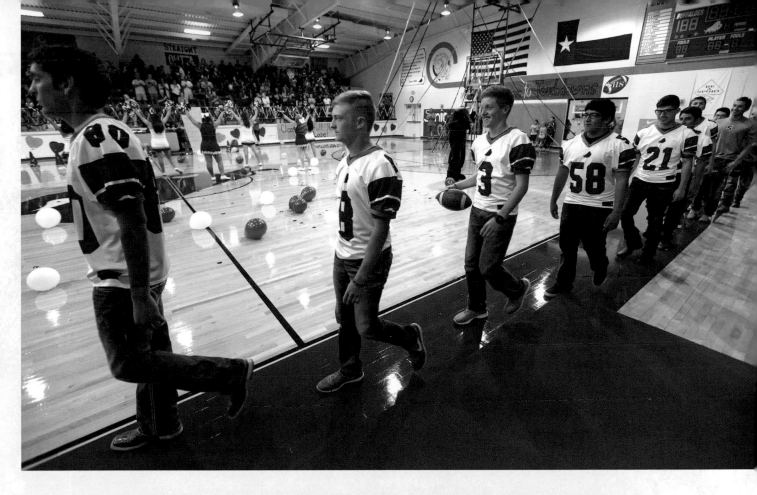

After the routines conclude, the members of the football team sit in a row of orange chairs on the basketball floor. The students, teachers, and administrators watch and listen as Lance Jenkins takes the microphone. Jenkins is a graduate of Stanton High, class of 1989. His daughter, Kelsee Jenkins, is a cheerleader here, performing with her friends in their uniforms on the basketball floor. Lance wears most of the Texan's unofficial uniform: long-sleeved blue shirt, blue jeans, and well-worn cowboy boots. The only thing missing is the cowboy hat (he's wearing a baseball hat instead).

Lance is a supervisor for the Texas Department of Transportation, and he works the chains at the Stanton Buffalo games to remain a part of something that still means so much to him. (The "chains" are the 10-yard measurements carried on the sideline that denote a first down.) Jenkins is no different than anybody else in this gym, with one glaring difference: He's black. While the number of Hispanics continues to rise in West Texas, there aren't many African Americans out here in Stanton.

> "I was raised knowing people and not their color," he says. "You treat people right and they will give you respect. I have never had a problem with [racism] out here, ever."

"I was raised knowing people and not their color," he says. "You treat people right and they will give you respect. I have never had a problem with [racism] out here, ever."

The gym is mostly quiet as the kids fight their short attention spans to listen to Lance Jenkins pass along his wisdom.

"The band. The cheerleaders. The football team," Lance tells the audience in a soft Texas drawl, "you are all family. You be there for your teammates. You give a hundred and ten percent, all the time. And the most important thing is your team. You help each other out."

What he has to say are mostly sports clichés, but he delivers his words with sincerity and passion. It is disarmingly simple and sincere. He means everything he tells these students. Jenkins is not very different from any kid who's ever played high school football. His last football game at Stanton was his last game. Football has no post-career equivalent to continue after school is long over. A basketball player can play pickup ball for decades. A baseball player can find the rec softball league team. Tennis, golf, swimming—they all last long after high school is over. When football is over, that is truly the

A baseball player can find the rec softball league team. Tennis, golf, swimming—they all last long after high school is over. When football is over, that is truly the end. They won't play it again.

end. They won't play it again. None of the high school football players sitting in this gym today can conceive of a world without football. They will live forever, and they will play football forever. They have no idea how much *right now* will matter one day, and how much it will mean to their lives.

Leaning against the gym wall, looking out at the kids that used to be him, Jenkins makes no apologies and has no regrets. "It was such a great time in my life. I loved it," he says. "It wasn't just playing football; it was all of it. It was the team. The friends. Getting out there and hitting people. And getting hit. And getting recognized for it.

"It was doing something that I loved."

3:03 P.M.

Permian High School indoor practice facility

On the exterior of the beige bricks at the front of what is arguably the most famous high school in the United States is the word "MOJO," in giant letters. Exactly what this means is up to individual interpretation, but most folks understand that it signifies a community sense of school spirit. The particulars are up for debate, but MOJO is the slogan, and it is used, often, to describe the power, the pride, and the passion of Permian.

No high school in the country is as recognized as Odessa Permian. People from Seattle to Maine to South Beach have heard of MOJO, and they've heard of Odessa Permian. While they may not know that some kids here call Odessa "Slowdeatha," they do know Permian. The reasons why folks outside of Texas are familiar with Odessa Permian may not always be flattering, but this truly is the price of fame.

The parking lot at Odessa Permian on Friday afternoon is like that of any other big high school in the United States—filled with oblivious teenagers, busy being busy.

> No high school in the country is as recognized as Odessa Permian. People from Seattle to Maine to South Beach have heard of MOJO, and they've heard of Odessa Permian. While they may not know that some kids here call Odessa "Slowdeatha," they do know Permian.

The year 2015 marks the twenty-fifth anniversary of *Friday Night Lights*, the book that made Permian a household name. Written by Buzz Bissinger, it became a long-running *New York Times* bestseller, spawned a Hollywood movie and a hit TV show, and is scheduled to be made into an additional movie based on the TV show. The title alone created a new genre in sportswriting. These three words are used from El Paso to the Rio Grande Valley, from Tyler to Sherman, to describe the euphoria that is Texas high school football. The title is associated with Permian, but it's become universally embedded in the American sports lexicon. The book changed this town and this school, in a way that some of its older citizens deplore.

Liz Faught is eighty and a 1973 graduate of Permian. She was the first person in town to get the coveted MOJO credit card (featuring the Permian Panther logo and slogan). "When that book came out, the coaches stayed up through the night to read it," she says. "[Head coach] Randy Mayes read it, and was heartbroken over the book. A lot of people felt betrayed by Buzz, and [felt] that he had an agenda. It did change the school."

They felt duped by Bissinger. He'd come here under the guise of trying to write a book about this "little" West Texas team and how it dominated Texas high school football. He came here expecting to find one thing, but the reporter in Buzz found something more compelling: adults exploiting teenagers in the name of winning high school football games. He essentially found private letters, including stories of racism and misplaced priorities, and then he made them public.

> "When that book came out, the coaches stayed up through the night to read it," she says. "[Head coach] Randy Mayes read it, and was heartbroken over the book. A lot of people felt betrayed by Buzz, and [felt] that he had an agenda. It did change the school."

The Panthers have not been the same since *Friday Night Lights* hit the shelves. People were embarrassed by the dirty laundry that was aired in the book, and city

leaders reacted by altering the way some things were done out here. The school district implemented an Advanced Placement program at Odessa High School that permitted students who would normally be enrolled at Permian to transfer, thereby diluting the talent pool. In 1990, the team was penalized for running illegal practices and was disqualified from the state playoffs. In 1993, the Panthers were forced to forfeit every district game for using an ineligible player, which ended their season after winning their first playoff game.

In 2004, the film adaptation of *Friday Night Lights* was released. While the movie was far more flattering than the book, it wasn't an entirely wart-free look at Permian football. Most of the movie was shot in Odessa, and lead actor Billy Bob Thornton made himself at home in town. Nearly everyone portrayed in the book gave their permission to be played in the film.

By sheer coincidence, the film's director, Peter Berg, happens to be Bissinger's cousin. Bissinger had no influence on the film, other than pleading with Berg about one detail: The Panthers should not win the state title game. Buzz felt it was essential to the story that the Panthers not be state champions.

"A lot of the book did *not* [really] happen," says Permian employee Alan Jones, unofficial Permian historian. "When the movie came out we were much happier with it. I think it healed a lot. A lot of the community worked on that film, and we got to know a lot of the cast and the crew."

A great many of the people from the book and the movie still live in the area.

A great many of the people from the book and the movie still live in the area. The running back covered in the book and the movie, Boobie Miles, is a legend out here.

The running back covered in the book and the movie, Boobie Miles, is a legend out here. He is another in the long line of "Greatest There Never Was," due to the knee injury he suffered during his senior year. Boobie had a hard time after high school, in and out of jail. He's a sweet guy, but good decisions have not always come easy for him.

Earlier this fall, many of the key players from the book all returned to Permian for a twenty-fifth anniversary celebration. While enjoying the fame and the royalties, there is always a certain eagerness to move on from the book. The parents of the students currently attending Permian know the book, while the kids know the movie and the TV show, the latter actually filmed near Austin.

In the back of the main building is the football team's *indoor* practice field. The Dallas Cowboys no longer have an indoor practice field, after a storm blew it down in 2009, but some of the state's wealthier high school teams still do.

In 2007, the team's boosters raised money to build this $2 million indoor facility. Former Permian, University of Texas, Detroit Lions, and Dallas Cowboys wide receiver Roy Williams helped with some of the original costs, and pays for the building's maintenance. After Roy was done with his nine-year NFL career in 2011, he retired and moved back to this area, where he's reportedly involved in the trucking business.

Inside this practice facility is another giant black-and-white sign that looks exactly like the one on the outdoor fields. It features all of this team's biggest accomplishments, most notably the state titles won in 1965, 1972, 1980, 1984, 1989, and 1991.

"This sign is actually a movie prop," Jones says. "When they were done making the movie, they just gave it to us, so we put it in here."

Adjacent to the indoor practice field is a cavernous weight room where most of the team chats among themselves. A large sign on the wall reads:

No earrings.
No cell phones.
No gum.
Must wear proper attire (no jeans).
Do not touch the stereo.
This is a working facility, not a social facility.

Not every sentence on this sign is followed to the letter.

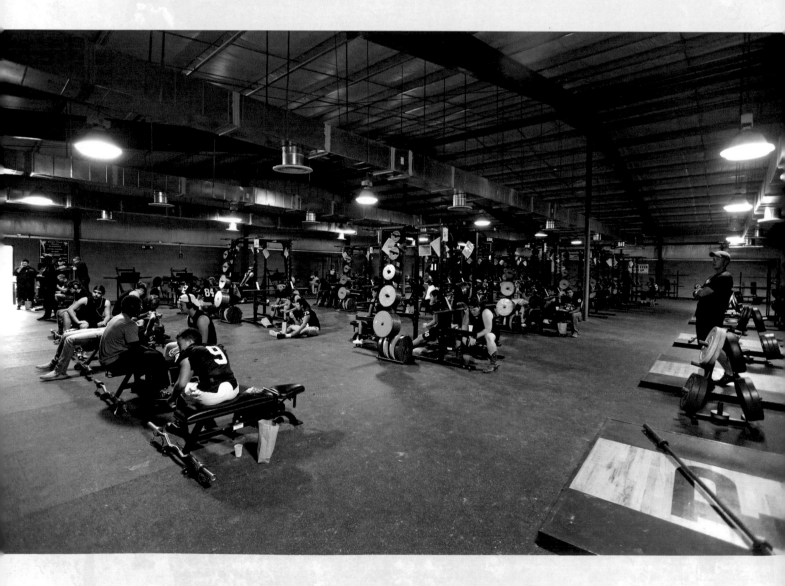

When you walk outside of the weight room and walk past the outdoor practice fields, you find the one room that still looks like the original 1988 book and film version. For the moment the locker room is decorated the way an Odessa Permian Panther locker room should be dressed on game day. On the narrow walls leading from the door to the locker stalls are the photographs of the great Permian teams and players who drew Bissinger from Philadelphia to West Texas in the first place.

When you walk outside of the weight room and walk past the outdoor practice fields, you find the one room that still looks like the original 1988 book and film version.

This is not spacious the way new locker rooms are—it's tight and cramped—yet every locker has been covered in black-and-white decorations by cheerleaders and boosters.

"We should have been in the new [locker room] already by now," Permian head coach Blake Feldt says. "The new one is going to be way bigger and much nicer. The one we're in was built in 1959; think about how much bigger kids are today than [they were] back then. The new facility will be fantastic."

One of the benefits of having a book (and film and TV show) written about your school is the money. Permian receives lots of royalties from the film each year, which goes to the school, or the athletics program.

"Over time," 1970s grad Liz Faught says, "everybody realizes a lot of good things [have come] back to us because of that book."

7:13 P.M.

Ratliff Stadium west stands

What is so striking about Ratliff Stadium is not its size but the sky over it. Ratliff's "ceiling" is a brilliant sunset and streaks of white clouds that go in all directions. This is the same sky described by Larry McMurtry in his romantic novel, *Lonesome Dove*—the same firmament captured by Western artist Frederic Remington. So much of the landscape has changed over the centuries. The buffalo that once grazed here are long gone. The only aspect that looks the same now as then is a sky comprised of orange, blue, red, yellow, and white that provides a serene painting every day.

What is so striking about Ratliff Stadium is not its size but the sky over it. Ratliff's "ceiling" is a brilliant sunset and streaks of white clouds that go in all directions.

A crowd of more than ten thousand is expected at Ratliff Stadium tonight—a big number, but far from capacity for Permian's Homecoming game against Midland Lee. The Panthers are 5-0, and for the first time in years they look like the type of team that gave them the reputation as the best in West Texas. Conversely, it appears that the Lee faithful don't have much faith in the Rebels this season.

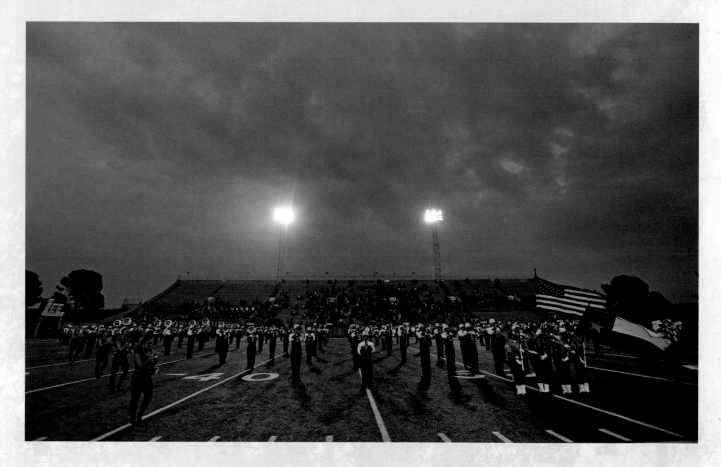

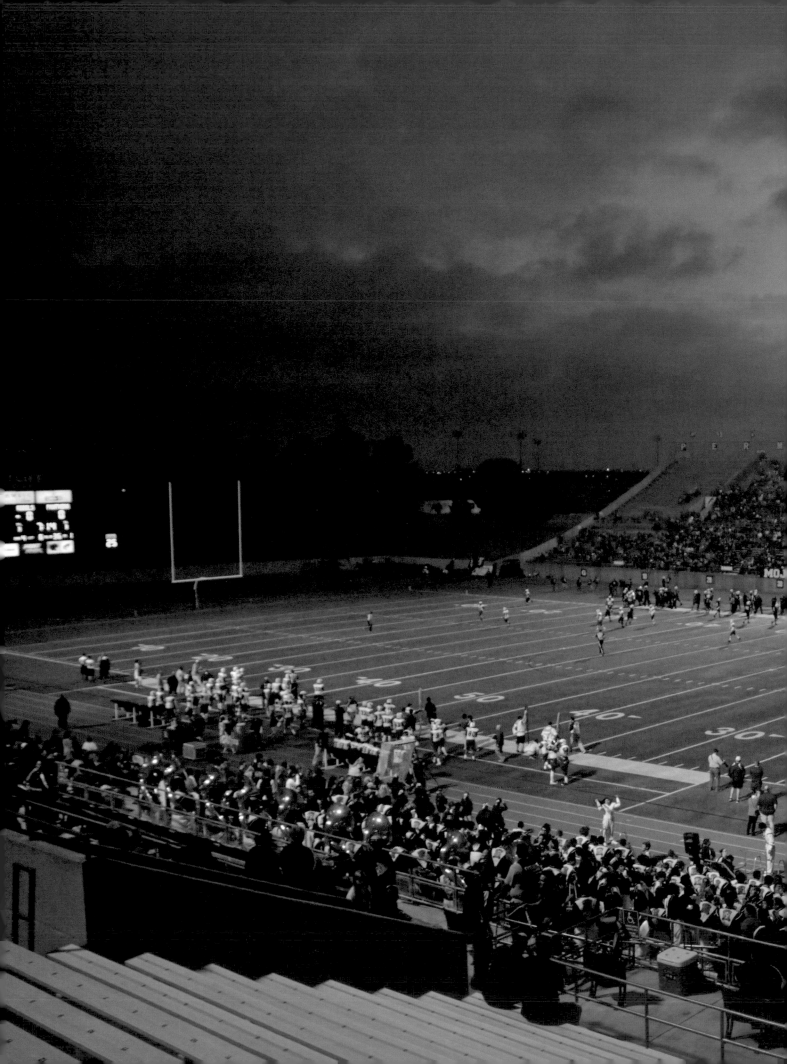

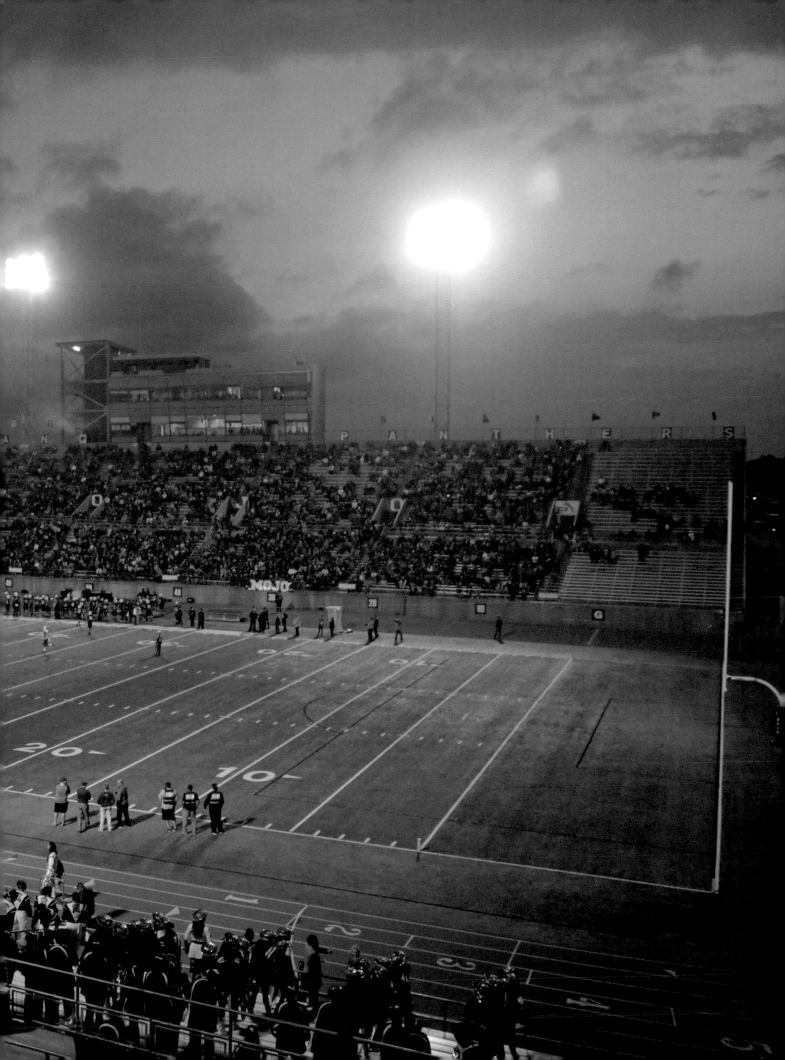

Although the names of the players and coaches change continually, Ratliff remains timeless. Built for high school football in 1982, the stadium seats 17,931. By the current-day yardstick in Texas communities like Allen, Mesquite, Katy, and Southlake, Ratliff is outdated, but almost everywhere else in the United States, Ratliff is still the gold standard.

Most of the cars have pulled into parking lots that flank the stands on either side of the field. There are a few tailgaters here, too, although nowhere near the level of a college game in this state.

Ratliff Stadium has always been pretty much a college stadium without a college team. That's finally changing. In 2014, the University of Texas of the Permian Basin announced it will start a football program that will begin play in the fall of 2016, in the Division II Lone Star Conference. There's a good chance the crowds for the high school games will be larger than those for the UTPB games.

Inside the stadium a few minutes before kickoff, the Permian students take their place on the east stands while the longtime regulars sit in their usual spots on the aluminum bleachers, on the west side. From afar, Ratliff looks the same as it has for the past twenty-five years. The track, the field, the stands, the press box, and the coaches' boxes are well-maintained. The video board in the north end zone doesn't feature any burned-out bulbs. Ratliff is over thirty years old, yet it remains timeless.

7:26 P.M.

Section E, Row 36, seats 19 and 20

Caroline and Jim Howard are bundled up in warm clothing as if a snowstorm is coming. When the weather "gets cold," Texans tend to overdress for the occasion. Tonight the temperatures are forecasted to drop all way the way down into the 50s. Jim is eighty-three and Caroline is eighty-one; at their age, they can wear whatever they want. They have lived long enough to see their town, and their team, evolve, and to do whatever they damn well please.

Caroline's first husband died not too long ago, and she married Jim, who was one of her husband's groomsmen, and one of his closest friends. Caroline's first husband was one of the people whose reputation grew for the wrong reasons because of "the book."

"Do you remember the man that made the comments about the Carter players?" she asks. "That was my husband."

In the book *Friday Night Lights* it was her late husband, Gene Ater, a Texas state district judge, who was quoted as saying the fans of the Dallas Carter team that defeated the Panthers in the 1988 state semifinals game sounded "like a bunch of African natives." Caroline uses this statement only as a point of reference; some people familiar with only the book version just remember the unflattering parts of Permian rather than the rest. Caroline and Jim have lived through the good and the bad in their

hometown, from its rise to its struggles in the '80s, when the economy went flat, to its resurgence and then its stagnation again.

Caroline and Jim are not the image of overzealous fans or sports parents. The passion for this program is still there, but the MOJO is fragmented. The Panthers' games remain an important social and cultural event, but surveying the stands and looking at the kids, it is undeniable: This is not the same place that Buzz Bissinger put on the map.

"You have to remember that the book was written when Permian was in its prime," Jim says. "It was written when this town was a lot different, and there was absolutely nothing else to do. The growth spurt that we have had out here has really taken away from football and the fan base. We didn't have soccer back then when that book was written, and now we have one of the best soccer programs in the state."

> "You have to remember that the book was written when Permian was in its prime," Jim says. "It was written when this town was a lot different, and there was absolutely nothing else to do."

Forget the football team for a moment. The city of Odessa is also not the same place that became so famous from that book, or the same as it was when the two grew up here.

"It's a tad bigger than it was fifteen years ago, and I know this is the last word you should use to describe Odessa, but it's much more cosmopolitan now," head football coach Blake Feldt says. This is not an excuse to explain why the Panthers have not won a state title since 1991. Teams go in cycles, and the state is stacked with good programs. These may not be the exact same Permian Panthers of the '80s, but Permian is still Permian.

"It's not quite to the level it was when I was a kid growing up here, but this is the job you want," Feldt says. "These are the best jobs to have as a football coach. You are given everything you need. You want to be in a place where you better win, or you're going to get fired."

7:27 P.M.

Permian run-through, north end zone

The entire Permian Panthers football team crouches behind the giant piece of paper they are about to run through and destroy. The players form a large circle, lock arms, and crouch, sway, and bounce in a rhythmic fashion. Permian is one of the few places left that still builds its own "run-throughs"—in their case, the traditional huge piece of paper held up by boosters, fans, or cheerleaders—part of the start of any high school game in Texas.

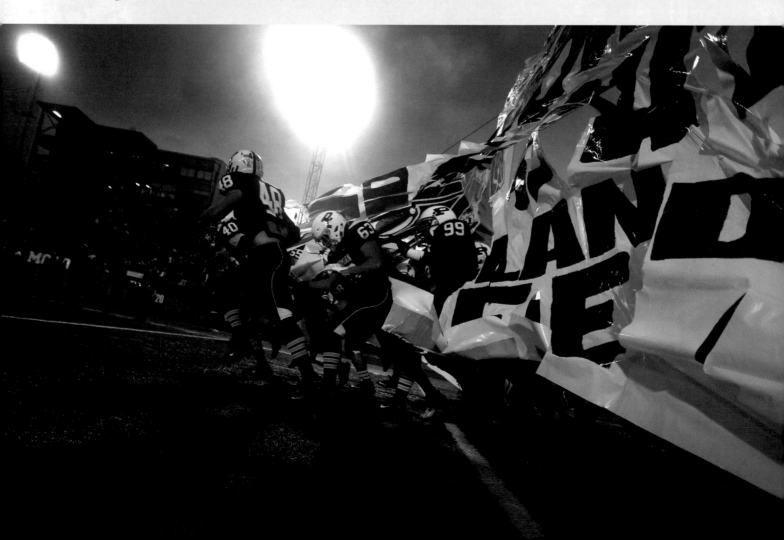

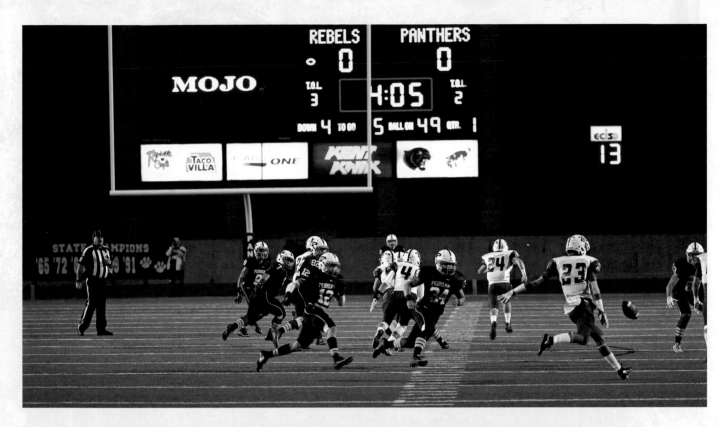

Permian is an exception to the rule with their version, as most high schools today pay around $2,500 for a giant inflatable tunnel to use for their run-throughs. Permian remains rooted in its tradition of building its own. Valerie Hammit helps construct the giant run-throughs that are made of paper and attached to PVC pipe for every Panthers game.

"We make twenty of them—one for the start of each half," she says. "Building them takes a whole lot of eight-hour days, and it's a *giant* pain, but I do love the tradition of doing it. I love doing all of it." Of course, one of the giant run-throughs she helps to make says "MOJO."

In the middle of this large huddle stands defensive back Desmon Smith. This scene could easily be confused with some ritualistic tribal dance before a battle. All of the players are dressed in black-and-white uniforms that feature the white helmets and the giant "P."

"I was just feeling it, and we decide the day of the game who stands up," Smith says. "I wanted to be the guy that gets us started. It's Lee. It's Homecoming. I want to be the one to get everybody hyped up."

Running through a tunnel before every game is as much of a tradition as what Smith is going through right now—recruiting. Smith is a senior and one of the best players on the team. He originally committed to play at Texas State University over the summer, but after the first game of the season, he de-committed and is open to play somewhere else. He had felt pressured into the decision, plus realized he might be able to play for a team in a better conference. Now he's feeling out offers from a handful of schools, most notably Texas Tech.

The passion of high school recruiting in Texas is often bigger than the games themselves. Recruiting is the gold of Texas football. Schools from all over the country invade this state every year to mine it, hoping to extract its best players, or at least, its second- and third-best. Where teenagers like Desmon Smith *may* go to college fills countless message boards and websites that are updated by the minute. Fans that follow Baylor, TCU, Oklahoma, Texas, and Texas Tech may not know a thing about Permian football, but when the Panthers have a Roy Williams or a Desmon Smith, they follow that team.

The passion of high school recruiting in Texas is often bigger than the games themselves. Recruiting is the gold of Texas football.

"Around here there are not that many Division I athletes, so I was going blind with it," he says. "I just did what everybody told me, and I got scared into doing it. When I was first being recruited, it was fun, but then once I got serious, [I realized] it's about figuring out what is best for you. It's crazy. There was some story about me on the Internet that someone sent me a link to, about what kind of player I was."

Smith is leaning toward playing at Texas Tech. He made an official visit there to watch Tech's home game against TCU last month, which ended with the Horned Frogs winning on a last-second touchdown catch on a deflected pass in the back of the end zone. Tech did not win the game, but it likely won Smith.

"It was crazy nuts," Smith says. "I loved the feeling there, and after that game, I know it's the place."

Smith still has plenty of time to change his mind before what's become a glorified holiday here in Texas: National Signing Day, in February. Right now the importance of recruiting or the tradition of running through a piece of paper is replaced with the priority of beating Lee.

8:01 P.M.

Ratliff Stadium east stands

Wearing her cowgirl outfit, Klarissa Mezza stands in the end zone of the Midland Lee section. Neither Lee nor Permian has scored in the first quarter, and both teams struggle to move the ball. Mezza is the captain of the Dixie Dolls, Lee's longtime dance team. The girls all stand on the bleachers with their fists at their hips, waiting to begin the next routine. Like seemingly all the rest of her classmates, Mezza wears makeup that makes her look a bit older than her seventeen years.

The Dixie Dolls are a girls' cheer group that doesn't tumble, dance, or do stunts. They perform in slick, sequined outfits complete with white boots and glittery cowgirl hats. Most of the big schools in Texas have their equivalent to the Dixie Dolls. They are part of the show, but on the sidelines.

"Personally, I love football. My whole family worships football," she says. "God first, family second, football third."

Mezza watches the game intently but is aware of when her next routine begins. Football is not just a means to give her a platform to perform.

"Personally, I love football. My whole family worships football," she says. "God first, family second, football third. Our family is very superstitious, and every Dallas Cowboys game, my mom wears the same shirt. But I can't watch the game with

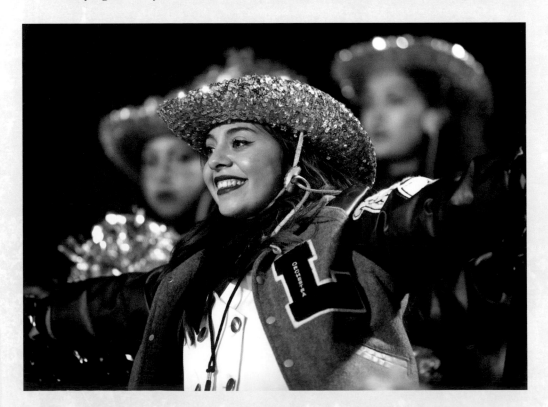

her. My mom thinks I'm bad luck. I actually watched the last game with her, and they lost. So we all watch in three different rooms—my mom in her room; I watch in the living room; my stepdad watches on the outdoor patio."

It's all rather charming, and equally Texan.

A high school football game can feel like a TV episode from the 1950s: The girls are here to cheer for the boys, and the moms tend to the little ones in the stands while the dads coach. Society has evolved since a group from Zanesville, Ohio, came here to Odessa in the late 1800s to build a railroad. Women do more than ever now, and yet football tradition dictates that in between the white lines is just not for girls.

Most of the girls don't care, because this is the way it has always been done here, and everywhere else.

"I love my team. I love my school," Mezza says. "I just don't think we get appreciated because we are girls."

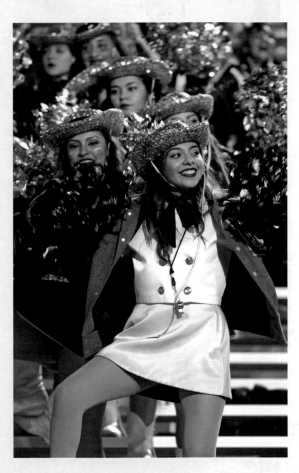

8:58 P.M.

Permian Panthers sidelines

Ratliff Stadium was ahead of the curve when its fancy scoreboard, which features a replay board, was installed in the north end zone. During one play in the middle of the second quarter there is an especially brutal hit that causes all of those in attendance to collectively, and loudly, say, "*OHHHHHhhhhhhhhhhhhh . . .*"

Fifteen years ago these types of hits were celebrated. Today, after an increasing amount of information has come out about the potentially life-altering effects of big collisions, celebrating big hits and showing them repeatedly is either done with less frequency, or not at all. After the hit, the Ratliff Stadium Jumbotron replays the hit with giant white letters over the video: WATCH THAT REPLAY!

Despite the growing number of stories and reports about the potential dangers of playing football, and specifically, the effects caused by chronic traumatic encephalopathy (CTE), participation in the sport in Texas has not waned at all. Permian features a varsity team, two junior varsity teams, and two freshman teams. Lee has a varsity, two junior varsity, and one freshman team. It's the same almost all over the state.

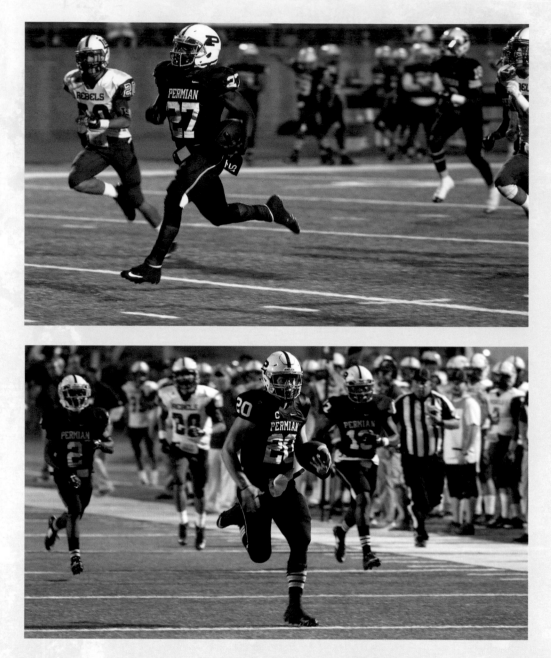

Whatever Midland Lee was doing during a scoreless first quarter no longer works. Permian is in the middle of scoring four consecutive touchdowns in the second quarter, turning the Homecoming game into a blowout. It will be the eighth time in the last ten meetings between these two teams that Permian will win.

Lost in the talk and the passion for Texas high school football or cheerleading are the lesser-known Texas high school bands. This could be the subject of a book or movie, and far funnier. There is so much material.

Halftime for tonight's game is scheduled for the standard twenty-eight minutes. Each band is allowed twelve minutes to squeeze in their respective performance, but this seldom happens on schedule. Although it's not typical, a halftime during a Texas high school football game can run as long as forty minutes.

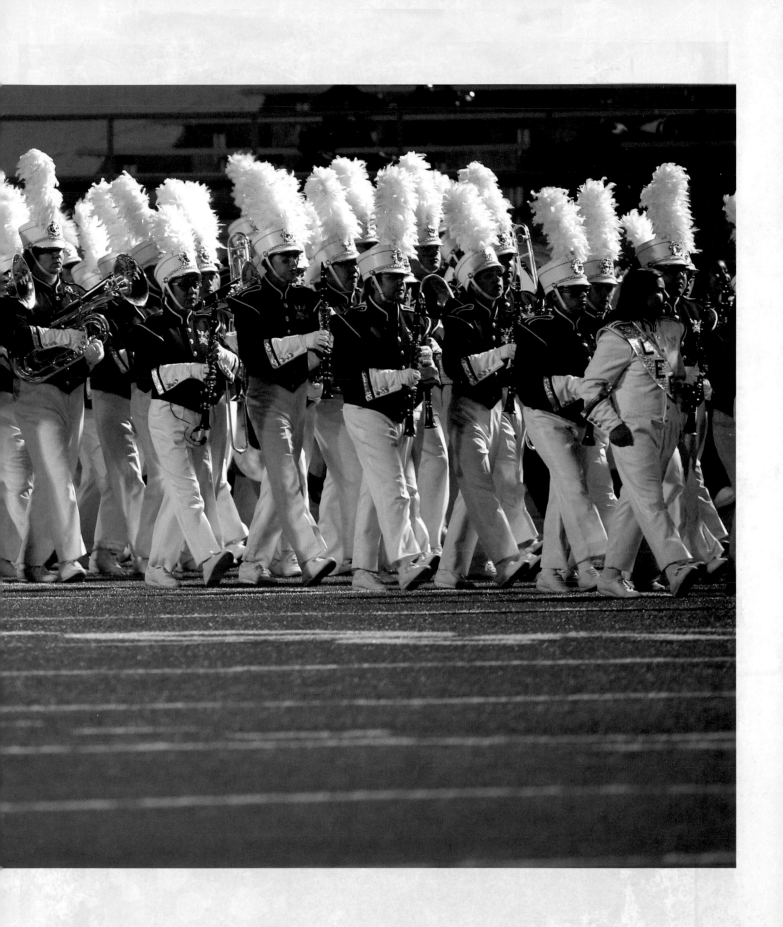

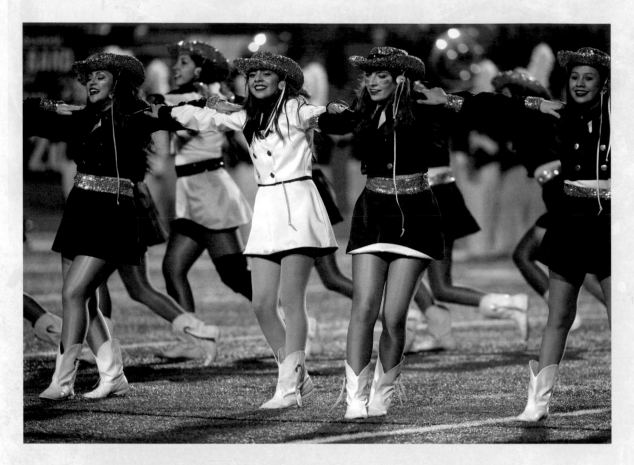

At the bigger schools in Texas, like Permian and Lee, the band performances are big, expertly choreographed, and entertaining. This is the 6A level, the biggest in a state that loves size.

As the Midland Lee band concludes its performance at halftime, the 318 members that make up the Permian marching band take the field. This includes brass, percussion, twirlers (more commonly called majorettes), and dancers (the flag wavers, or "the guard"). This halftime routine is called "To the Moon!," inspired by the American moon shot. Tonight is the debut performance of this number, intended for the state competition. It is grand and well-choreographed, every member in unison (at least, to the layman). It all goes smoothly, even if it runs a bit long. Tonight, there will be no penalties caused by either band.

9:58 P.M.

South end zone

Lauren Sprayberry is a senior at Permian, and her eyes are fixated on the play clock that shows the time remaining on her high school career. She has no idea what she wants to be when she grows up, other than she has a desire to get out of Odessa. She's no different from most juniors and seniors—they're just ready to go. She is also firmly

aware that part of her identity is her high school and MOJO.

"You know, I've never read the book," she says. "Now, whenever I go anywhere—like Dallas or Austin—I get questions all the time about it. *All* the time. When I think of *Friday Night Lights*, I don't think of the book, the movie, or the TV show—I think of my school."

In the background as she talks the unmistakable chant that permeates Permian games starts as the third quarter of this blowout rolls on: *MO-JO MO-JO MO-JO MO-JO*. Out here in Odessa, it's impossible not to see these giant four letters every time you turn your head. What is MOJO?

"Ummm—school spirit?" she asks. "I would say it's school spirit, and everyone [being] together."

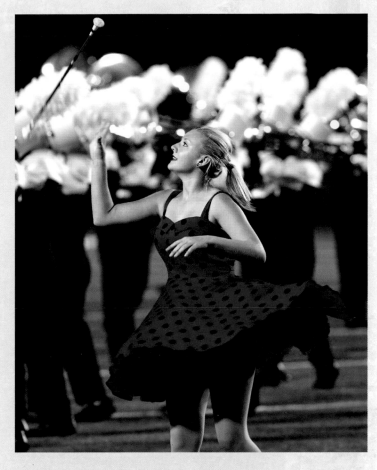

Charles Robcats is a senior at Permian, and the captain of the flag crew. This is the handful of guys who run up and down the sidelines, or the field, waving the giant flags. His flag is black with white letters that read MOJO 7TH FLAG OVER TEXAS. The previous six flags over Texas represent the countries that the state was a part of: Spain, France, Mexico, the Republic of Texas, the Confederate States of America, and the United States of America.

Lauren Sprayberry is a senior at Permian, and her eyes are fixated on the play clock that shows the time remaining on her high school career. She has no idea what she wants to be when she grows up, other than she has a desire to get out of Odessa.

He's a wiry kid who doesn't look like he could bench-press more than a small bucket of water. It isn't until he picks up the MOJO flag that one senses this kid is much stronger than he looks: The pole and flag combined weigh more than sixty pounds.

Surely he will know what MOJO means.

"It's the spirit—all of it—of the school," he says, with the conviction of a local pastor. But what is it, exactly?

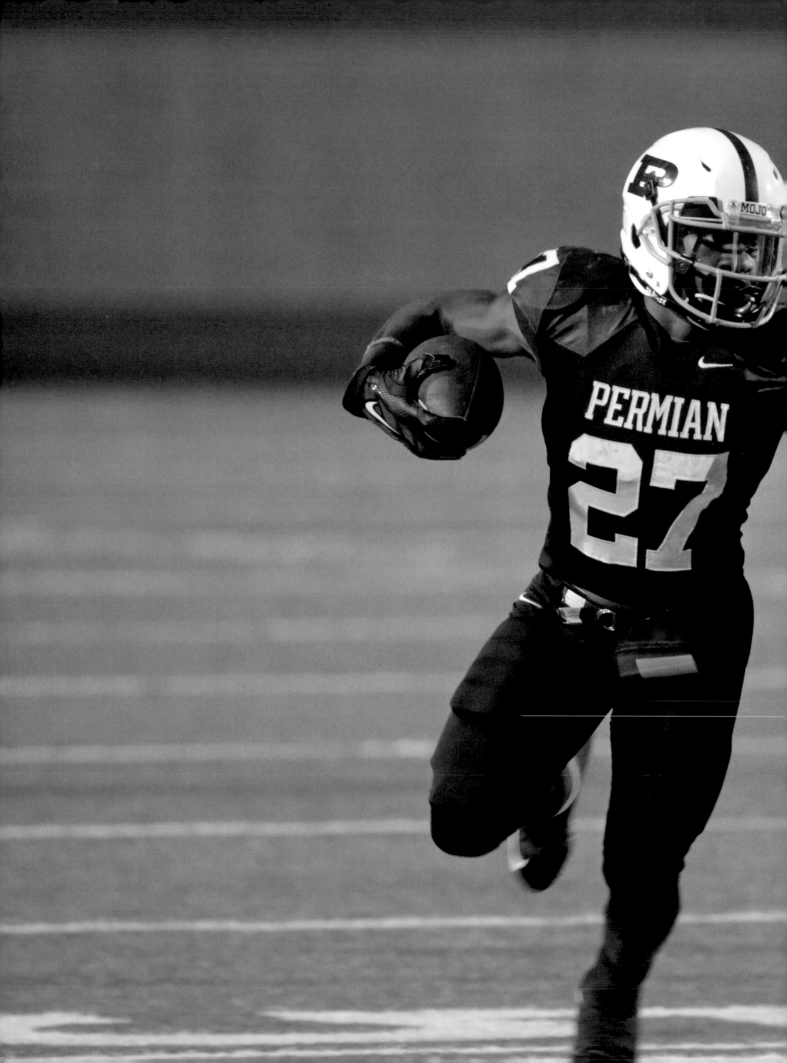

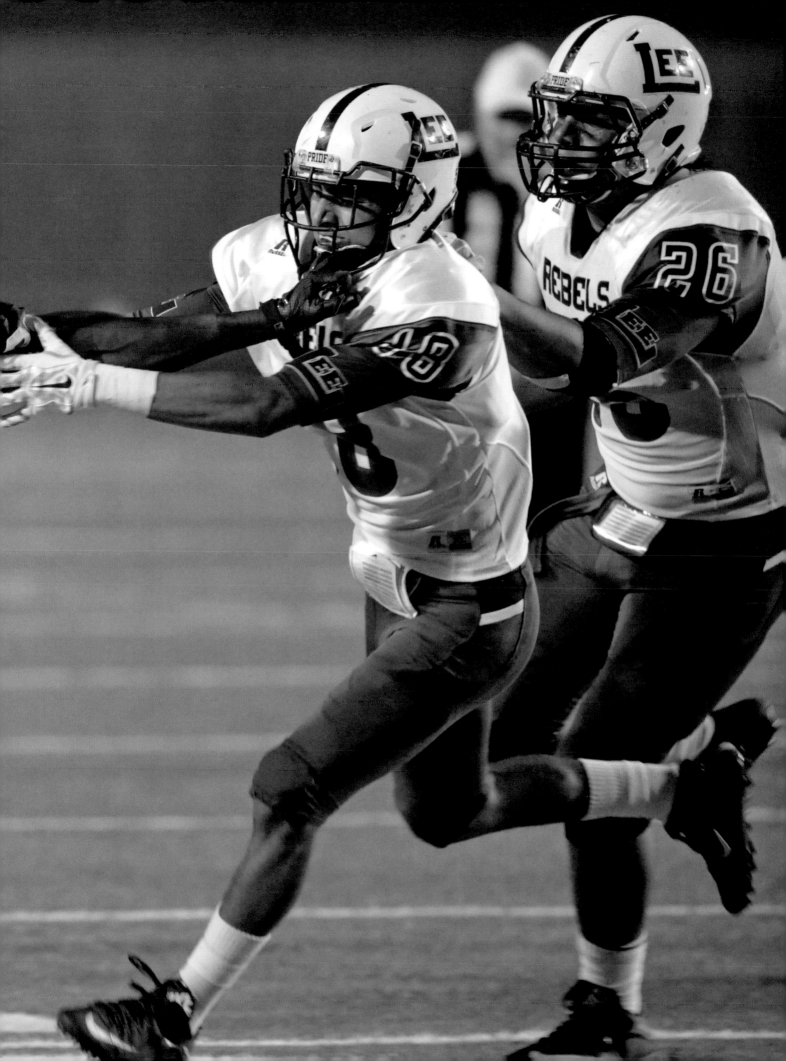

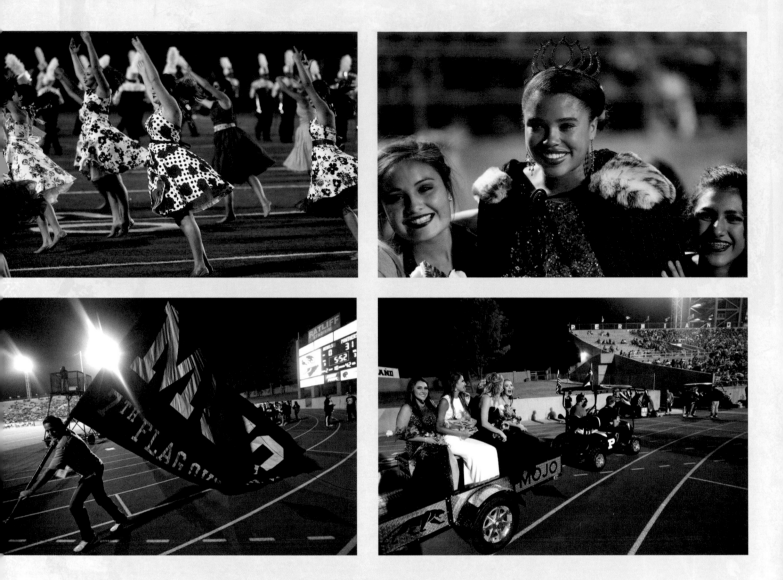

The origin of MOJO around here depends on who you ask. One of the better stories is that a handful of drunk alums stumbled into the chant, and it took off decades ago.

The origin of MOJO around here depends on who you ask. One of the better stories is that a handful of drunk alums stumbled into the chant, and it took off decades ago.

Whatever the case, MOJO is associated with Permian the same way "Luck of the Irish" is attached to Notre Dame. Somehow MOJO helps to explain Permian's success, and all of those state titles, and its sixteen state quarter-final appearances between 1965 and 1995.

No luck or anything mystical is required for Permian to defeat Midland Lee tonight. By the start of the fourth quarter, the concession stands are jammed with high school kids who don't want to go home, or to Rosa's Café, the popular hangout of choice for these teenagers

The final score is 45–0, and the Panthers are 6-0. They look like one of the best teams in the state. Things may have changed in Odessa, but Permian looks like Permian again.

"When I was in eighth grade, I really considered transferring to Arlington [Texas] to play at Arlington Martin [High School]," Desmon Smith says. "It was just so bad for a while. Guys were getting in fights in the locker room. Guys were flunking and missing games because of games on Friday night. Guys skipped workouts. Then Coach Feldt came here and he turned it around.

"We made the playoffs last year, and we made the third round of the playoffs and lost against Trinity. They were just bigger than us, but we played Permian football. We brought back Permian football."

Most of the adult portion of the more than ten thousand fans here head home long before the end of the game. As they file out into the parking lots, an echo from inside Ratliff Stadium is audible: *MO-JO MO-JO MO-JO.*

11:55 P.M.

Interstate 20

For several miles east the stadium lights from Ratliff Stadium are clearly visible on these flat plains. Headed east out of Midland–Odessa those "Friday Night Lights" are eventually replaced by oil rig lights and the increasing number of wind farms.

The red lights on the wind farms blink at intervals, which gives the night landscape an Area 51, UFO-landing-pad feel. The area is so vast, so flat, and so full of emptiness that it's captivating and mesmerizing; much like staring at the ocean's horizon, the empty lands never ends.

If you're headed along Interstate 20 in West Texas from Midland–Odessa toward Dallas–Fort Worth, you'll come upon one of the more famously unknown spots in the history of American football. About two hours east of Midland–Odessa is the tiny town of Sweetwater, Texas, and just to the north is an even smaller speck of dust called Rotan. There is damn near nothing in Rotan—except for the single greatest and most influential football player that ever played, Slingin' Sammy Baugh.

For Baugh, the draw of this place, and his single-story ranch house on a giant piece of property, was a lone "mountain" peak a few hundred yards in the distance from his front porch. Wearing blue jeans, boots, a big belt buckle, long-sleeved shirt, and a cowboy hat, Baugh was the image of the quintessential Texan, a cowboy at heart who excelled at football. He was a cowboy in the sense that he was just a plain guy perfectly at peace in his own skin in the middle of nowhere.

After passing on the opportunity to play college football at the University of Texas, Baugh opted to play at TCU in the 1930s, where he became an All-American. In the palace of Texas football royalty are names such as Darrell Royal, John David Crow, Earl Campbell, Eric Dickerson, Ricky Williams, and Slingin' Sammy.

After Baugh left TCU he starred for the Washington Redskins, eventually had roles in a few Hollywood movies, and established that a football player could be a household name across America just like a baseball player. Baugh played offense, defense, and special teams, and to some—most notably, famed *Sports Illustrated* writer and TCU alum Dan Jenkins—Baugh was the best, most complete football player who ever lived. When Baugh died in 2008 at the age of ninety-four, he was the last surviving member of the Pro Football Hall of Fame's inaugural class.

When he retired from football and his public life, Baugh moved to that small, one-story ranch house in Rotan, a considerable distance from modern society, or even traffic lights. The location of his home suggested that he was a gridiron version of Greta Garbo, a notorious recluse in her later years after she left Hollywood. That wasn't the case. Baugh played golf well into his eighties, and for a long time he sold and traded livestock in this region. He was routinely invited to return to TCU, or to the Redskins, and nearly every single time he said, "Thanks, but no thanks." Baugh was just much happier at home; adulation from crowds of fans made him uncomfortable.

After Baugh left TCU he starred for the Washington Redskins, eventually had roles in a few Hollywood movies, and established that a football player could be a household name across America just like a baseball player.

Baugh was actually quite hospitable, provided that you came to him. He didn't want to go anywhere; maybe he'd go as far as Sweetwater. Members of the media who wanted to visit for an interview were welcome. Sports memorabilia collectors would occasionally visit, and he would sign as many cards, hats, and whatever else they brought with them, never asking for a certain price. He just told the collectors to pay him what they thought was fair.

TRAVEL LOG, DAY 2

Logistically, we knew this would be the hardest of the four days—and that was if everything went according to plan.

By the middle of Day 1, Ron Jenkins's assistant, veteran *Dallas Morning News* shooter Michael Ainsworth, had joined us. Fortunately, there were no delays in departing from Houston Hobby Airport for Midland–Odessa. There was valid concern that rain in West Texas could slow us down considerably; in certain parts of Texas, it often acts like a giant snowstorm does around Boston. There are certain cities in Texas that simply don't deal well with the wet stuff.

There was also the issue of sleep. We knew the lack of it would catch up with us; it was just a matter of when.

The only mishap on this day took place after eating lunch at KD's Bar-B-Q in Midland, when I accidentally drove in the wrong direction toward Odessa. This wrong turn put us in Stanton, Texas, where we fell into a wonderful scene of small-town Texas and Americana that was too good to ignore. Like every other school and place we visited, everybody at Stanton High School could not have been more welcoming, polite, or decent in accommodating us.

About five p.m.—two hours before Permian's game against Midland Lee was set to begin—fatigue had set in. Coffee was useless. A five-hour energy drink may as well have been labeled "five-second energy."

Immediately after the game was the hardest part. Driving from Midland–Odessa to Dallas–Fort Worth is a four-and-a-half-hour exercise in boredom. There's nothing to see out here, and at 1:30 a.m., there is even less.

After I successfully drove about eighty-five miles an hour for the first two hours, Ainsworth assured us that after his catnap earlier in the day, he was rested enough to drive the remainder of the trip. One of the benefits to driving on Interstate 20 in the middle of the night is that there's really nothing to hit, and much of the road is a direct line of sight between Midland and Fort Worth.

We all made it back to our respective homes at around three a.m.-ish. That meant we had roughly four hours to sleep before heading to the Cotton Bowl for the eleven a.m. kickoff between Oklahoma and Texas.

We started the day in Houston, flew to Midland, and then drove to Stanton; from there, we proceeded on to Odessa and then Fort Worth. It was well worth it, but we were all exhausted.

He drank Dr. Pepper from a can. He dipped chewing tobacco. He wore a hat to cover up his white hair. He swore like a trucker. He would sit in an old, plush recliner and tell stories about how as a kid he would practice by throwing a football through a swinging tire attached to a tree. He was not some old-timer who watched the present-day version of football with disdain. Baugh watched games and enjoyed them.

When he was alive, Sammy Baugh was out here in West Texas, available to nearly anybody who wanted to visit. It's just that not many people knew it.

When he was alive, Sammy Baugh was out here in West Texas, available to nearly anybody who wanted to visit. It's just that not many people knew it.

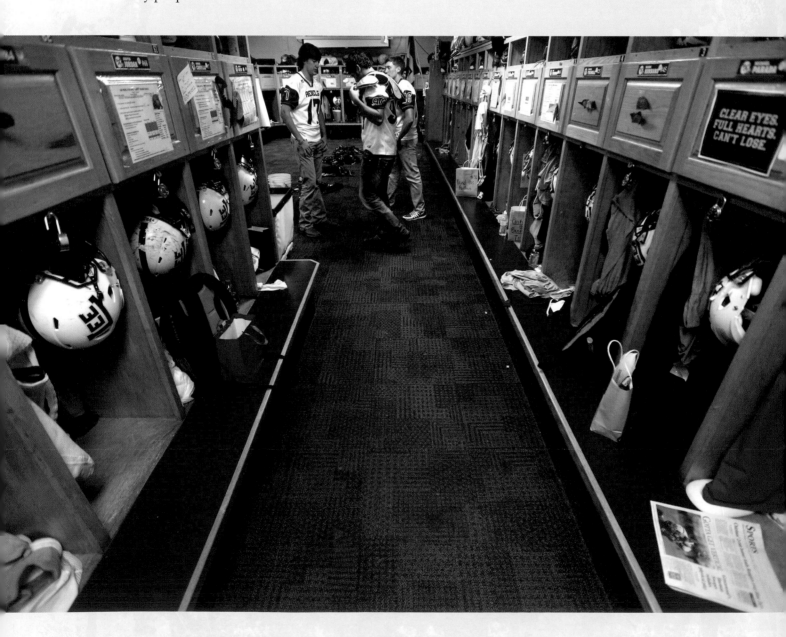

DINING LOG, DAY 2

While people may go to Houston for the food, the same is not quite said about Midland or Odessa; however, there are still some good options out here:

KD's Bar-B-Q. This is the quintessential Texas barbecue dining experience. All of the meat is smoked on-site, and the ambience is informal. Patrons serve themselves. (Garden City Highway, Midland; m.mainstreet hub.com/kdsbarbq)

The Cork & Pig Tavern. The high school kids prefer Rosa's Café, which is a good Tex-Mex choice, but the adults like the Cork & Pig because it's a tad more upscale, with a slightly more expensive menu. There are tacos and wood-fired pizzas and entrees; the double-cut pork chop is a great choice. (7260 TX-191 #204, Odessa; corkandpig.com/home.php)

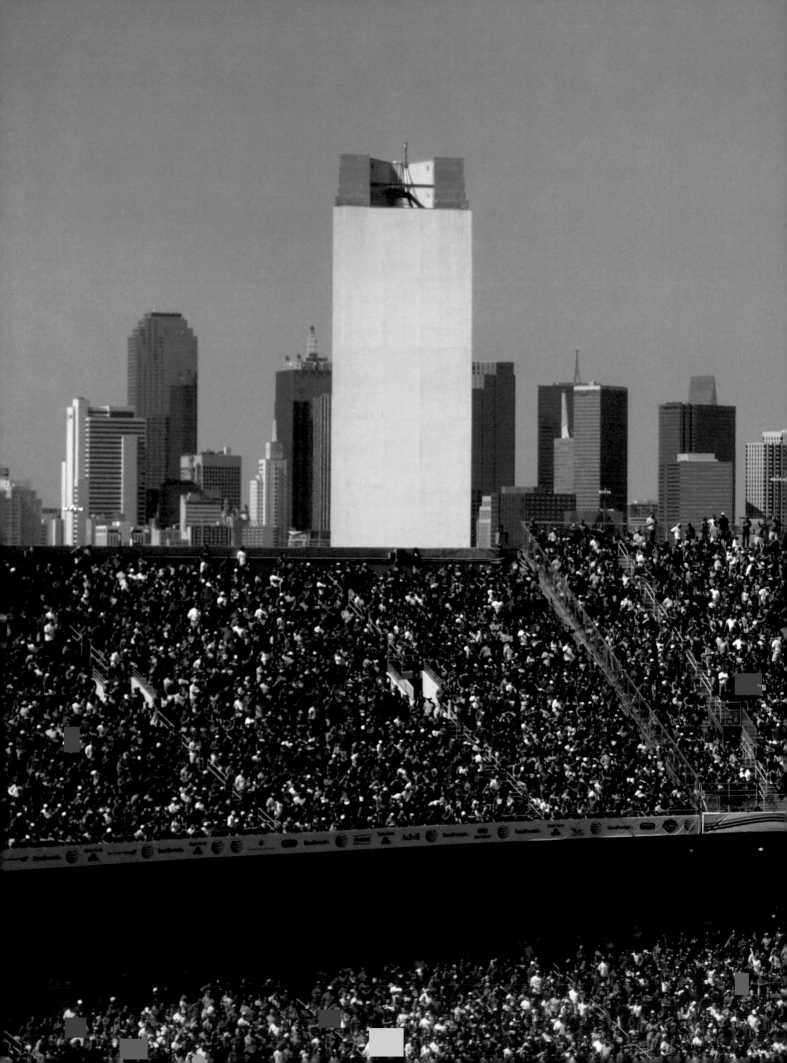

LONGHORN
ON SATURDAYS

AND A
COWBOY
ON SUNDAYS

As large, historic, and important as high school football is to Texas, the college game equals it in every sense. There are twelve football bowl division teams in the state, eight at the football championship series, sixteen combined in the Division II and III levels, five junior college teams, and four NAIA teams. Beginning with tailgates that start as early as seven a.m., or sometimes the night before, hundreds of thousands of Texans will take part in a college game today.

Some of the most celebrated names and traditions in the history of college football originated in Texas, from Davey O'Brien and Tom Landry at TCU to SMU's Pony Express, to Twelfth Man at Texas A&M. Each of the most prominent schools in the state features a hand sign to signal where your loyalties lie—"Gig 'Em" at A&M, "Guns Up" at Texas Tech.

Texas's dedication to the college game makes it nationally relevant in nearly every other state. For so many in Texas, the college season trumps that of high school or the pros.

> **Texas's dedication to the college game makes it nationally relevant in nearly every other state. For so many in Texas, the college season trumps that of high school or the pros.**

8:17 A.M.

Dealey Plaza

The sun pops off the most visible site in downtown Dallas—Reunion Tower—on the busiest football weekend in this city. Reunion Tower may be the most visible, but it's not the most coveted tourist spot in Dallas. That would be the Texas School Book Depository, closed at this early hour—the perch from which Lee Harvey Oswald aimed his rifle and fired the shot that killed President John F. Kennedy on November 22, 1963.

The Kennedy assassination gave this region an unfortunate distinction that defined it for multiple generations. Kennedy changed the way presidents behaved toward football, while football changed the way Americans viewed Texas. In both downtown Fort Worth and Dallas there are monuments and historical plaques honoring the thirty-fifth president's last steps.

After Kennedy's death, Lyndon B. Johnson was the second Texan to become president; the first was Dwight Eisenhower, who was also the first to have actually played football. Ike did not make the baseball team when he was at West Point, which led to him playing football. He made the team as a running back and a linebacker. During one game against the Carlisle Indians, he tackled the most famous athlete of the first half of the twentieth century, Jim Thorpe.

While Eisenhower was the first Texan to be president, he was not like LBJ, a much more stereotypical Texan. Eisenhower was born in Denison, Texas, and lived there for just eighteen months before his family moved to Kansas. Johnson was born and raised in Texas, more into baseball than football.

American presidents are historically depicted as passionate baseball fans, which LBJ was; Kennedy was the first man to occupy the Oval Office who was a full-fledged, visible football fan. In fact, he was the first president to make football an equal to baseball. The game itself wasn't quite old enough for his predecessors to enjoy, much less play. JFK played on the junior varsity football team at Harvard, and the touch football games he and his brothers played on the White House lawn were just one more facet of the glowing family that made Camelot so enchanting.

Nearly all of Kennedy's successors have been unabashed football fans, particularly Richard Nixon, Gerald Ford (who played at Michigan), Ronald Reagan (who played at Eureka College, and as an actor, played Notre Dame legend George Gipp), both Bushes, and Bill Clinton.

In 1969, President Richard Nixon left the White House to attend the "Big Shootout" in Fayetteville, Arkansas, to watch number-two Arkansas and number-one Texas. That Texas team won the national championship under head coach Darrell K. Royal. It was men like Royal and some of the players on his title teams in 1969 and the 1970s, such as James Street, Bobby Mitchell, and Freddie Steinmark, who helped to distinguish Texas as something beyond the place where Kennedy was killed.

The football team and the football people who made the biggest impact on the national perception of the city of Dallas were Tom Landry, Roger Staubach, and the 1970s Dallas Cowboys. That team and their dynasty in the '70s changed the reputation of an entire city. (The TV show *Dallas* helped, too.)

This morning, thousands of people drive down that internationally famous confluence of three streets—past the Sixth Floor Museum, south of the fence that previously marked the "Grassy Knoll," to exit ramp 428B for Interstate 35E South, then moving over for Interstate 30E and the long line of cars headed to "Fair Park" and the Texas–Oklahoma football game.

9:12 A.M.

Fair Park

Part of the charm of the Texas–Oklahoma game is where it's played—at the State Fair of Texas *during* the State Fair. It makes for a wonderful scene, as well as horrendous traffic and the seventh level of Dante's Parking Lot. The only relief from the traffic is that the Texas fans have no faith in the Longhorns coming close to defeating their most hated rival, so many are staying home; less faith means less traffic.

The secondary and online ticket market for the 110th edition of this game is depressed because practically no one believes this game will be worth watching. Fans could buy tickets for about $35 apiece online the night before the game; face value is over $100. The University of Texas athletic department returned thousands of tickets to the Cotton Bowl a few days before the game because they were not sold. When the two teams are good, a ticket can cost well over $1,000, and ushers are always rumored to accept a few bills to allow fans to walk in without a ticket.

Oddsmakers in Las Vegas have the Sooners as 16.5-point favorites, which feels like a safe-enough bet. Oklahoma is 4-0, and ranked number ten in the country. Texas is 1-4, and the previous Saturday lost 50–7 to TCU across town in Fort Worth. This start is the worst for the team in nearly sixty years, and second-year coach Charlie Strong is feeling the pressure to win. A bad game today, and there most certainly will be calls for his firing.

Inside the parking lot at Fair Park is a pickup truck with Oklahoma license plates; on one of the rear passenger windows is written THIS WON'T TAKE LONG.

9:33 A.M.

Fair Park parking lot tailgate

Fans coming to this game normally try to arrive by nine a.m., which means an absurdly early wake-up call for a big college football game. This is the one "big game" all season routinely played at the undesirable eleven a.m. time slot, the worst kickoff of them all for tailgating. Because the game shares the same parking lot as the one used for the State Fair, the tailgate scene here is not concentrated, but rather spread out among football fans and fairgoers alike.

Despite the low chance of Texas being competitive, the Red River game is just one of those things that people do every October. This is a social tradition as much as it is a football tradition. Even if your team stinks, you still go to the Red River game; if this wasn't Texas–OU, there would be even more tickets available at a discounted price.

Andy Jasso and his wife Ruth are from the Texas–Mexican border town of Laredo, where his dad was a high school football coach. Like so many in Texas, and all over the United States, Andy and Ruth went to UT for school, and then they stayed in Austin to live. Austin's population sits at

> **Because the game shares the same parking lot as the one used for the State Fair, the tailgate scene here is not concentrated, but rather spread out among football fans and fairgoers alike.**

around 825,000, but the greater Austin area has a population of well over one million, swelling with newcomers by the day. This motivates the town's "keepers" to "Keep Austin Weird."

This pair has lived in Austin since they attended UT together, finishing their undergrad degrees in 2010. They were high school sweethearts, doing the very Texas thing of getting married right out of college.

In the Fair Park parking lot, Ruth and Andy entertain a collection of nearly forty people for their tailgate, nearly all of whom are Latino. Andy was the first one in his family to attend the University of Texas, but this large group of family and friends all look like UTers. They are currently draped in a color scheme only an alum of this university can love—burnt orange. Like so many colleges, the color scheme for the University of Texas is not particularly appealing unless it's your school. Burnt orange goes with nothing other than Texas, but it cannot be confused with any other school.

On a small grill Andy and Ruth cook breakfast tacos with chorizo and eggs, served with a hefty dose of mimosas. This is part of the tradition, and everyone here is fairly certain the tailgate will be the highlight of the entire day.

> **On a small grill Andy and Ruth cook breakfast tacos with chorizo and eggs, served with a hefty dose of mimosas. This is part of the tradition, and everyone here is fairly certain the tailgate will be the highlight of the entire day.**

"You have to understand—we don't do this [a tailgate] in Austin, but we do it here [every year], because this runs deep in our family," Andy Jasso says. "I know we probably won't win, but we'll always do this."

9:59 A.M.

Gate K, The Cotton Bowl

Texas–OU is one of *those* games. There are only about four or five of them, and each year this is one that people are drawn to even if they don't care about either team.

It's because of the scene. Texas–Oklahoma is Alabama–Auburn, Michigan–Ohio State, Florida–Georgia, and Army–Navy. Texas–OU is what gives college football its color, character, tradition, and, ultimately, its distinction from the National Football League. While the NFL may be more popular, it can't replicate the inborn tradition of this game, or the disdain that comes with a real rivalry.

Unlike every other "big game" in college football, what separates Texas–Oklahoma is not the stadium, but the fact that it's played at the State Fair. At the main entrance to the State Fair, visitors are greeted with the famous baritone greeting, "Howwwdeee, folks!," from fifty-two-foot-tall "Big Tex."

This morning, Big Tex—a giant mechanical cowboy dressed in blue jeans, boots, a denim-and-red shirt, and a white, seventy-five-gallon cowboy hat—works perfectly.

Texas–OU is one of *those* games. There are only about four or five of them, and each year this is one that people are drawn to even if they don't care about either team.

Back on October 19, 2012, Big Tex became a piece of Texas toast when an electrical short in his right boot caused him to burn up during the Fair. Video of the incident went viral, prompting all sorts of one-liners, the top one being "I didn't know Big Tex smoked." Big Tex was rebuilt, and one hour before kickoff fans are waiting to have their picture taken with one of this state's most recognized and agreeable celebrities.

Twenty-four days long, the State Fair of Texas is the longest fair in the United States, thus continuing this state's unofficial edict that everything *must* be bigger. Today will be the single busiest day of its calendar.

It's a full-on sensory experience, complete with views of downtown Dallas, corny dogs and other creative, fatty fried foods at the Fair, and the giant Ferris wheel in the midway. This combines with the other sights and smells from the livestock area, including pig races, plus the scene of 95,000 people crammed into the stadium itself. One-half of the Cotton Bowl's blue-and-white seats are reserved for the crimson and white of Oklahoma, while the other half are meant for the burnt orange and white of Texas. It creates traditional scenes that the camera loves.

Twenty-four days long, the State Fair of Texas is the longest fair in the United States, thus continuing this state's unofficial edict that everything *must* be bigger.

The only thing lacking from a typical big-time college football rivalry is that this is not a home game for either team. The parking lots contain a mix of college football fans and fairgoers. Fair Park is located in the South Oak Cliff neighborhood, which was crushed when integrated schooling all over America in the 1960s led to a panic, resulting in white flight. This neighborhood has since remained a low-income area that needs updating, or capital improvement spending. Despite the changes, the Cotton Bowl stuck, as has this game.

The game used to be called the Red River Shootout, but to accommodate our PC times, it is now titled the Red River Showdown. The only other rivalry of this

magnitude not played in either campus stadium is Florida and Georgia, which is played in Jacksonville, Florida. UT–OU has not been played in either Austin or Norman since 1923. It was played ten times in Austin and once in Houston between 1900 and 1923. The Sooners played in Oklahoma six times during that stretch, four times in Norman, and twice in Oklahoma City.

Unlike Florida–Georgia—which is played at the austere EverBank Field, home of the NFL's Jacksonville Jaguars—much of the UT–OU charm is derived from location, location, location. The Cotton Bowl in Fair Park is held in a no-frills stadium. Nearly all of the 95,000 seats are plain bleacher style, and this ode to concrete boasts nearly none of the high-priced extras that come with new stadiums.

Only because it's the Cotton Bowl, long lines to buy a hot dog (and no place to purchase anything remotely gourmet) is acceptable because this place feels like a time warp to the 1930s, when it was built. Today's fans can actually feel some kinship with the fans who watched the Texas–OU games in the 1930s and '40s, back to OU Bud Wilkinson's undefeated teams, to Earl Campbell, Billy Sims, to Barry Switzer and Darrell K. Royal.

This is the first place the Dallas Cowboys called home, and they shared the venue with the then Dallas Texans of the American Football League.

This is the first place the Dallas Cowboys called home, and they shared the venue with the then Dallas Texans of the American Football League. After three years, the man who founded

the AFL, and the Texans—Lamar Hunt—moved his team to Kansas City and made them the Chiefs. Twice the Dallas Cowboys flirted with building a stadium in this part of town—once in the 1970s, and again, around 2005—but both times city lawmakers balked at the proposed deals.

The one place in this neighborhood Dallas lawmakers could agree to spend some money was the Cotton Bowl itself. In 2012, the city agreed to spend $25.5 million to slap some lipstick on the old place. This was on top of the successful bonds that were approved in 1995, 2003, and 2006, totaling $51.5 million.

This game means millions of tourism dollars to the local economy, and to lose it would be a morale killer for Dallas. Every so often one or both of the schools will make some noise about turning this game into a home-and-home series, but for now, both sides are happy. Each school receives $500,000, they split the ticket sales, and the latest contract runs through 2025.

In the end, there was nothing the Dallas city council could do to prevent the Cotton Bowl postseason game from relocating to the AT&T Stadium to ensure its place in the college football bowl hierarchy. Dallas could never keep—or reunite with—the Cowboys, but it has always found a way to keep Texas and OU.

10:01 A.M.

The Cotton Bowl west end zone

It is neither difficult to get into the Cotton Bowl, nor terribly challenging to go wherever you want; that's what makes it the Cotton Bowl. A confident wave, a pair of sunglasses, and a determined pace can get you through nearly any gate, including onto the field one hour before kickoff. The west end zone is draped in a long, cool shadow this morning as the spirit squads from the University of Oklahoma prepare for today's slaughter.

Once Texas A&M relocated to the Southeastern Conference in 2011, thus ending its long-standing annual game against Texas, the biggest "in-state" rivalry is this: Texas versus Oklahoma. The best in-state rivalry of the day is TCU and Baylor, but the biggest remains Texas and Oklahoma.

Although Oklahoma is technically not Texas, Norman is but 180 miles from Dallas, the same distance as Austin. Often the best Sooners are Texans. Two of the biggest names in Sooners history—running back Billy Sims and linebacker Brian Bosworth—are from Texas, much to the chagrin of UT fans. OU's current team features fifty-one kids from Texas, and a starting quarterback (from Austin) who started at Texas Tech and is now a Sooner, Baker Mayfield.

> **Once Texas A&M relocated to the Southeastern Conference in 2011, thus ending its long-standing annual game against Texas, the biggest "in-state" rivalry is this: Texas versus Oklahoma.**

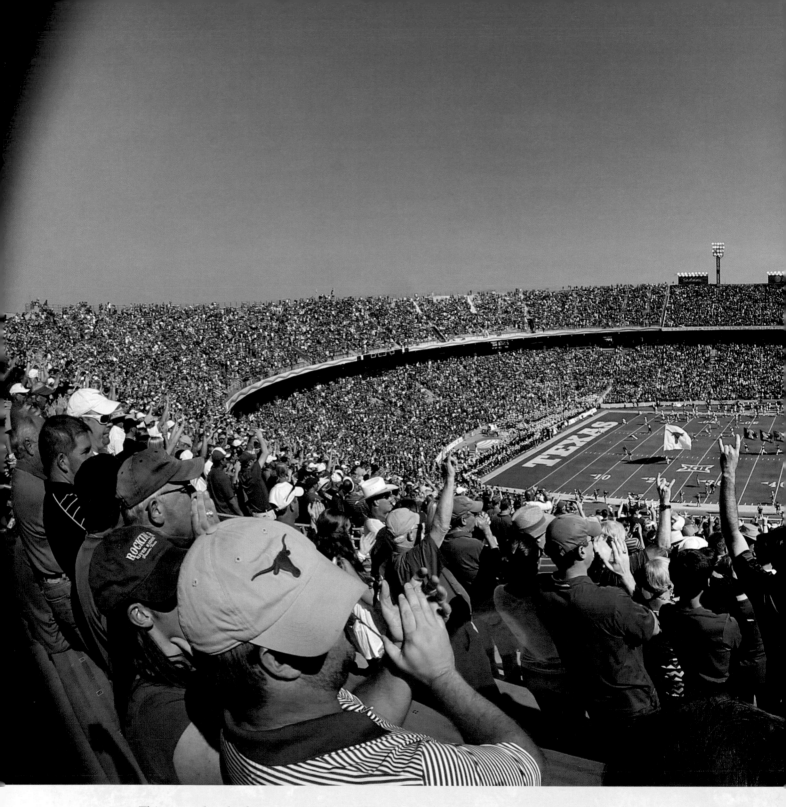

This game has had some great football icons, like Royal, Switzer, The Boz, Ricky, VY, Street, Roy Williams (Sooners), Roy Williams (Longhorns), Holloway, and Wilkinson, and made a Gardere into Peter the Great.

The University of Oklahoma and the University of Texas despise each other. It doesn't matter that UT's enrollment of approximately 50,000 is nearly double that of OU's, or that UT's endowment of more than $25 billion is a mere $24 billion more than OU's. What matters more than anything else is that Oklahoma is better at football.

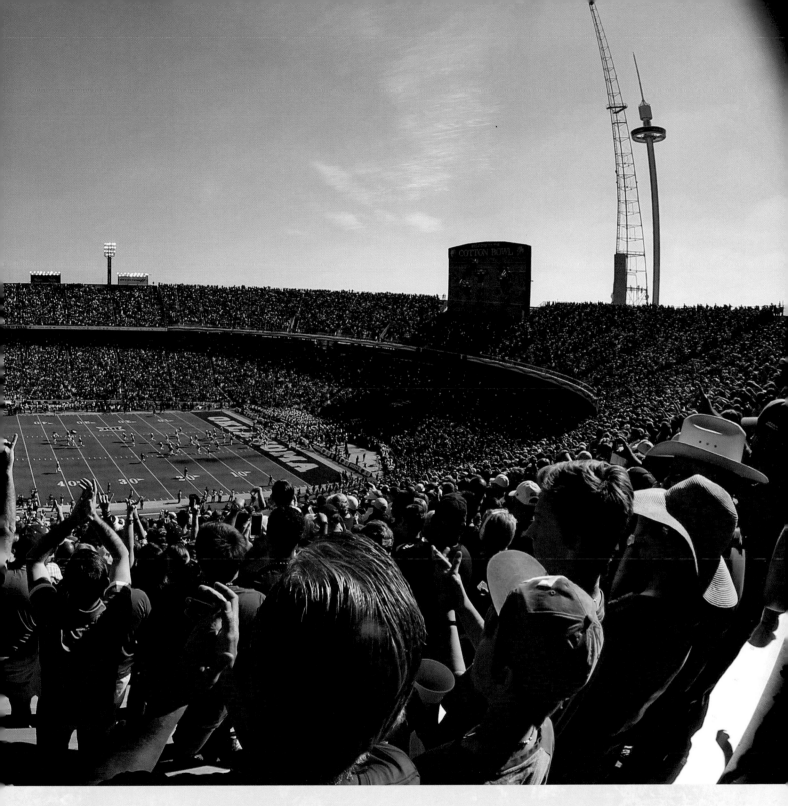

For the two schools, the coaches, and the players, this is the regular-season game that matters more than any other. This is the game where the wealthy, powerful alums who have the cell-phone numbers of the head coaches will call and kindly suggest, "Do yourself a favor and don't lose this one." This is the type of game where if the coach wins, he could theoretically lose the rest and be okay for a year.

"I definitely had dreams of playing this game; I would watch this game on television," Texas quarterback Jerrod Heard says. "The Texas–OU game is *the* one I wanted

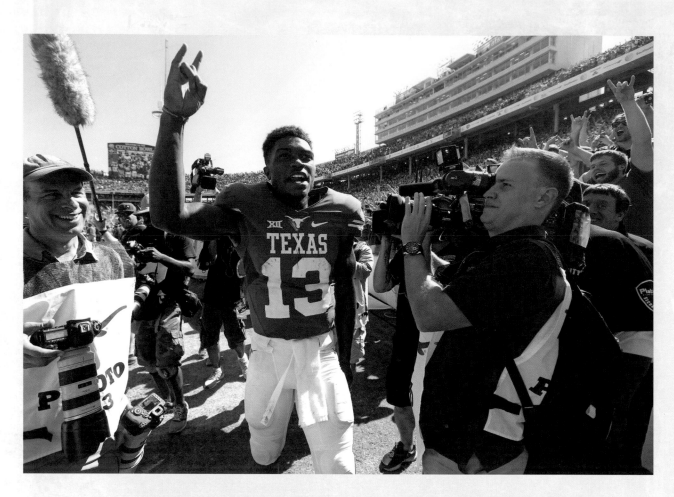

to play in. Seeing the whole stadium split from crimson to burnt orange. I always wanted to be the one to wear the gold hat."

Yes, *the* gold hat is the trophy awarded to the winner of this game. It was established in 1941, and it's a loud, garish, bright golden replica of a ten-gallon hat that coaches and players will take turns wearing for a few seconds after today's game concludes.

10:13 A.M.

Cotton Bowl field

The Iron Bowl in Alabama may be bigger, and it's hard to match the San Gabriel Mountains behind the Rose Bowl, but there is not another game that can match the scene at the Cotton Bowl for Texas–OU. It is visual feast awash in excess, from the bright colors, pretty people and everyday people, to the boots, cleavage, characters, animals, instruments, and firearms.

Behind the east end zone the University of Texas band crams into an area so tight that it makes it difficult to breathe, or walk. A fire marshal would have a ball issuing

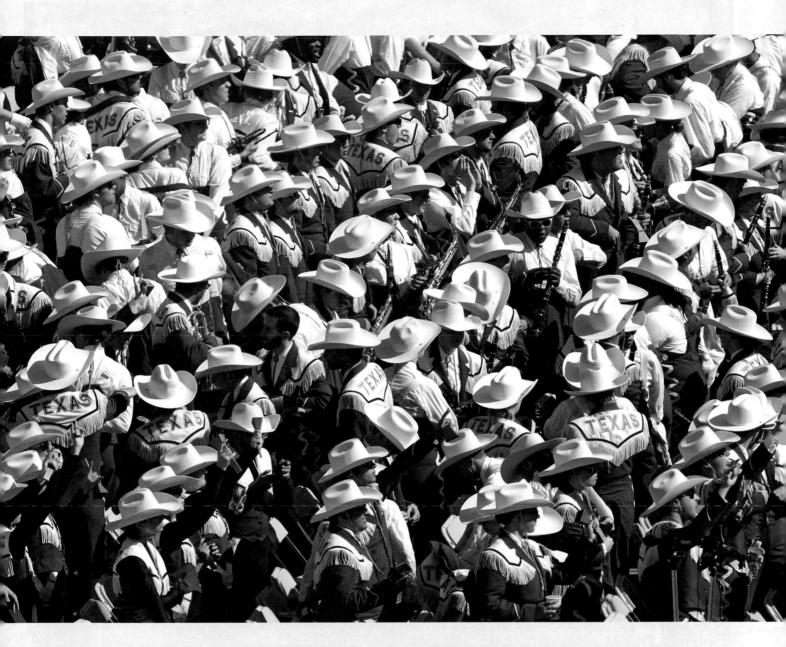

violations here. Only a few feet separate the band from the end zone, or each other. In the other corner of this end zone are the Texas Cowboys. Along with a few other groups, they give this game a Texan flair.

The Texas Cowboys are the UT undergrads who wear blue jeans, brown cowboy boots, leather chaps, button-up white shirts, and black cowboy hats. The organization has been around since 1922, but it didn't begin the business of firing the big cannon until it was created in 1953. It was built as a response to the shotgun blasts apparently fired by Oklahoma fans at the Red River Shootout.

Since 1955, Smokey the Cannon has been a UT constant. Every home game and every neutral-site game, Old Smokey is set up behind an end zone to go boom after every Longhorns score.

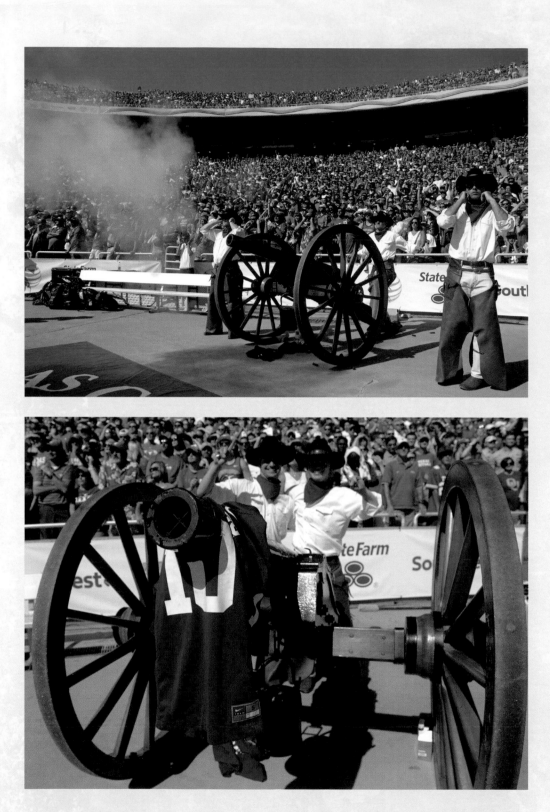

Since 1955, Smokey the Cannon has been a UT constant. Every home game and every neutral-site game, Old Smokey is set up behind an end zone to go boom after every Longhorns score. It's a Civil War replica, and today's version is Old Smokey III. It weighs over 1,200 pounds and fires four ten-gauge blank bullets. If you are too

close, it won't kill you, but it will scare the living hell out of you. There have been some complaints to the NCAA about Old Smokey, and every now and then an unsuspecting referee may whine, but Smokey is not going anywhere.

The four young men who stand over Smokey—Brad Eral, Jaan Bains, James Barton, and Andrew Campbell—all take pride in the responsibility that comes with this long-standing UT tradition. These guys, this cannon, are so unmistakably Texan, giving this afternoon, this team, and this game the unique feel that it enjoys.

There is one constant noticeably absent from the UT end zone this morning, however; the field is steer-less. Bevo is not here today.

Bevo is the actual big Texas longhorn steer that dutifully attends every UT home game. He was unable to make this trip to Dallas after being diagnosed with bovine leukemia earlier in the month. Bevo XIV is thirteen, and at the moment, no one is sure if he's going to make it. The prognosis is not great.

This Bevo, whose given name is Sunrise Studly, has been the UT mascot since 2004. He had sideline views for UT's win against Michigan in the Rose Bowl, its win over USC for the National Title in the Rose Bowl, and its loss to Alabama for the title in the Rose Bowl. He also attended the second inauguration of President George W. Bush in 2005. While members of the Silver Spurs organization that handles Bevo are here, the absence of this beautifully stoic animal is hard to ignore.

FIRST QUARTER, 15:00

Oklahoma's ball

The Cotton Bowl seats 95,000, but at kickoff on this beautiful, perfectly mild morning, sunny and 69 degrees, there are a few scattered empty seats. There are pockets of crimson in the burnt orange end zone, suggesting that some UTers sold out. The rational expectation is that this Red River game will ultimately play out like some of the previous beat-downs OU coach Bob Stoops has inflicted on former Texas coach Mack Brown.

The rational expectation is that this Red River game will ultimately play out like some of the previous beat-downs OU coach Bob Stoops has inflicted on former Texas coach Mack Brown.

Mack and UT were on the wrong end of the following games: 2000, OU 63–14; 2003, OU 65–13; 2011, 55–17; and 2012, 63–21. At halftime during each of those games, the overhead shot of the Cotton Bowl was decidedly crimson. The UT half of the Cotton Bowl featured a smattering of burnt orange, but mostly blue-and-white seats, while the other half was solid Oklahoma red.

For whatever the reason, OU fans have a tendency to remain until the bitter end, even when Vince Young's eventual national-title team defeated the Sooners in 2005

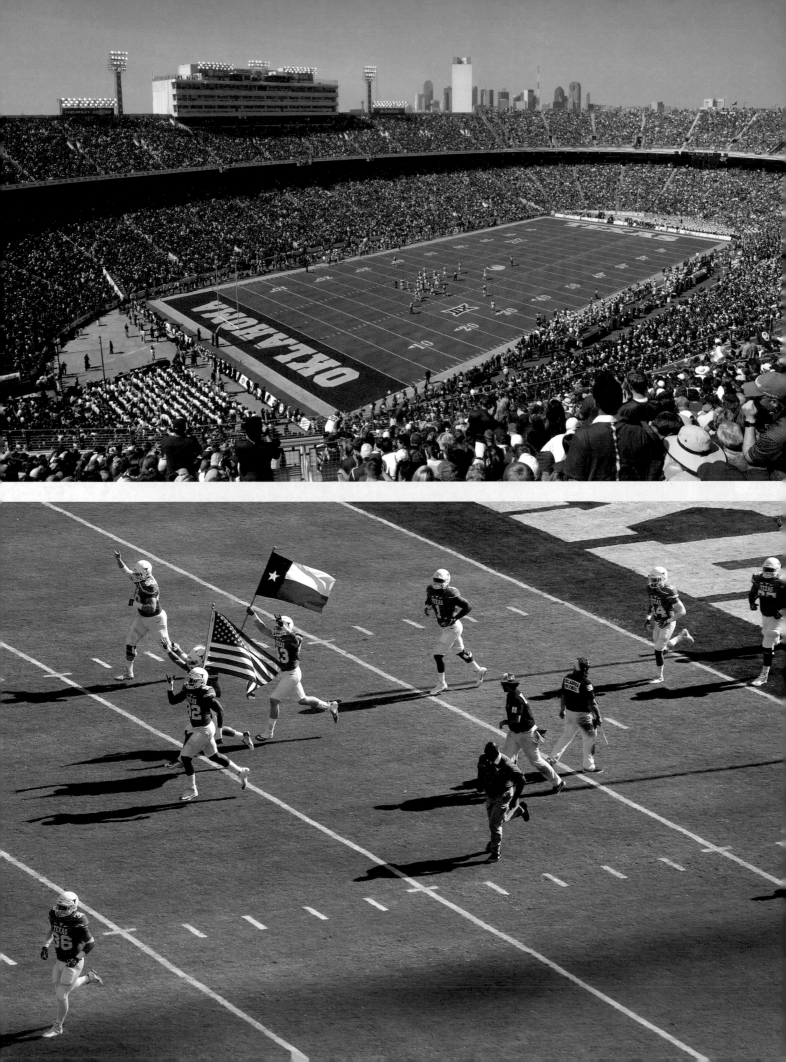

with a score of 45–12. Starting in 2006, the Cotton Bowl has remained full for the duration of the games, as UT won four of these next five games.

Now it's back to OU. The Sooners have won four of the last five, the exception being one of the biggest upsets in this series in 2013, when Mack Brown's unranked team stunned number-twelve OU by 16 points. But if ever there was a game that looks like it has 61–13 potential, it's today's.

"We don't need a signature win," Charlie Strong says. "We need a win."

When Texas's defense forces Oklahoma to a three-and-out on its first possession, the UT fans in attendance nervously applaud. Thus far, this team has mastered the art of doing just enough to punish their fans. The Longhorns lost at Notre Dame in the season-opener on national TV, by 35, and a few weeks later, authored two of the most impressively painful losses in the school's history. In Austin against California, UT scored 20 consecutive points in the fourth quarter, and, with seventy-one seconds remaining, just needed an extra point to tie the game. The kicker missed.

> **Thus far, this team has mastered the art of doing just enough to punish their fans. The Longhorns lost at Notre Dame in the season-opener on national TV, by 35, and a few weeks later authored two of the most impressively painful losses in the school's history.**

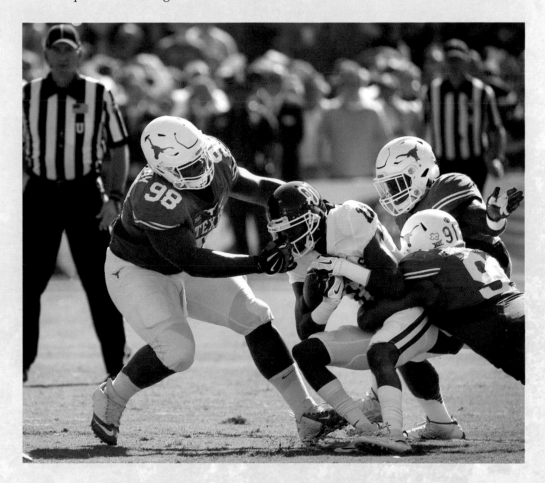

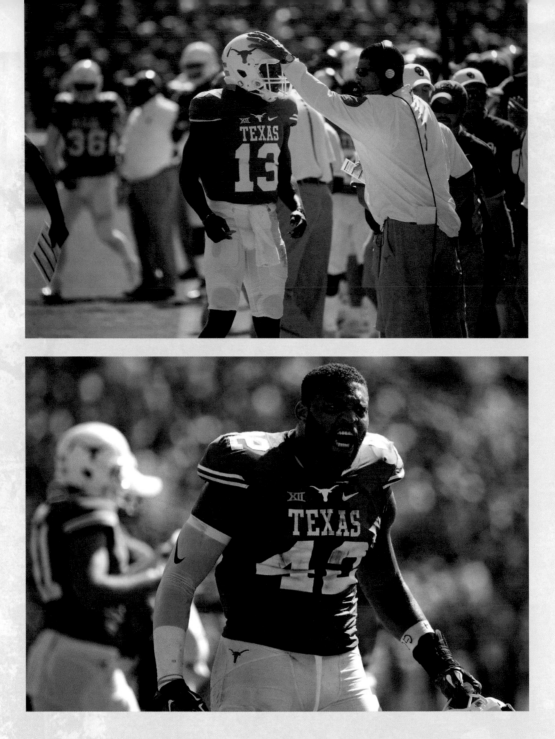

The next week, at home against Oklahoma State, the game was tied late in the fourth quarter. With thirty-six seconds remaining, punter Michael Dickson dropped the snap deep in UT territory and his punt traveled only 10 yards. The botched special-teams play gave Oklahoma State a short field to win the game by 3.

With four losses already, and only early October, the season is gone; faith in second-year coach Charlie Strong has waned considerably. Texas's four losses are against teams that are all ranked in the Top 25, and players are holding players-only meetings.

One of the biggest reasons Texas is a decisive underdog is seen after Oklahoma's first possession ends in a three-and-out. Quarterback Jerrod Heard claps his hands as he takes the field for the Longhorns.

FIRST QUARTER, 11:17

Texas's ball

Texas takes the ball for the second time this morning to start a drive from its own 23. The defense has sacked Mayfield, and held its own. The concern is the offense, and whether their quarterbacks can make positive plays for the team. At some point Texas will need a positive play or two from a position that has befuddled both Strong and Brown, and ultimately cost the latter his job.

To start the 2015 season, the following quarterbacks are all from the state of Texas and starting in the NFL, and none of them attended the University of Texas: Drew Brees (Purdue), Nick Foles (Arizona), Andy Dalton (TCU), Andrew Luck (Stanford), Matt Stafford (Georgia), Ryan Tannehill (Texas A&M), Josh McCown (SMU/Sam Houston),

Johnny Manziel (Texas A&M), Ryan Mallett (Michigan/Arkansas), and Derek Carr (Fresno State). Absent from this list is former Redskins starting quarterback Robert Griffin III, who won the Heisman Trophy for Baylor, and was for a time the starter in DC.

Brown's inability to find a quarterback cost him his job, and when he left after the 2013 season, there were no proven or decent options available to Strong. Heard is a redshirt freshman from Denton who previously broke Vince Young's school record for most offense in a single game, and then turned around and did nothing at TCU. Last year's starter, Tyrone Swoopes, essentially lost his job earlier in the season. Fans are praying that Heard is an upgrade, although considering how little he has played, it's hard to feel secure.

Brown's inability to find a quarterback cost him his job, and when he left after the 2013 season, there were no proven or decent options available to Strong.

"This is definitely bigger. Definitely bigger than I realized," Heard says. "When you have this job as the starter for the University of Texas, I am not going to lie, there is a lot of pressure. What you do with the pressure is how you manage everything."

The 'Horns are not planning to win this game by passing. Strong has told his team, "We are going to run the ball right down their throats." Strong wants to beat Oklahoma by running the ball *at* Oklahoma, and alternating two quarterbacks.

During this drive UT receiver Marcus Johnson's trick pass is intercepted by OU defender Zack Sanchez. The play is negated by an OU penalty, and five plays later Heard is credited with a shovel pass, but it's essentially a hand-off to Johnson.

"We worked that," Oklahoma defensive coordinator Mike Stoops says. "That should be a no-gain play."

Instead, Johnson runs around the left end and breaks, or runs through, five tackles to score a touchdown.

Old Smokey fires her four ten-gauge bullets, the Texas Cowboys celebrate with the Texas players in the end zone, and Texas leads Oklahoma, 7–0. The burnt-orange-and-white section of the Cotton Bowl pops in delight.

Old Smokey fires her four ten-gauge bullets, the Texas Cowboys celebrate with the Texas players in the end zone, and Texas leads Oklahoma, 7–0. The burnt-orange-and-white section of the Cotton Bowl pops in delight.

The noise level increases when on the ensuing kickoff, Oklahoma returner Alex Ross loses the ball after he is hit by DeShon Elliott. Half of the Cotton Bowl howls with an *Ohhhhhhhhhhhh . . . yeeeeeaaaaahhhhh!*

Texas has recovered, and is 41 yards from a 14–0 lead.

"This is a different Texas team," ESPN game analyst Chris Spielman says.

The Texas fans chant, "O-U SUCKS! O-U SUCKS! O-U SUCKS!"

FIRST QUARTER, 6:21

Texas's ball

Oklahoma coach Bob Stoops calls his first timeout of the game. Heard is out of the game in favor of one of the nicest kids you'd ever want to meet: Tyrone Swoopes.

If any kid embodies the misfortune of being compared to another, it would be Swoopes. If any kid should not have signed with Texas, it would be Swoopes. He stands six-foot-four and weighs 245 pounds. Physically there is a resemblance to another former UT quarterback, Vince Young. The difference, however, is that Vince Young was the best athlete on any field he played on during his high school and college careers. By the time Young left Texas he had led the Longhorns to a national title, and is now beloved by every generation of UT fans.

When Brown signed Swoopes, the comparisons to Young began. Swoopes's high school team won by one game during his senior year at the 2A level, suggesting that despite his gifts, he lacked something. Before he arrived in Austin he was labeled as the "Next VY." Swoopes struggled as a freshman in 2014, and he has lost his starting job to Heard. Strong, however, thought he could find some way to use the tall kid whose confidence appeared to be all but shattered when he was benched a few weeks prior to this game.

His team is 14 yards away from its second touchdown, and the 'Horns need one yard to extend this drive. Swoopes keeps the ball and rushes for 7 yards and a first down. Swoopes runs the ball on the next two plays, the last for 3 yards into the end zone, but as he crosses, he fumbles the ball. The referees review the play for several minutes and the fans nervously await the decision. Replays show that Swoopes may have indeed fumbled the ball only a fraction before the ball crossed the plane of the goal line. It would be so 2015 Texas if the Longhorns lost this touchdown.

Replays show that Swoopes may have indeed fumbled the ball only a fraction before the ball crossed the plane of the goal line. It would be so 2015 Texas if the Longhorns lost this touchdown.

"After further review," referee Cooper Castleberry tells the crowd, "the ruling on the field is confirmed—touchdown."

One half of the Cotton Bowl erupts with shocked glee while the other sits in equal shocked silence. Everything that went against Texas in the previous weeks works now. This is not the same team that lost the previous week in Fort Worth, during which Texas defensive back Kris Boyd used his phone to send a tweet during halftime.

In the past decade, local chefs and cooks have creatively waged a full frontal assault on healthy eating at the State Fair. This is not always worth bragging about, but Texans can live up to the idea that they eat as big as the state. The State Fair of Texas doesn't help anyone who's battling an expanding waistline, but the food here is too good to ignore. You can feel your belt tightening just walking by the scent of hot oil.

In the past decade, local chefs and cooks have creatively waged a full frontal assault on healthy eating at the State Fair.

The delight of deep-frying a hot dog covered in cornmeal was just the first step of the deep-fried craze that is the guiltiest of pleasures at the game. Every year the Texas State Fair issues a host of new foods, wait times for which can stretch as long as forty-five minutes on a busy day or evening. The food has become a bigger attraction at the State Fair than the Ferris wheel or the House of Mirrors, or even the game.

If it can be dipped in buttermilk, rolled in flour, and dropped in bubbling vegetable oil, it has likely been done here. Now the challenge is to see who can come up with the best "worst" food. One of the bigger insults these chefs will hurl at the other, behind their backs, is that their cuisine is "a gimmick."

The most famous creation was that of local chef Abel Gonzalez, whose invention of "Deep-Fried Butter" landed him a spot on Oprah Winfrey's TV show before she retired. Deep-Fried Butter is one tablespoon of butter placed in an uncooked biscuit patty, dropped in hot oil at 350 degrees for about one minute, or until golden; give it about thirty seconds to cool, if that, and then promptly devour. It's better when covered in strawberry or chocolate syrup, or even powdered sugar.

"I think it's funny. I also think it's Texas being Texas—as big and as crazy as you can make it," says celebrity chef Tim Love, who has become a regular on the Food Network, and whose Fort Worth restaurant, Lonesome Dove, is one of the finest in the region. "While everyone knows that if you [deep-]fry a flip-flop it will probably taste

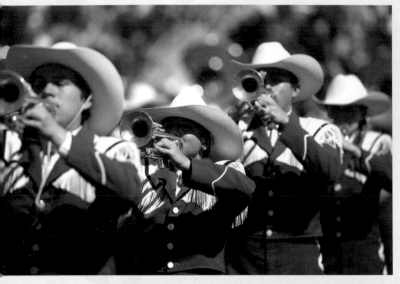
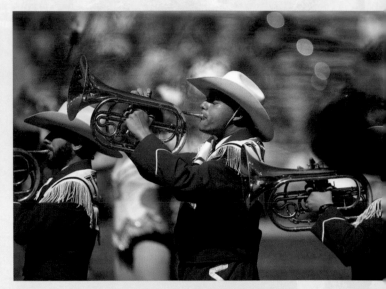

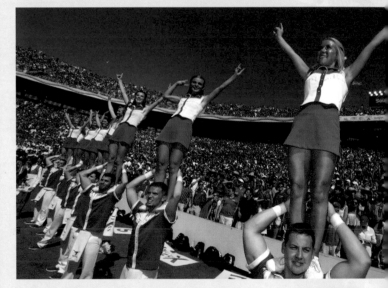

at least okay, there are some possibilities of some delicious, unusual, deep-fried stuff. The question is, what will it be for the particular year?"

This list includes other high-calorie creations like Deep-Fried Coke, Deep-Fried Snickers, Deep-Fried Oreos, Deep-Fried Beer, or this year's collection that boasts Deep-Fried Cheeseburger, Pumpkin Spice Donut Chip, Milk Chocolate Bacon on a Stick, Deep-Fried Tailgate Party, and Fried East Texas Sausage and Pepper Jack Cheese on a Stick.

It's only a matter of time before there's Deep-Fried Kale.

HALFTIME

Section III

What's considered proper attire for a sporting event in America has evolved over time, from business suits with a fedora to game jerseys and jeans, to the widely accepted comfort of today's T-shirts, baseball caps, cargo shorts, and painted faces. To the women of Texas, there is no football fashion statement as versatile, sexy, or as time-lessly Texan as a pair of boots with a dress or a skirt.

In Texas, a pair of nicely pressed blue jeans qualifies as formal attire; likewise, a pair of boots. Mind you, these are not work boots covered in mud and dirt. These boots are expensive. A good pair can cost anywhere from $50 to $2,000, and they are a staple in nearly every closet in the state. It is almost impossible to see a woman at this game sporting anything other than a pair of boots to complement the rest of her attire

of skirts, dresses, or Daisy Duke shorts. This is not just a young woman's outfit; it's age-appropriate for all.

With a few minutes remaining before the end of halftime, Kingsley Gourley and her mother, Kelly, stand waiting for the second half to begin. They're both sporting boots and dresses.

"I am really not sure why or where it started, but it's so comfortable," Kingsley says. "Once you break them in, they are the best shoes to wear."

In Texas, a pair of nicely pressed blue jeans qualifies as formal attire; likewise, a pair of boots.

Wearing these boots and a white dress, Kingsley cuts the perfect image of a Texan girl. She has long brown hair and the fresh skin of someone in their early twenties. She was a high school cheerleader in Austin, and a competitive cheerleader for ten years. Her boyfriend is Ryan Taggart, who was an all-district quarterback at one of the premier high school programs in the state—Euless Trinity, about thirty minutes west of the Cotton Bowl. Taggart played college ball at Holy Cross and played in Germany, too. Ryan looks like a quarterback and Kingsley looks like a cheerleader. They look like young Texans.

And wearing their boots, Kingsley and her mom both look relaxed and informally formal—quintessential Texans.

"When you have a little girl in Texas," Kelly says, "you buy them a pair of pink boots."

THIRD QUARTER, 8:18

Texas's ball

Everybody is back in their seats for the start of the second half. The announced attendance is 91,546, but the way the afternoon is developing, this will be one of those games that every member of the Texas Exes, its official alumni group, will claim to have attended, and many will sneak in from the Fair.

Despite a 14–3 lead, nobody associated with Texas feels safe. Oklahoma is better, and Oklahoma should be winning.

Strong did not believe his team to be inferior. During the week, Strong told his team, "At some point, we just gotta go, guys. We just gotta play up to our ability."

Texas is down, but it's still the University of Texas. It's still a roster loaded with Texans whose high school careers were some of the best in the nation. The final thirty minutes will determine if UT is going anywhere.

Texas begins the second half with the ball, and it keeps possession for nearly the first seven minutes. The drive reaches the Oklahoma 10 before the Sooners' defense finally tightens and prevents Texas from running for yet another first down, or

touchdown. UT settles for a field goal and leads 17–3, with 8:18 remaining in the third quarter. Had UT scored a touchdown here, for the first time this afternoon the game would have felt out of reach for Oklahoma.

For now, the game is still in play.

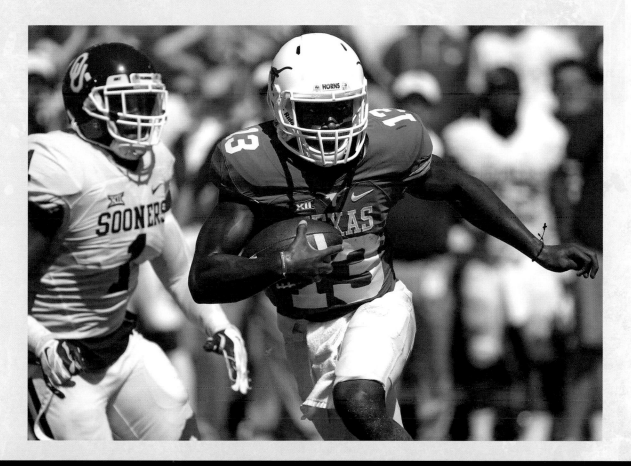

Oklahoma's ball

Mayfield signals to his offense after completing a screen pass to wide receiver Sterling Shepard, for a first down to the Oklahoma 43-yard line. It's the first time today Oklahoma looks like the number-ten team in the nation.

While the combination of Heard and Swoopes is working today, there is not a Texas fan in these stands or watching that would not trade them both for Mayfield.

In the Sooners' second game, Mayfield showed just how bad Texas, Texas Tech, TCU, and so many others missed out on him; Mayfield led OU to two fourth-quarter touchdowns at number-twenty-three Tennessee, and defeated the Volunteers in overtime.

This kid is just another in a maddeningly long line of quality Texan quarterbacks that did not, or do not, play for the University of Texas. Mayfield was told by the Texas coaches that there wasn't a spot for him at UT, even to walk on. At the time UT had five quarterbacks. Mayfield hoped for a scholarship at TCU, and instead walked on at Texas Tech. He was named the Big 12 Offensive Freshman of the Year, but he was never handed a scholarship by Texas Tech, so he transferred to Oklahoma.

In the Sooners' second game, Mayfield showed just how bad Texas, Texas Tech, TCU, and so many others missed out on him; Mayfield led OU to two fourth-quarter touchdowns at number-twenty-three Tennessee, and defeated the Volunteers in overtime. Whatever he lacks in God-given ability he makes up for in a visible willingness to never quit on himself,

a play, a game, or a season. He is a bundle of muscle, intensity, attitude, and persistent exertion.

He and Shepard are OU's best chance to tie this game.

Shepard is the son of one of the best wide receivers in the history of the entire Texas–Oklahoma rivalry. Derrick Shepard played for the Sooners from 1983 to '86, and was on their national-title team in 1985. He died of a heart attack in 1999, at the age of thirty-five.

Sterling may be better than his dad, but as of right now, Texas has contained him. That changes on the next play, when Mayfield finds Shepard for a 50-yard pass completion to the Texas 7. Two plays later, Mayfield throws his first touchdown pass of the day, and dread hangs over the burnt-orange side of the Cotton Bowl. Never has a 17–10 lead felt so weak.

THIRD QUARTER, 00:40

Texas's ball

The Longhorns start the final drive of the third quarter at their own 10-yard line. They are the better team today, but the momentum they earned by dominating the line of scrimmage is tenuous. This is a young team that has lost in painful ways so far, with quarterbacks that no one trusts.

The 'Horns face a second-and-twelve, and Heard is in the shotgun, with running back D'Onta Foreman standing to his right. Foreman's twin brother, Armanti, is lined up wide right as a wide receiver.

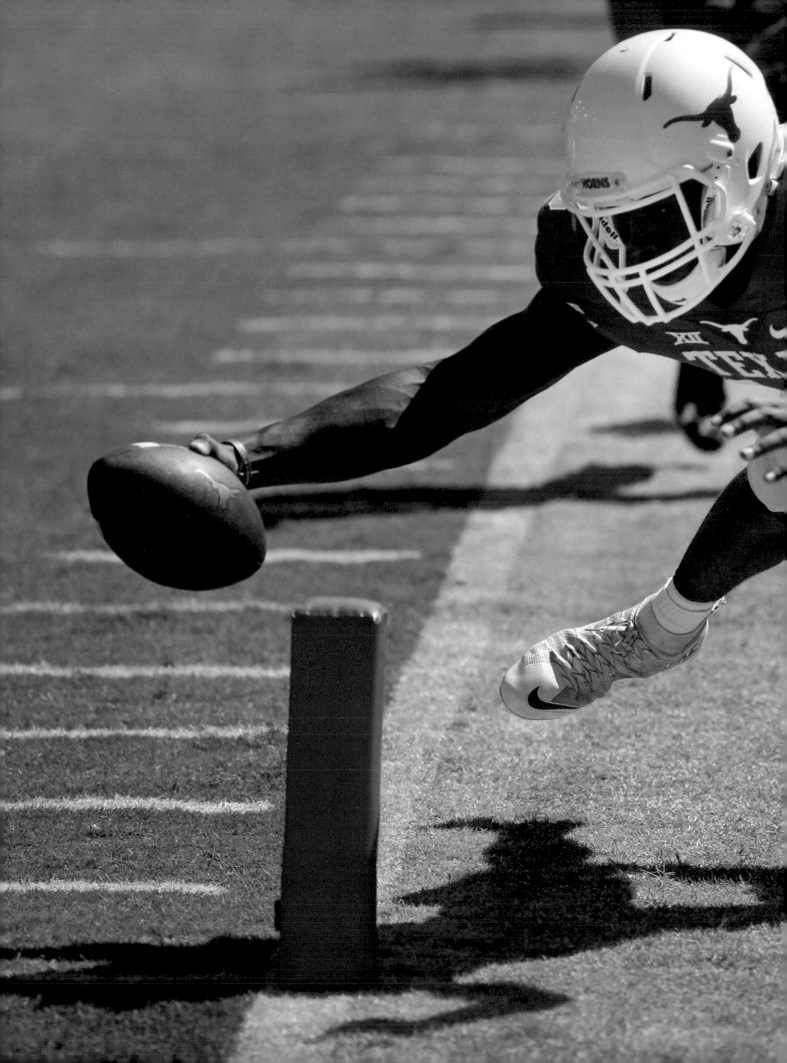

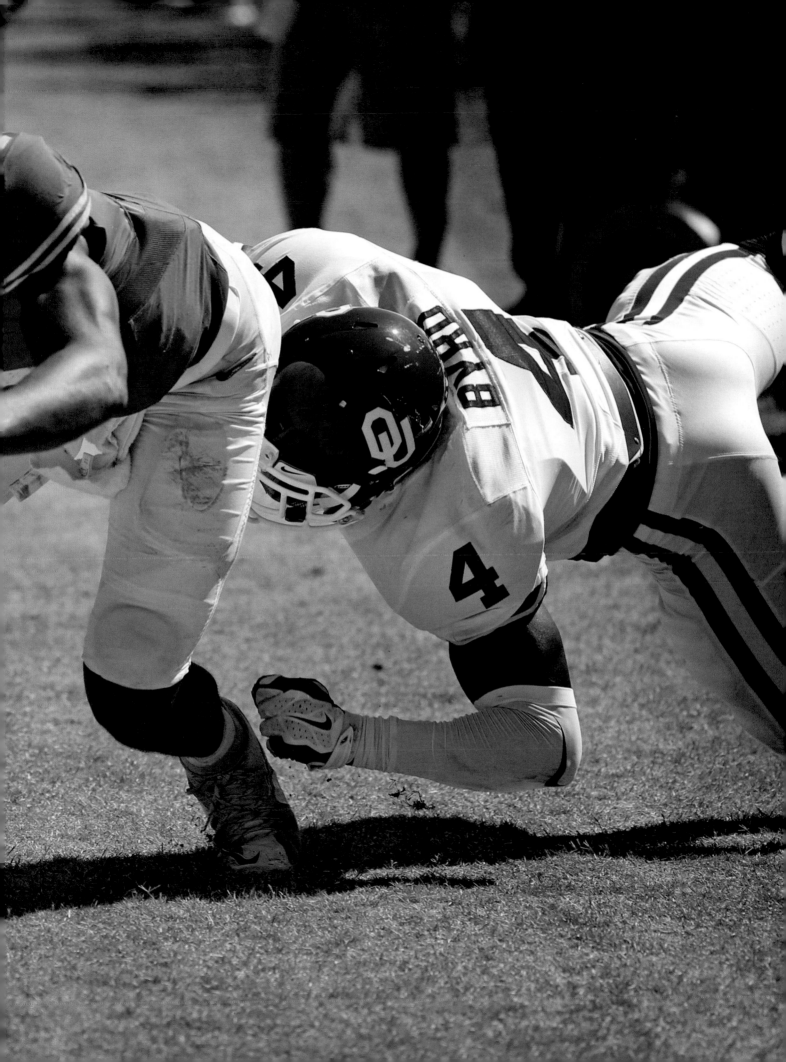

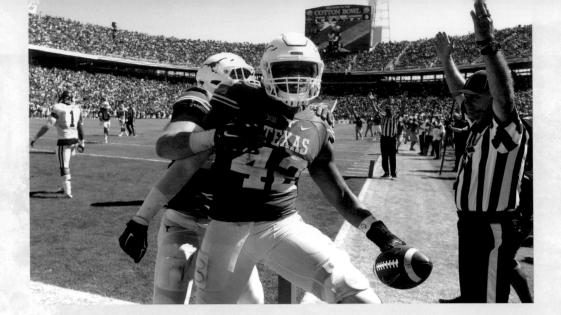

A lot of Texas players hate Oklahoma for a variety of reasons, but few people swing an ax against Oklahoma coach Bob Stoops the way D'Onta does. Both he and his twin were highly sought-after recruits coming out of one of those blue-collar oil towns near Houston, Texas City. Armanti was offered a scholarship by Oklahoma and D'Onta was not. They both accepted offers to Texas, but D'Onta will never forgive OU.

Heard slaps his hands to signal he is ready for the snap. He catches the ball. He takes three steps to his right. He hands it to D'Onta, who has an enormous hole in front of him. The play is a simple sprint draw, and D'Onta takes the ball at his own 3-yard line.

"We were aware of the sprint draw for sure, and defended it really well," Bob Stoops says. "All it takes is one time."

D'Onta runs untouched for the first 16 yards; here is where he *should be* tackled. Instead, the two OU defenders collide with each other.

This will be that one time. D'Onta runs untouched for the first 16 yards; here is where he *should be* tackled. Instead, the two OU defenders collide with each other.

"D'Onta Foreman rumbling free!" McDonough says. "Across midfield!"

The missed tackles spring D'Onta for one of the biggest plays in the history of the school. D'Onta is eventually run out of bounds on this, the final play of the third quarter, at the Oklahoma 10-yard line, only a matter of feet from the Oklahoma cheerleaders.

Armanti Foreman trails his twin on the play, and is one of the first to celebrate the play with his brother.

D'Onta is slightly annoyed that he's caught from behind by Oklahoma safety Zack Sanchez to stop the run at just 81 yards—the twelfth-longest run in school history. With one run, Foreman has flipped the field.

Sixty-eight seconds into the fourth quarter, Swoopes fakes a run and completes a jump pass to a wide-open Caleb Bluiett in the back of the end zone, for a 24–10 Longhorns lead. It's Swoopes's first pass attempt of the game. Oklahoma feels the weight of possibly being upset by its most hated rival in a game the Sooners should win by double digits. No Oklahoma team ranked this high has ever lost to any team this bad, this late in the season.

FOURTH QUARTER, 6:05

Oklahoma's ball

This is the kind of moment Mayfield thrived on during the team's win at Tennessee. Oklahoma has been the better team by a wide margin in the past few possessions,

All teams and all schools in Texas are compared to the University of Texas. In the modern era, no other team from Texas has won a national title but the University of Texas.

and the impending doom Texas fans have tried to suppress is defeating the hope they'd started to feel. Rather than pulling off an upset, this will go down as yet another choke.

On the Sooners' last offensive possession, they move the ball 75 yards on fifteen plays to score a touchdown that makes the score 24–17. When Texas has the ball with a chance to answer with a score, or kill the clock, the Longhorns generate minus-2 yards on three plays before punting.

This is how it's going to go down: Oklahoma will drive the length of the field to score. The Longhorns will do nothing on the following offensive possession. The Sooners will win in overtime. This feels inevitable, when on the second play Mayfield finds Shepard for a 14-yard gain.

But then a football miracle happens.

On the next play the best defensive player on the field all afternoon sacks Mayfield for an 8-yard loss. Nobody from Oklahoma can block true freshman linebacker Malik Jefferson, his second sack of Mayfield in his sixth tackle.

Jefferson is UT's hope to reverse what so far has been a historically awful start to the season. With a bright smile and dreadlocks that flop and flow, he has All-American talent and NFL ability. He is bright, affable, and charming, his personality and confidence matching his physical skills. He knows Texas is down, but he also knows that no

school in a state that drinks football like water has wattage like UT. All teams and all schools in Texas are compared to the University of Texas. In the modern era, no other team from Texas has won a national title but the University of Texas.

"That is the truth, and we know that. All of those kids in this state that went to other schools know that, too," Jefferson says. "That

is why they feel like they won the national championship when they beat us. We are always the big brother, and they know that."

Two plays later, Oklahoma faces a third-and-fourteen to extend their game-tying drive. Rather than register another first down, Mayfield is sacked by Naashon Hughes and Poona Ford, to start a celebration that Charlie Strong has no interest in stopping.

FOURTH QUARTER, 2:50

Texas's ball

OU's dicey chances to tie the game drop further when its punter boots a puny 32-yard kick. The Sooners' defense is spent, embarrassed, and down to its final chance. Bob Stoops has called his last timeout. The best OU can do is to stop Texas on this play, and then hope that Texas's kicker will miss a long field goal.

It is the Cotton Bowl. It is the Red River Rivalry. Horrible things have happened to Texas this season. Stupid happens.

Texas faces a third-and-ten from its own 29-yard line, and Strong will not allow Heard to attempt a pass. This is about killing the clock. Dread, Anticipation, and Suspense all have a seat next to everyone here at the Cotton Bowl.

Lined up in the shotgun at his own 35, Heard fakes a hand-off and runs the ball up the middle to the 30. He picks up a beautiful block in the middle of the field at the 24. Heard cuts left at the 19. He has more than enough for the first down, and he slides down to keep the clock running.

On his way back to the huddle, Heard exchanges a low five with his head coach. Both men realize the significance of what just happened: Texas is going to beat Oklahoma.

On his way back to the huddle, Heard exchanges a low five with his head coach. Both men realize the significance of what just happened: Texas is going to beat Oklahoma.

To kill the clock, Strong calls Johnathan Gray's number. If any player deserves this moment, or to be in this game, it's this kid. He is all that is right about college athletics. His story is often forgotten because it didn't go quite the way it was supposed to, coming out of high school. Like so many kids, Gray's career was stuffed with high school accomplishments, awards, and accolades. He was scheduled to be another Mr. Longhorn. Instead, college football has been not as easy for the five-foot-ten running back from Aledo, Texas, a well-to-do suburb west of Fort Worth.

Gray looked like he could be a decent replacement for former UT All-American running back Cedric Benson, the kid from Midland Lee. As a sophomore, Gray tore his Achilles', and he's never been the same since. The burst and speed that made him an uncatchable special running back is gone. The gear that he possessed before that injury is no longer there.

Gray is a good, bright young man who will graduate with a degree from the University of Texas, but on the field his career has not worked out the way both he and the Longhorns had hoped. He won't win a national title, or be named an All-American, and today will be his last Texas–OU game.

"This game means a lot," Gray says. "It's not just a game. This is a war. It's bragging rights for 365 days. To be able to win this in my senior year?"

He shakes his head, as does nearly everyone watching.

They did it. Texas defeats Oklahoma, 24–17.

3:31 P.M.

Cotton Bowl, east end zone

As the Oklahoma players jog off the field with their heads hanging in disgust and dismay, the Sooners' fan base flees the stands, heading to the State Fair for a corn dog, or to the parking lot to go home. What was supposed to "be over soon" instead turned into one of the single biggest upsets in the history of this rivalry.

"This is one of the toughest losses I've had since I've been at OU, and probably in my career playing football," OU safety Steven Parker says.

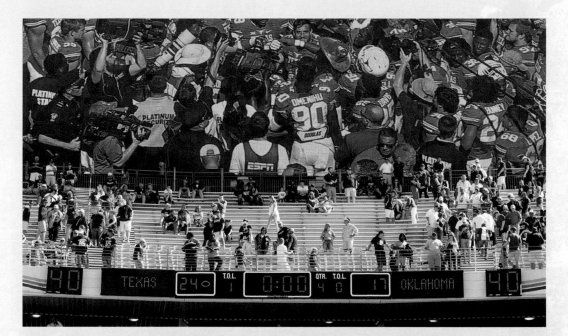

Nearly all of the Texas fans stand at their seats to celebrate and flash the "Hook 'Em" signs with their index finger and pinky pointed high. The UT band plays "The Eyes of Texas," and nearly everyone remaining at the Cotton Bowl can sing the song from memory, even though it was written by John Sinclair way back in 1903:

The eyes of Texas are upon you,
All the livelong day.
The eyes of Texas are upon you,
And you cannot get away.
Do not think you can escape them
At night or early in the morn—
The eyes of Texas are upon you
Till Gabriel blows his horn.

Texas could lose the rest, and everyone here will still have this. Smokey fires once more, the giant white flag with the burnt-orange steer is run all over the field, and the players sprint throughout the UT end zone to celebrate, like they just saved their coaches' jobs.

Texas Republican governor Greg Abbott, who is paralyzed from the waist down—this nation's first elected governor to be in a wheelchair since Alabama's George Wallace—wins his bet of a little barbecue with Oklahoma Republican governor Mary Fallin.

The win is celebrated by all of Burnt Orange Nation, but it's not about a governor, powerful alums, or even the players. In the eye of this giant rave on the field is a man whose smile and stature make him impossible to miss. With his bald head and his barrel chest, Charlie Strong may be the single most imposing head coach in college football. He looks like he could play right now, but he's too busy smiling.

It's hard not to be happy for Strong when his players pick him up; he lays flat on his back and is pushed up in the air time and time again in celebration. Strong pumps his arms repeatedly as his players lift him up and down. This is easily the biggest win of his brief tenure at Texas, the type of badly needed evidence that proves he can succeed as the head coach.

Just one month prior to this celebration, the man who hired Strong, UT athletic director Steve Patterson, was fired. The wealthy alums and boosters who wield

tremendous influence at the University of Texas wanted Alabama's Nick Saban as their head coach. The decision to hire Strong to replace Mack Brown was not a wildly popular one.

Strong is a former defensive coordinator at the University of Florida who built his reputation as an old-school, hard-ass coach when he was at Louisville. Since his arrival in Austin, he's tried to create a different culture—one that has included kicking off several players. Strong is the first black head football coach at the University of Texas, and the state's highest-paid employee. The day he was introduced it all looked good, but the team still finished 6-7 in his first season. Before today, the Longhorns were 7-11 in his tenure.

Strong needs something to sell to his employers, fan base, and players, something to confirm that he knows what he's doing. "They can build something special here," Strong says. "It's such a big deal. I think what our fans were waiting on was a breakout win, because we had not had one in so long. To get this one is really big."

The decision to hire Strong to replace Mack Brown was not a wildly popular one.

Since the start of the season, no Texan has been more beleaguered than Strong, and his players celebrate for their coach as much as for themselves. They want this for him. In a giant circle of players and assistant coaches, Strong is handed the golden ten-gallon hat. He wears it proudly as the eyes of Texas smile on him.

7:13 P.M.

Buffalo Bros. Bar and Restaurant, Fort Worth

One of the greatest things about Texas football is that there's always a Texas-related game on; the question is picking which ones to watch. Three teams in Texas are currently ranked in the top ten. During Texas's upset of Oklahoma, number-three-ranked Baylor disposed of Kansas in Lawrence, 66–7. Number-nine-ranked Texas A&M is on a bye week, and will host number-eight Alabama next Saturday at Kyle Field in College Station.

> One of the greatest things about Texas football is that there's always a Texas-related game on; the question is picking which ones to watch.

Thirty-eight miles due west of the chaos of the Cotton Bowl is an equally noisy scene in this sports bar, located on TCU's campus. Folks have gathered here to watch the number-two team in the nation at Kansas State. TCU has an enrollment of a little more than eight thousand, and over the last thirty years, few schools in America have expanded any more successfully than this private school, following the path of football to do so. The T is for Texas, the C is for Christian, and the F is silent—but it stands for football.

This restaurant and bar, co-owned by a local celebrity chef named Jon Bonnell, is located in a small strip of restaurants and bars that is part of TCU's original footprint. While this strip has remained basically the same, much of the university has changed over the last twenty years, mostly because of the school's plan to invest heavily in athletics, specifically football.

The younger crowd watching the game on the many TVs in the restaurant can't envision a time when TCU was terrible, or imagine that their favorite college football team was close to the same type of penalty imposed on cross-town rival SMU in the 1980s. The older generation remembers those wild paydays of the old Southwest Conference, when boosters brazenly paid high school kids to entice them to sign with their alma mater. SMU remains the face of those scandalous times, when the NCAA handed them the "Death Penalty," forcing the school to shut down the football program in 1987.

The younger crowd watching the game on the many TVs in the restaurant can't envision a time when TCU was terrible, or imagine that their favorite college football team was close to the same type of penalty imposed on cross-town rival SMU in the 1980s.

TCU was not far off from receiving a similar penalty in 1986, when then coach Jim Wacker self-reported to the NCAA. The organization handed the school a three-year probation for the sixty-four infractions. Around here, to the decreasing few who remember, TCU was given the "Walking Death Penalty." It took the school more than a decade to recover. SMU never has.

"That's what people never understood—SMU got the Death Penalty, but ours was the second-worst penalty ever," says WC Nix, who was an offensive lineman for the Horned Frogs from 1984 to '87. "It tore down the program for at least ten years. Wacker was trying to do the right thing, but it didn't work. They tried to be positive and to strive, but that's when it went south."

Gary Joe Lewis is forty-five, and a 1992 graduate of TCU, a season where TCU finished 2-8-1. He sits at a table with a friend and their sons. Gary Joe remembers when TCU was a joke, left out of the creation of the Big 12 in 1996.

"I would never have dreamed any of this would have happened," Gary Joe says. "It's always in the back of my mind, that I think we can be bad again. This entire generation doesn't know any better, or how bad we used to be."

On the TVs TCU Heisman Trophy hopeful Trevone Boykin runs around and throws darts to wide receiver Josh Doctson. The entire bar is packed with people wearing purple TCU hats, or TCU shirts. Throughout all of the 1990s, there were no such scenes for a TCU football game, away or at home. The traffic cops at home games at Amon G. Carter Stadium would sometimes fall asleep on the job. In the late '90s TCU gutted its athletic department, and the school committed to spending millions to upgrade and modernize. It fell into hiring a defensive coach in Gary Patterson, who matured into one of the best coaches in the sport.

"It shows you what can happen when you hire a good coach. When we hired him I wasn't so sure, but boy, am I glad they did," Nix says. "Looking back on it, I am not so sure if all of this would have happened had we gone into the Big 12. Did I think we would ever be here? Honestly, no. When you are in those smaller conferences like we were, you don't know if you'll ever get it. What they built is unbelievable."

All of this led up to an undefeated season and a Rose Bowl win on New Year's Day in 2011, and eventually, to an invitation to the Big 12. Winning a national title is now thought possible for the school that had to play its way from the Western Athletic Conference, Conference USA, and Mountain West Conference, and finally, a spot in a

TRAVEL LOG, DAY 3

During Captain Robert Falcon Scott's bid to be the first man to reach the South Pole, he noticed that his sled dogs became disinterested and considerably slower when running toward an endless horizon. Without an aim, the sled dogs slackened their efforts. Once the dogs established a focal point and could see a destination, their energy, mood, and speed all improved.

Ron, Michael, and I are the sled dogs. The good news for us is that unlike the dogs of Scott's doomed trip in 1912, no one will eat us to live.

The morning of Day 3 was focal-pointless. It was only forty-eight more hours, but this stretch was always going to be the most difficult. Operating for a second consecutive day on four hours of sleep—less on this night—is not a great idea.

The morning began with a venti Starbucks drink, and it ended with a beer in Fort Worth. In between, the Texas–Oklahoma game provided the much-desired drama, enough to keep anybody awake without the aid of a bucket of caffeine. Today's Texas–OU game is why we watch, and the TCU–Kansas State game is why you don't skip on the chance to watch special players like Doctson and Boykin. It's why you stay until the end. It's why you never lose hope. It's why you never stop being a fan.

We caught a major break with perfect weather, and a perfect day of games.

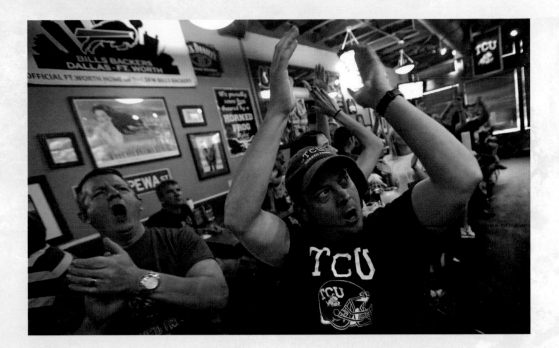

league with the University of Texas, Baylor, Texas Tech, and its old Southwest Conference rivals.

By halftime of this game, though, everybody in this packed sports bar has "Give Up" written across their brow. TCU trails 35–17, and Boykin to Doctson is not enough. By the end of the game, however, much like the school, this changes.

"I keep telling you guys," Patterson says, "you should enjoy Josh Doctson and Trevone Boykin."

TCU scores 35 second-half points, which includes a 69-yard TD run from Boykin and a game-winning 55-yard TD pass from Boykin to Doctson, with seventy seconds remaining. TCU remains undefeated and number two in the nation, and those leaving the bar are thrilled at the chance of doing it all again next week.

DINING LOG, DAY 3

As a major metropolitan area, Dallas–Fort Worth offers the standard staggering number of dining selections. On our trip thus far, we've done seafood and barbecue. Now it's time for two other favorites:

Wingfield's Breakfast & Burger. Dallas is jammed with good places to eat, but for burger loyalists, it's hard to top this institution, located in South Oak Cliff. This is not a dine-in type of place, but the burgers are big, traditional, and delicious—some of the best you'll find anywhere in Texas. (2615 South Beckley Ave., Dallas)

Los Asaderos. You don't travel to Texas and not eat Tex-Mex. This is traditional Tex-Mex cuisine that is authentic, modestly priced, and features fantastic, thick guacamole. (1535 North Main St., Fort Worth)

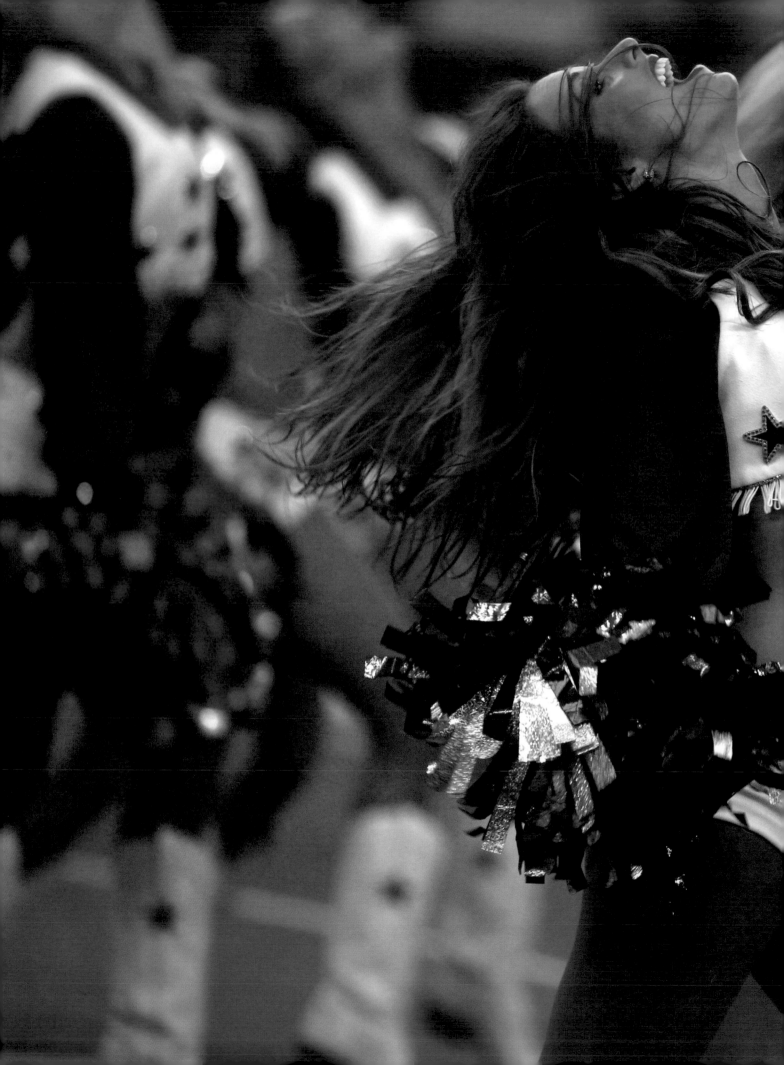

SUNDAY, OCTOBER 11, 2015

New England Patriots at Dallas Cowboys,
AT&T Stadium, Arlington

All of the amateur games are concluded, and all eyes turn to the most popular team in Texas. The moment the Dallas Cowboys began in 1960, they immediately created a bond with fans that didn't have a direct affiliation to Texas, Texas A&M or Texas Tech, or any other college. Team president Tex Schramm deliberately courted the blue-collar football fan who wanted a team to cheer for but didn't feel a particular loyalty to any college team.

Since then both the Dallas Cowboys and the entire NFL have followed that model to become the most popular league in North America. Despite not having won a Super Bowl in twenty years, the Dallas Cowboys remain the most valuable and most watched NFL team in the league. The NFL owns fall Sundays, and the Cowboys remain at the top of the NFL, even if their record says they should not.

> **Despite not having won a Super Bowl in twenty years, the Dallas Cowboys remain the most valuable and most watched NFL team in the league.**

The Houston Texans have created a small dent in this popularity around Houston, but for the majority of people in this state, Sunday belongs to God and the Cowboys, and not necessarily always in that order.

10:12 A.M.

New Mount Carmel Missionary Baptist Church, Fort Worth

Two blocks away from the football practice field at Fort Worth Polytechnic High School is this quaint Baptist church. The modest-size building is nothing like megachurches Dallas First Baptist, or T. D. Jakes's The Potter's House in Dallas.

The New Mount Carmel Missionary Baptist Church is what you would expect of a small community church. It looks like it was built in the 1970s, and its small chapel and rows of wooden-bench pews put the congregation close to Pastor R. A. Toliver. There is nothing megachurch about this place; this is, in layman's terms, a "black church." Pastor Toliver will preside at this morning's eleven a.m. service, but at the moment he is unavailable. He is meditating.

Football is a religion in Texas, but it's not God, Jesus, and the Bible. Religion in Texas is not the joke "Christian conservatism" often used as a punch line by out-of-staters and comedians to insult Texas. Going to church is not a box to be checked off on the weekly to-do list down here. Nothing is any bigger in this state than God and Jesus Christ—not even football. With the exception of small pockets in Austin and other major cities, this state is the de facto capital of conservative beliefs and practices in America. There is a reason why during campaign season Democratic presidential nominee Barack Obama made minimal attempts at courting the Texas vote. The last time Texans voted for a Democrat for president was Jimmy Carter in 1976.

Football is a religion in Texas, but it's not God, Jesus, and the Bible.

Parishioners will not begin showing up here for another twenty minutes or so, and when they arrive, they'll be decked out in their Sunday best: suits, jackets, ties, dresses, and lavish hats. There is no room for "Casual Friday" attire in a traditional Southern church, and no exceptions are made for football fans in the Lord's house. This includes

twelve o'clock kickoffs on Sunday. Depending on what time the Dallas Cowboys—or any team—kicks off, it can directly affect church attendance for an eleven a.m. service. If the game is noon, it's not uncommon for the sermon to be cut short by a couple of minutes, or for people to attend the early service.

Neither is happening at the New Mount Carmel Missionary Baptist Church—not on this Sunday.

"We go as long as we need to," sister Pearl Barnette says as she puts a bookmark in her Bible. "As long as the spirit of the Lord is moving us, that's as long as we go."

If that means sixty minutes, it means sixty minutes. If it means seventy-five minutes, nobody is leaving. If that means two hours, football, and the Dallas Cowboys, will have to wait. This is not some religious shtick, or big talk to show off her love of Jesus Christ and the Holy Spirit. There is a time for football, but the game is not bigger than the Word.

> **This is not some religious shtick, or big talk to show off her love of Jesus Christ and the Holy Spirit. There is a time for football, but the game is not bigger than the Word.**

At least one person at this church, however, does acknowledge that kickoff sometimes affects things. Michael Jarman is an assistant pastor from Nigeria. He is fifty-three and speaks fluent English, with an African accent.

"We do have a lot of Cowboys fans here, and possibly they come to Sunday school instead of in the morning," he says. "When the Cowboys went to the Super Bowl [in the 1990s], I know it was different then."

The Cowboys don't like to talk about this—Lord knows, it's the ugly truth—but it's been twenty years since the franchise last won a Super Bowl, something their fans bemoan routinely every disappointing Sunday.

Jarman has lived in the United States for thirty-five years, but was well versed in the status of America's Team even growing up on a faraway continent. He does missionary work, and says in every country he visits, he sees people wearing hats or shirts of two American sports franchises: the New York Yankees and the Dallas Cowboys.

"I love football," he says.

Jarman doesn't live in Fort Worth, but rather in nearby Arlington. He loves football so much that he was one of a majority of voters in Arlington who voted to approve a tax hike in 2004 to fund the new stadium project proposed by Dallas Cowboys owner Jerry Jones and the mayor of Arlington, Bob Cluck.

Jones envisioned something beautiful on the grandest of scales, a plan with which Cluck excitedly agreed—with one provision: Arlington taxpayers would not pay any more than $325 million. Not another penny for a project that was set at a budget of $650 million. The measure passed, with 55.2 percent of the voters approving a tax hike. In reality, the price of the entire project increased to a bank-buckling $1.3 billion, and to secure the additional money, Jones put the Cowboys franchise up as collateral.

Visible characters like Jones and Cluck are given credit for the creation of AT&T Stadium, but it is citizens like Michael Jarman who made the project possible.

Visible characters like Jones and Cluck are given credit for the creation of AT&T Stadium, but it is citizens like Michael Jarman who made the project possible. "I'm glad I voted 'Yes,'" he says. "I went to the first meeting the town had about what it was going to be, and I thought it would be good for the city, and I love the Cowboys."

Most people here at this church love the Cowboys, too, but not enough to put a kickoff ahead of the Lord. Today they caught a break; the Cowboys are the late game.

11:43 A.M.

AT&T Stadium / Texas Rangers Ballpark parking lot B

When the NFL announced its regular season schedule, this Sunday was one of those days that CBS, the league, and anybody with a remote interest in the NFL celebrated as an "*It* game." The Dallas Cowboys versus the New England Patriots is a guaranteed TV ratings bonanza, with the chance to be the single most-watched game of the entire season. What the Cowboys are to the NFL's old-school dynasty era, the Patriots are for this generation. While the Cowboys built their brand with success in the 1960s, '70s, and early '80s, and into a dynasty in the '90s, the Patriots have established themselves as the NFL's premier franchise in this century.

Because of the Patriots' success, it's not uncommon to see fans here wearing Tom Brady jerseys or Patriots hats and shirts amid an endless horizon of Cowboys silver and blue. It's not that much different than a Cowboys road game, when their colors often trump that of the home team.

The Cowboys are a national brand with an international identity, but the roots of this popular franchise are local. The Cowboys pride themselves as "America's Team," a moniker given to them by the late former team president Tex Schramm, in a move that was both shrewd marketing and truth telling. The Cowboys are a national team, but the locals love them like they do a son, or their crazy uncle Jerry.

As much as the Rangers brand has grown over the last eight years, baseball is not football, and they are not the Cowboys.

With yet another day of sunny and mild temperatures, the tailgate scene in Arlington is crowded early; today is the rare day that the Dallas Cowboys will share the parking lots with the Texas Rangers. The local baseball team in recent years has enjoyed success up to and including World Series appearances, and will host the Toronto Blue Jays in Game 4 of the American League Division Series at 7:05 p.m. The Rangers lead the series 2-1, and can advance to the ALCS with a win tonight.

A fan could potentially attend both big games on what will be the single busiest day in Arlington this year. As much as the Rangers brand has grown over the last eight years, baseball is not football, and they are not the Cowboys.

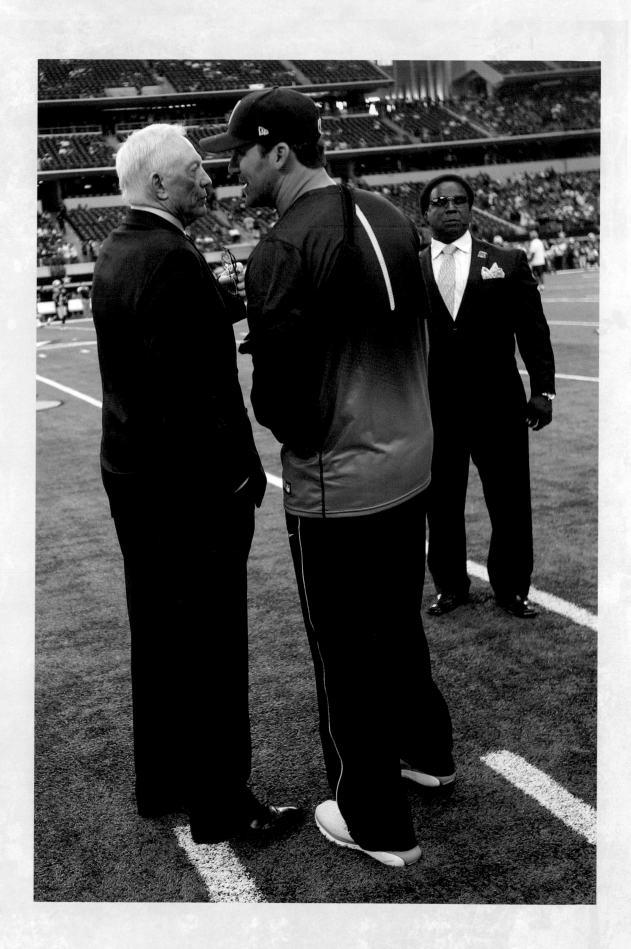

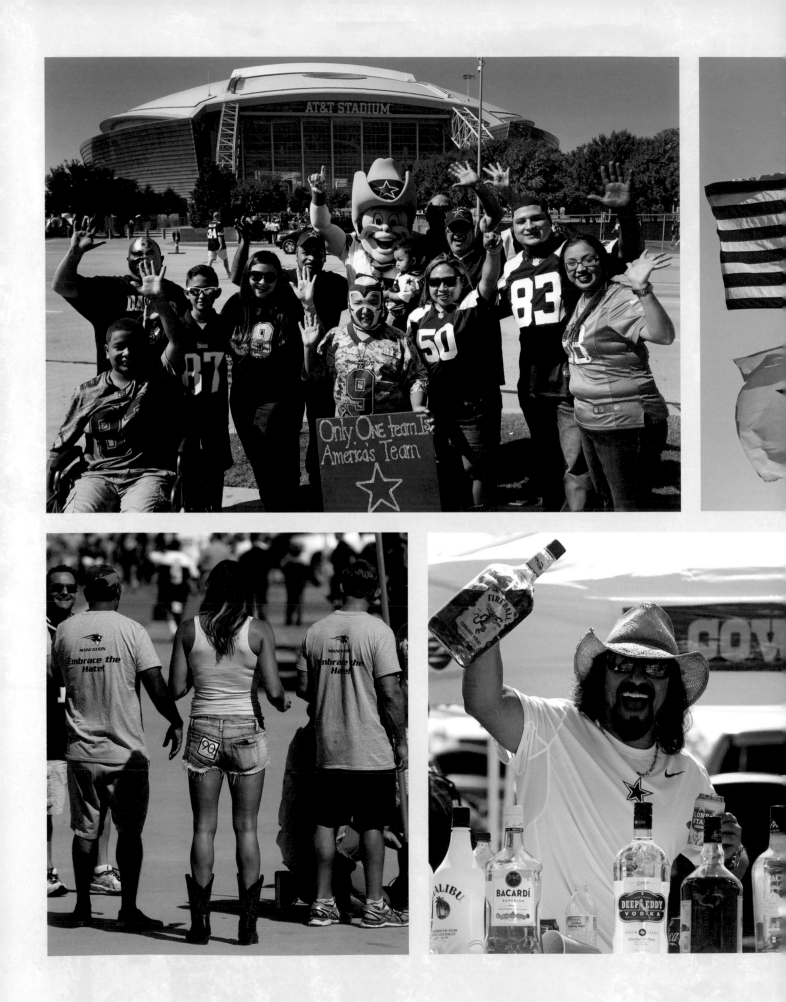

Dallas Cowboys vice president Charlotte Jones Anderson

The magnitude of the football game has changed seemingly fifty times before today. When the season schedule was announced back in April, Patriots celebrity quarterback and husband of supermodel Gisele Bündchen, Tom Brady, was to miss this game due to his involvement in the infamous "Deflategate" during the 2014 AFC title game. This earned Brady a four-game suspension by NFL commissioner Roger Goodell. The Cowboys–Patriots game was going to feature the two most famous football players from Eastern Illinois University, Tony Romo and Brady's backup, Jimmy Garoppolo, but Brady won his appeal shortly before the season started, and Brady versus Romo was back on.

Nonetheless, the star wattage of today's game dipped when the Cowboys lost All Pro wide receiver Dez Bryant to a foot injury in week one, and Romo, to a broken clavicle in week two. So now it's Brady versus Brandon Weeden.

As the teams warm up well before kickoff, Patriots owner Bob Kraft and Cowboys owner Jerry Jones exchange a sincere and warm handshake on the field.

"Go easy on us," Kraft says, deliberately ignoring the irony of the statement.

Jerry does a double take and says, "Oh my goodness."

The original matchup was scheduled to be the defending Super Bowl champion Patriots against a team that is destined to go this year. (The Cowboys won the NFC East last season, and were a controversial call away from advancing to the NFC title game.) Without Romo the Cowboys have dropped two straight games and are 2-2, while the Patriots are cruising at 3-0. Judging from the parking lots and tailgaters here a few hours before kickoff, absolutely none of that matters.

11:49 A.M.

Sky Mirror

When Jerry Jones and his collaborators designed this stadium, the priority was to make it the most elaborate venue in the world—something that would serve as a tourist destination. Jerry involved his entire family; they wanted to make this stadium the equivalent of what the Astrodome was when it opened in 1965, only better, and far more expensive.

Several details set the stadium apart from every other, most notably an extensive collection of modern art. During the early stages of the project Jerry asked his wife, Eugenia "Gene" Jones, to fill the stadium with art that would be consistent with the design of the building: modern.

"I was all about impressionistic art as a younger person," Gene says. "I had trouble understanding contemporary art."

When Jerry Jones and his collaborators designed this stadium, the priority was to make it the most elaborate venue in the world—something that would serve as a tourist destination.

One of their goals for AT&T Stadium was to use it as a platform for the arts, so Gene assembled an art council consisting of experts and curators from San Francisco, the Dallas Museum of Art, and the Fort Worth Modern Art Museum. This concept—filling a stadium with expensive art—was not exactly well received among artists, or family members.

"When we opened it, there was tremendous pushback from the artists because they couldn't imagine artwork for a football stadium," Gene says. Their youngest son, Jerry Jr., found the idea questionable. Gene recalls him saying, " 'Mom, fans are going to throw beer cans and hot dogs at these things.' They thought the art would get abused. We wanted the stadium to be unexpected and to be a real joy to our fans and supporters, and a gift to North Texas. We didn't think we needed art [of] the players and coaches. It's a contemporary building, and it needed contemporary art."

These days, there are AT&T Stadium art tours, and schoolchildren from throughout the area come here on field trips with the express purpose of being exposed to the nearly sixty pieces of art at the stadium, including more than a dozen works commissioned specifically for this place.

These days, there are AT&T Stadium art tours, and schoolchildren from throughout the area come here on field trips with the express purpose of being exposed to the nearly sixty pieces of art at the stadium, including more than a dozen works commissioned specifically for this place.

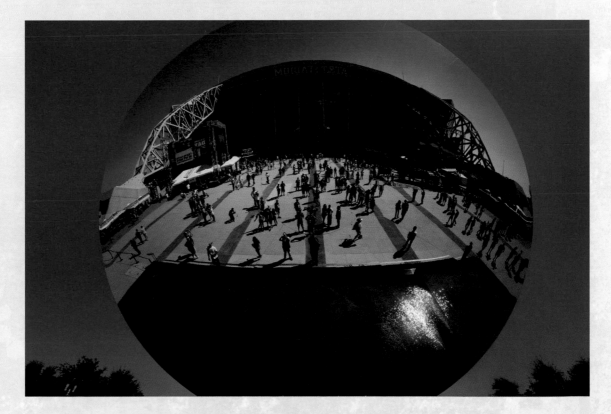

Of all the impressive and expensive works of art displayed on the walls and in the atriums, none stops traffic the way the fifteen-ton stainless-steel *Sky Mirror* does, in the east plaza outside of the stadium. It's a safe bet that none of the more than ninety

thousand fans here today, including thousands that will have their picture taken in front of the waterfall and this reflective mirror, have ever heard the names Anish Kapoor or Ellsworth Kelly.

People here know names like Aikman, Staubach, and Emmitt—not Olafur Eliasson, Jenny Holzer, Doug Aitken, or any of the other artists whose works of art give this place its high-dollar feel. The average football fan doesn't know the name Ellsworth Kelly, yet people who have walked through the main entrance of AT&T Stadium know his sculpture, *White Form*, which coincidentally looks like a giant letter "C." (No, it doesn't stand for "Cowboys.")

Most people here don't know that Anish Kapoor is a sculptor who in 1991 was awarded the Turner Prize, the art world's version of the MVP award for contemporary art. He built the internationally famous *Cloud Gate* in Millennium Park in Chicago. When Jerry and Gene saw that famous piece of vertical art, they had the idea of bringing something similar to AT&T Stadium. *Sky Mirror* had previously been displayed in London, New York, and Sydney before it found its permanent home in Arlington, Texas.

Most people here don't know that Anish Kapoor is a sculptor who in 1991 was awarded the Turner Prize, the art world's version of the MVP award for contemporary art.

"It was in a big pasture in Sydney," Gene says. "It was not in a place where people could enjoy it. We wanted it to have [its own] special place."

In October of 2013, Gene Jones triumphantly unveiled the large round mirror that is set in a large block of granite in a pool of water. During the game that evening, Kapoor sat next to Gene in the owner's suite and was shown on the video board overhead. An announcement was made that he was the artist who had created the latest addition to the stadium's art collection. Gene heartily clapped and cheered along with the fans.

So while not everyone may know Anish Kapoor or Ellsworth Kelly by name, thanks to Jerry and Gene Jones and the art collection at AT&T Stadium, people are getting to know their work.

12:01 P.M.

AT&T Stadium, party pass section, west end zone

Part of Jerry and Gene's inspiration for this stadium came from a Celine Dion concert at Caesar's Palace in Las Vegas. What Jerry created is a ninety-thousand-plus-seat venue with varying levels of excess, beginning with the "party pass section" in each end zone. He also included scores of exclusive clubs and seating areas that are available to anyone, provided you pay just a bit more for each level.

The party pass section is an area where fans can pull an end-around on the system to watch a high-priced NFL game on the cheap. They just need to be okay with arriving

early, standing, and waiting while being pressed against other bargain-hunting fans, all for roughly six hours. From a business standpoint, it's a genius move. The Cowboys squeezed a little bit more money out of an area that otherwise could have been standard end zone seating.

What Jerry created is a ninety-thousand-plus-seat venue with varying levels of excess, beginning with the "party pass section" in each end zone.

Fabian and Alicia Hernandez wait with the other thousands of fans for the right to run to a spot. For $20 extra per person, they became "preferred" members of the Dallas Cowboys' Club. The package includes early access to this party pass area, a full thirty minutes before the rest of the masses are released through the glass doors to find a spot. Fabian and Alicia spent $89 each on tickets for today's game. They are among the few to enter AT&T Stadium with the hope of finding "the perfect spot" along a bar-style railing in the end zone to watch this game. They drove more than six hundred miles from El Paso for this.

Having this ticket allows them access to areas in the respective mezzanine end zone areas, as well as the giant stairwells that fans can stand along to watch. The rest of AT&T Stadium is effectively off-limits to the "party pass" class.

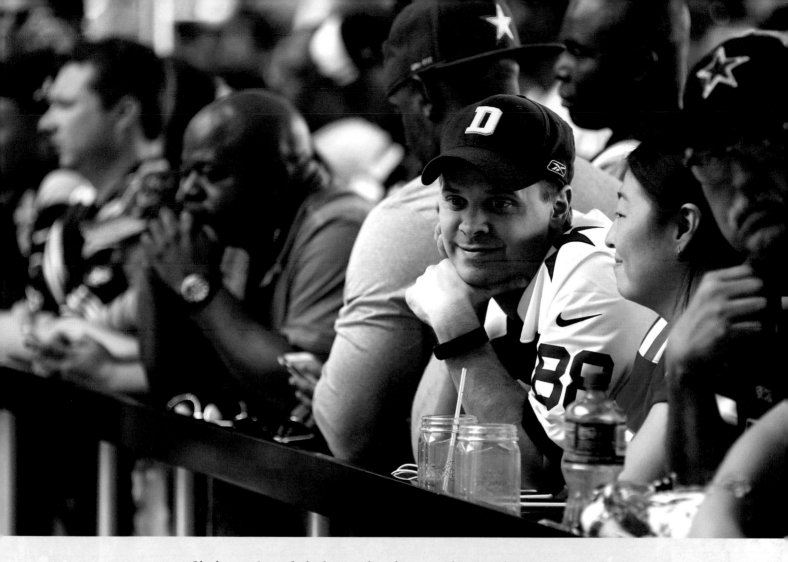

If a fan can't reach the long railing for an unobstructed view, they stand in a crowd, trying to peer over the shoulders, heads, and hats of others. It's not uncommon to see the two respective party pass areas ten and twenty deep, full of fans. If the fan is tall enough, maybe he or she can see some of the action, but most of the people rely on the one feature that keeps this building from growing old: the huge display screens. Fans in the end zones have a perfect view of the end zone displays, fifty-one-by-twenty-nine-foot HD screens hanging over the field. Each one weighs 25,000 pounds and has a screen that is 1,439 square feet.

> The defining feature of AT&T Stadium is not the modern art or its monumental arches outside, but the huge video board hanging from the top.

The defining feature of AT&T Stadium is not the modern art or its monumental arches outside, but the huge video board hanging from the top. The Jumbotron is 11,393 square feet and contains an elevator and an air conditioner, and uses thirty million lightbulbs. The screen is so big, its clarity so sharp, that your eyes tend to drift to the Jumbotron rather than the live action on the field. While this video board is a monument to excess, it does turn the worst spot in the house into a decent seat.

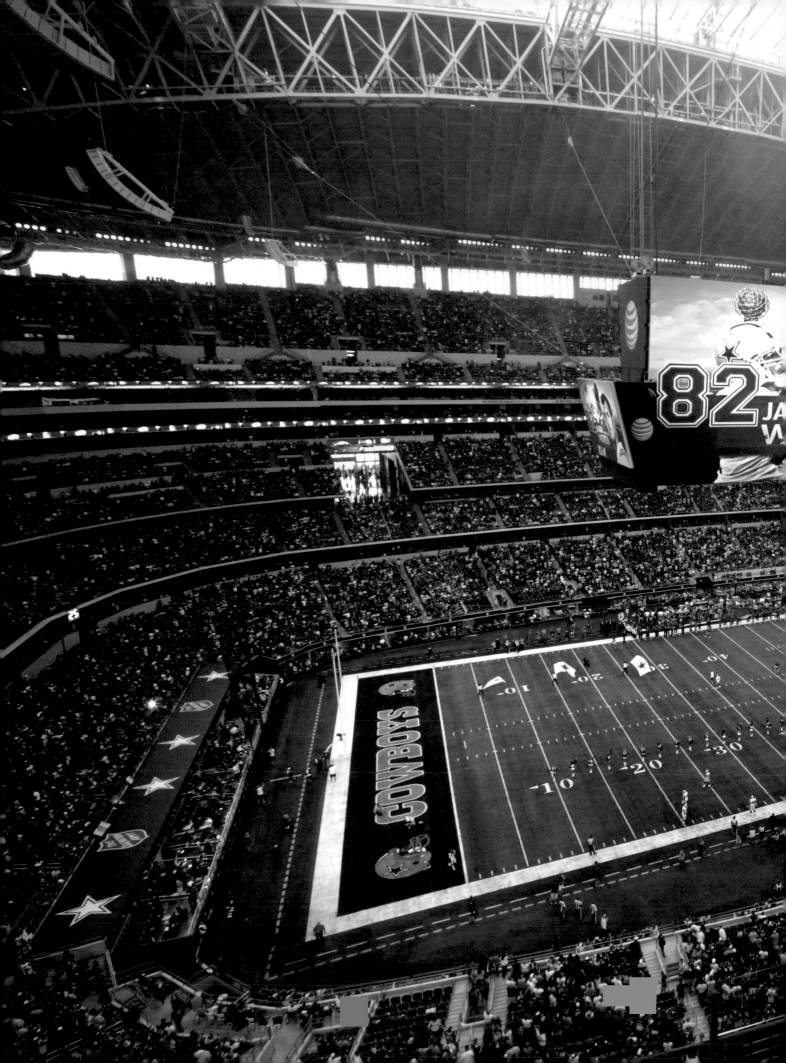

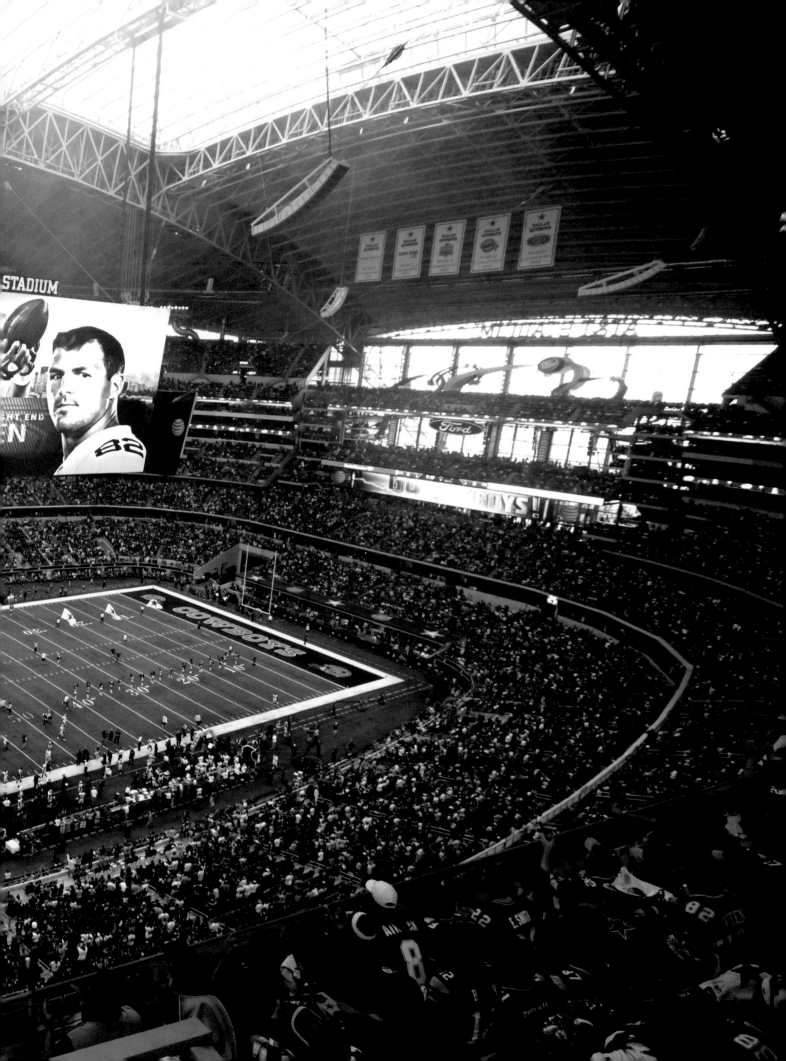

12:43 P.M.

AT&T Stadium TV booth

The A-team for CBS's NFL coverage relaxes in the best seat in this place—the main TV booth. It is at the 50-yard line, approximately twenty rows high. Veteran play-by-play man Jim Nantz scrolls through his iPad, reading newspaper columns about the two teams. Next to him is former Super Bowl MVP and ex–New York Giants quarterback Phil Simms. He serves as his color analyst. Being the number-one team for CBS mostly means they do the "best" game carried on the network on Sunday.

Today's game is a home-coming for Nantz, who lives in California but comes back to Texas often.

The pair was in Houston on Thursday night to do the Colts–Texans game, and rather than fly, Nantz made the four-hour drive up Interstate 45 with his wife and their young daughter. He takes out his phone to show his daughter sitting in a play area of a restaurant in Centerville, Texas.

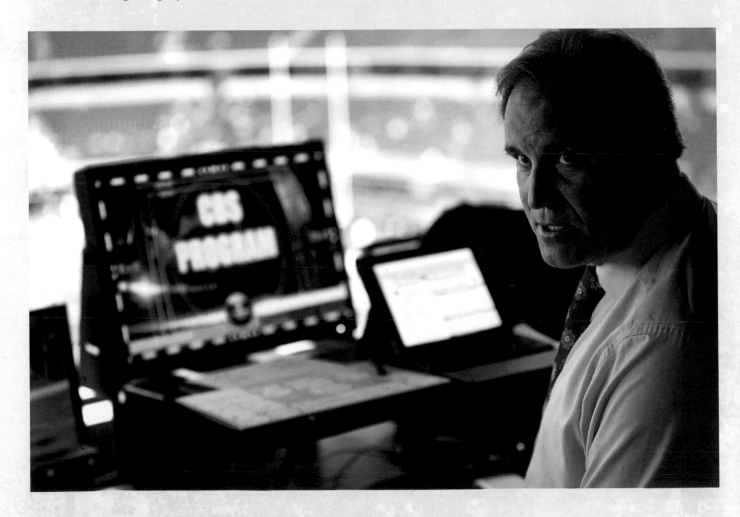

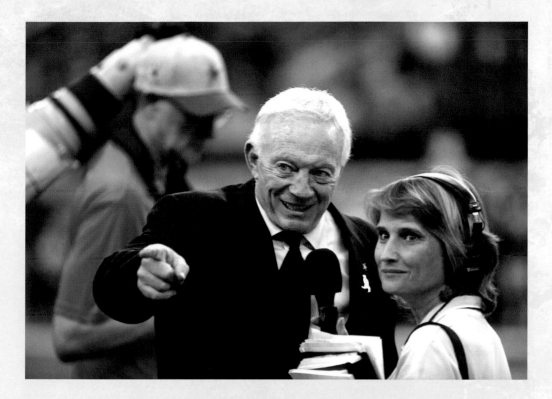

"When I can, I like to make the drive," he says.

Today's game is a homecoming for Nantz, who lives in California but comes back to Texas often. Nantz began his broadcasting career in Houston, where he was the roommate and teammate of future PGA star Fred Couples on the University of Houston golf team.

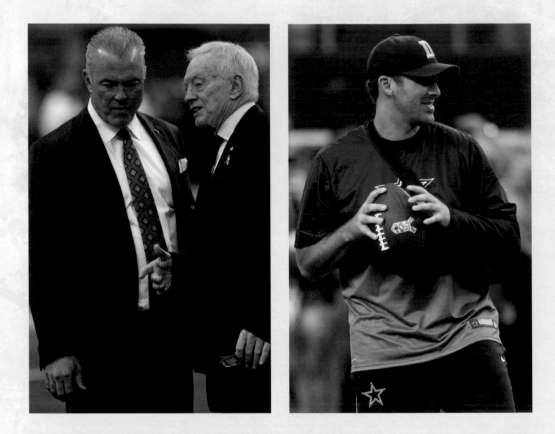

"I played golf for one year. I was the last guy on the team," Nantz says. "I was there to figure out a way to get to CBS. I had no passion for playing golf. Seriously, I knew I wasn't good enough. I knew what I wanted to do, which is exactly what I am doing now. I studied communications. That was my hook.

"I went to every Oilers game. I was a stringer for the CBS radio network, had a radio show. I had just turned twenty. I did the Houston game of the week. My freshman year was the year of the great Stratford team that had Craig James."

In a few hours, Nantz will begin the telecast to a national audience with his trademark "Hello, friends," which he actually introduced when he called Super Bowl XLI. It's a tribute to his late father, who he says did not know a stranger.

"Without question, high school football is bigger here than anywhere I've ever been," Simms says. "Without question."

Simms's ties to Texas are not as deep, but his son Chris was the starting quarterback for the University of Texas from 1999 to 2002. Simms lives in New Jersey and is a football junkie, regularly attending high school games in this area when he's here for work.

"Without question, high school football is bigger here than anywhere I've ever been," Simms says. "Without question."

Nantz once took Simms and their producer, Lance Barrow, to a Fort Worth Christian football game. Fort Worth Christian is a tiny private school, and telling this story gives Nantz the chance to do something he does effortlessly.

"Lance is a big TCU fan, but he was the long snapper at Abilene Christian," Nantz says. Abilene Christian is located on Interstate 20, about halfway between Arlington and Midland–Odessa. "Lance snapped the ball on the longest field goal in the history of college football—Ove Johansson," Nantz says.

Jim could do this all afternoon; he has a can't-miss memory, with volumes of stories and facts stored in his head. And he is correct. On October 16, 1976, the Swedish kicker for this NAIA school nailed a 69-yard field goal. It helped that he had a fifteen-mile-an-hour wind at his back to make what was the longest field goal in history. Johansson's kick broke the previous college record, set earlier that afternoon by Texas A&M's Tony Franklin, who made a 65-yarder against Baylor. Franklin played his high school ball about twenty minutes from here, at Fort Worth Arlington Heights.

"Football is totally a part of the culture here, more than any other sport is with any other state," Nantz says. "The only one closer is Indiana and basketball. It's the way of the land here, and I loved it when I was here."

1:23 P.M.

Victoria's Secret PINK Store, AT&T Stadium

At any other sporting venue in the world, a store that is known for women's lingerie, sexy thongs, and push-up bras is out of place. With the Dallas Cowboys, the PINK

store fits in quite nicely with the rest of the merchandise available at the team shop, the elaborate decor, and the million-dollar art. *Only* the Cowboys can do this.

In September of 2012, the Cowboys held a ribbon-cutting for this new Victoria's Secret store at AT&T Stadium, which included appearances by supermodels Elsa Hosk and Jessica Hart. The opening created national headlines, and perpetual punchlines. *Of course* the Cowboys would sell women's panties.

> **In September of 2012, the Cowboys held a ribbon-cutting for this new Victoria's Secret store at AT&T Stadium, which included appearances by supermodels Elsa Hosk and Jessica Hart.**

This is a funny joke, but it's two hours before kickoff, and PINK is doing brisk business. Once again, Jerry Jones laughs as his wallet widens. The store sells only Dallas Cowboys–related merchandise designed for women, including T-shirts, sweatpants, and designer-looking hats with glitter. This is not the place to shop for a sexy nightie, and none of this stuff is cheap. The most popular items cannot even be purchased here any longer. When the place opened, the thong panties that featured the Cowboys trademark blue star over the crotch routinely sold out.

According to the sales staff who run the store, all of whom are women, the few men who dare—oftentimes skittishly—to approach this place usually buy underwear for their special someone.

2:03 P.M.

Owner's Suite

This is the premier spot to be seen in the entire NFL. No other stadium in America matches the owner's suite at AT&T Stadium for exclusivity. The only other place like this in all of sports would be ringside for a major prizefight in Las Vegas, or courtside seats at a Los Angeles Lakers or New York Knicks game during the playoffs.

This is the place where politicians, models, actors, and America's cool crowd come to watch America's Team. This is the location that validates the Jones family as being among the most popular high rollers in America. It's a giant, lavish dinner party akin to something like a "poor version" of a White House state dinner, or an after-party for the Golden Globes. The only thing missing is the red carpet.

Not long after Jerry Jones bought the Cowboys, the family invited actress Elizabeth Taylor to the owner's suite for a game, and an atmosphere that is supposed to be jovial and fun turned uptight and tense.

"We were all very much in awe and very nervous," Gene Jones says. "I had never met her before. It was exciting to have her, but we wanted to respect her privacy and leave her alone so she could enjoy the game. Everybody there was very anxious, and it

wasn't like being at a football game. It was like being at church. My brother happened to be sitting next to her, and I think he forgot because he said a four-letter word. She said, 'Thank goodness there are some real people in this room!' She became a real person [after that], and it broke the ice."

For every game, team vice president Charlotte Jones Anderson and her mother, Gene, compile a select list of invitees to join them in the suite's forty-eight seats. This suite can accommodate more people, but those without an appointed cushioned seat sit or stand in the back, or lean against one of the many tables.

With the exception of former president George W. Bush, who has a standing invitation, the guests for this suite are normally invited for one game during the season. Typically, a "famous" person receives an invitation to attend a game sometime during June or July, which includes a suite ticket and the highly exclusive parking pass under AT&T Stadium. From that parking spot they take an elevator from inside the stadium directly to this suite.

Nobody pays for anything in here. This is truly a case of "Please grace us with your presence." No one is obligated to cheer for the Cowboys; this is a place to enjoy the fruits of fame, or being a member of the Jones family, or a longtime friend.

Gene and Charlotte watch the game and entertain, but the only Jones daughter is usually wearing a headset to track what's happening on the video board.

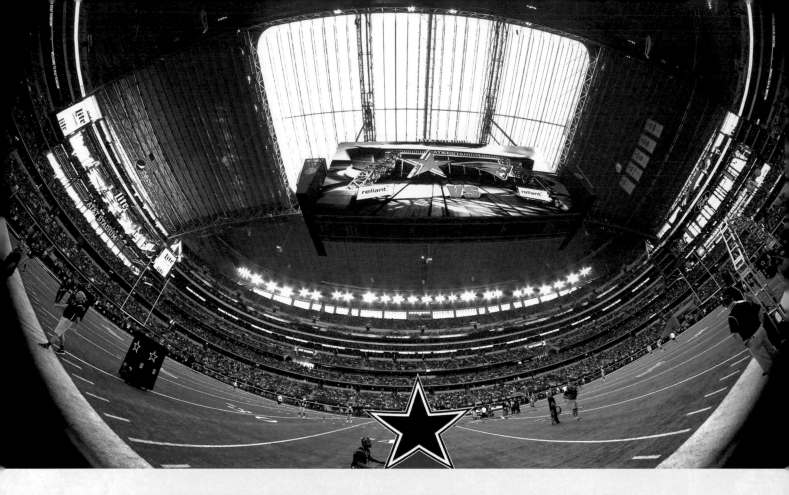

The catering company that takes care of the elaborate food and drink here is the same one that collaborates with the New York Yankees to take care of their stadium. If a patron is so inclined, he or she can buy a Hublot watch here, too. A pair of cheerleaders visits at some point during the game to pose for pictures. Every guest receives a gift bag that includes Cowboys gear, and no one leaves this place without having had a good time.

"We want to have great food and a great experience," Gene Jones says.

Few families throw a party like the Joneses.

3:14 P.M.

Miller Lite Club

As the popularity of the NFL and sports overall has grown over the decades, the divide between the fans and players and coaches has only widened. Security concerns, as well as a crushing number of interested observers, have necessitated a large space between performer and patron. This is both good and bad in a state that bleeds football.

When AT&T Stadium was designed, it created an area where fans can be right there with the players, to truly *feel* the game. Or at least it was designed to create that illusion. Immediately behind the Cowboys bench is the tunnel the players and coaches walk through to retreat to their locker room. The path runs through the middle of the

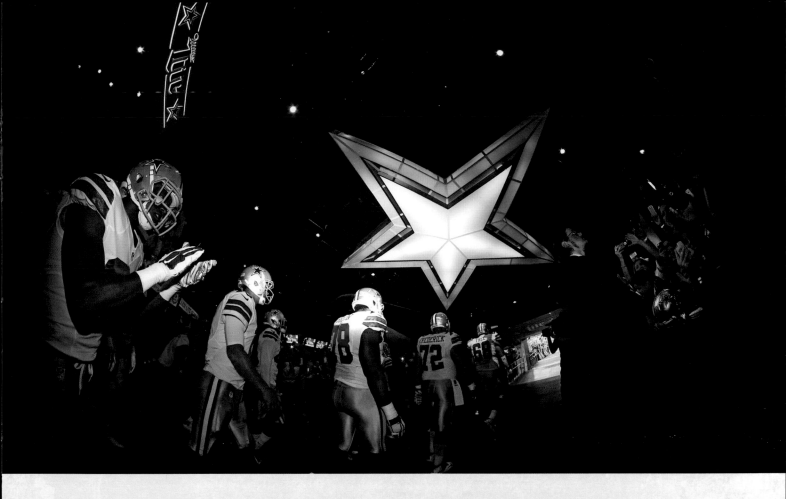

Miller Lite Club, the team's walkway flanked by bars where fans can drink a beer, a glass of Chardonnay, or Jack and Coke to get lubricated before kickoff.

"It was a big ol' circus with this and that and the Jumbotron," Patriots wide receiver Julian Edelman says. "It's a cool place to play."

Dallas Cowboys head coach Jason Garrett's facial expression is stoic as he walks by, and a few of the players nod their heads up and down, their eyes focused, not distracted by the party that's going on around them. The fans scream and hoot

> When AT&T Stadium was designed, it created an area where fans can be right there with the players, to truly *feel* the game.

and holler, holding up their iPhones as the Cowboys take the field. It provides a feeling like no other bar in any other venue in America.

It's time to play the game, the reason for the party.

3:28 P.M.

National Anthem

The last time the New England Patriots played the Cowboys in Texas, the National Anthem was performed by country star Billy Ray Cyrus, and it was at Texas Stadium. Much has changed since that game on October 14, 2007, when both teams were 5-0, the

stadium suites were filled with Hollywood's pretty people, most notably actors Kate Hudson and William Fichtner, and Billy Ray Cyrus was still known more for one of his own songs than for his daughter.

The Cowboys had just handed Tony Romo a five-year contract to be their official replacement for Troy Aikman, and his girlfriend was pop star Jessica Simpson. The team's head coach was Wade Phillips. His offensive coordinator was Jason Garrett.

The coach for the Patriots was Bill Belichick, and their quarterback was Tom Brady.

The game that day was televised by CBS, called by Jim Nantz and Phil Simms. It was a beautiful afternoon, with the sun flooding through the famous "hole in the roof" (a design wonder back when Texas Stadium used the line that former Cowboys' linebacker D. D. Lewis had famously uttered: "It existed so God could watch his team play."). The hole created fantastic shadow shots, but it played hell on the TV cameras.

The Cowboys wanted to keep the hole in the roof for the new stadium, and installed a retractable version. Despite the mild temperatures all weekend, the roof is closed on this day (as it is more often than not, to the disappointment of fans). God is going to have to find another way to watch Mr. Freddie Jones as he stands in front of a microphone, belting out a stirring rendition of "The Star-Spangled Banner" on his trumpet.

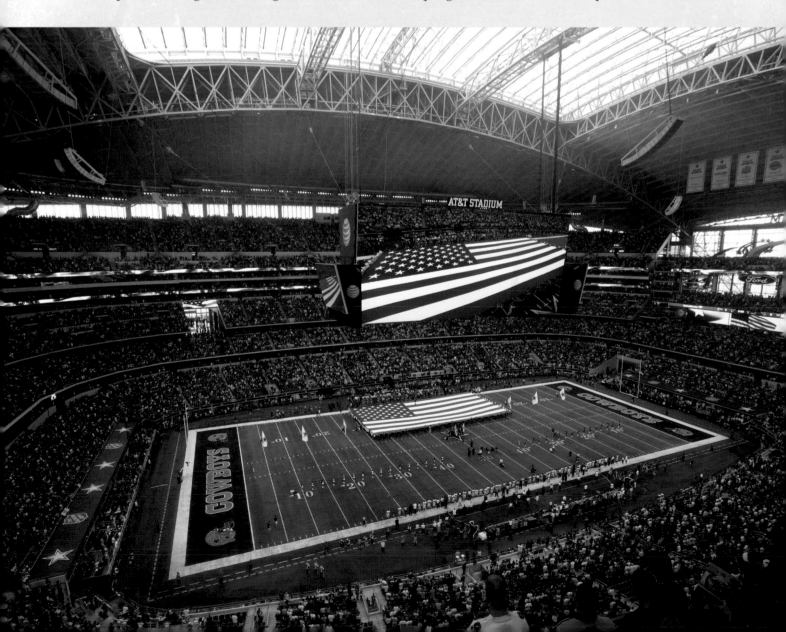

FIRST QUARTER, 14:03

The Joneses' Perch

As exclusive and fun as the owner's suite is, there is no more serious spot in the stands than the small space exclusively set aside for the owner of the Dallas Cowboys. The Joneses' Perch is located directly above the owner's suite, and to gain access requires taking an elevator directly from the suite.

This is where Jerry Jones and his sons, Stephen and Jerry Jr., watch the game. Grandsons are permitted here, as well as Jerry's longtime personal security man, Roosevelt Riley. Rosie is African American, a barrel-chested bull of a figure who has a thin mustache and a wry sense of humor, along with an affinity for women's basketball. He takes care of everything for Jerry. The stories he must have would make for a wonderful Netflix miniseries, and would likely get him fired, and sued.

Jerry and his two sons will meet and greet down below in the owner's suite, but shortly before kickoff they take the elevator up to watch the game from here. To be included here requires the rarest of passes. In 2014 New Jersey governor and noted Cowboys' fan Chris Christie sat here because he's a friend, and was perceived to be a good luck charm. That's the exception.

Not even Gene comes up here.

> Rosie is African American, a barrel-chested bull of a figure who has a thin mustache and a wry sense of humor, along with an affinity for women's basketball.

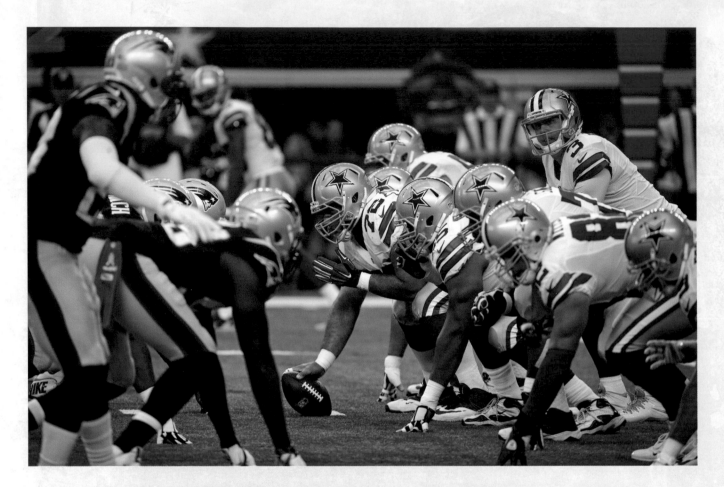

"I've been up there once," she says. In 2010, Gene went up after Tony Romo suffered a broken collarbone, which essentially flushed the season in October. "I ran up there to be with Jerry as that happened; we all collapsed and cried," Gene says of her only visit to The Perch. "He does not want visitors up there. Every play is critical. It has to be silent unless there is something to celebrate. Only [if] the game is going good will he come down to the suite to be with us."

When he first bought the Cowboys and Texas Stadium, Jerry would watch the game among the many guests he had invited, but that became too difficult. He had The Perch specifically designed so he could watch the game without distraction. There is a small bar up here with a table, but it mostly serves as a place to watch in quiet. This is the one spot in the entire stadium where Jerry can be Jerry, without filter. He can cuss, kick, clench, scream, and complain about everything from the players to the coaches' calls to anything else. This truly is his personal living room.

This is the one spot in the entire stadium where Jerry can be Jerry, without filter.

Since he bought the Cowboys from Bum Bright in 1989, and promptly fired sainted head coach Tom Landry, Jerry has become the most visible owner in all of North American professional sports. Despite the presence of Hall of Fame players from Troy

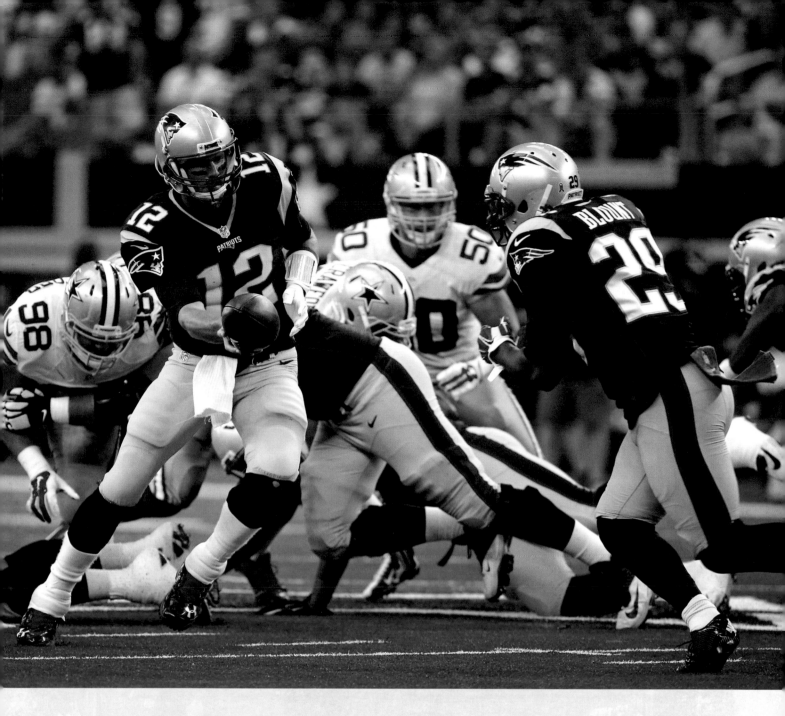

Aikman to Emmitt Smith to Michael Irvin, the face of the Cowboys since Jerry bought the team is Jerry. He bought the Cowboys because he wanted to run a pro football team, and to be involved in the daily operations. Long before he bought the Cowboys he wanted to buy the San Diego Chargers, but did not have the money. When he thought about buying the Cowboys, he approached fellow Arkansas alum and the founder of Tyson Foods, Don Tyson, about forming a partnership to run the team. Tyson told Jerry that Jerry should buy it himself, and run it himself.

A former starting offensive lineman from the University of Arkansas, Jones often calls himself a "frustrated coach." He has been labeled a meddlesome egomaniac who is comfortable with risk and the type of press and publicity that would make a normal person bitter and angry.

Jerry remains charming, optimistic, and a friend to his biggest critics. He is the only owner in sports that has his own radio show, which he does twice a week on the flagship radio station. Those appearances are must-listen radio, and often supply national headlines for the day, or the week. He is passionate about making money, but he loves football.

As he watches his overmatched team play against the best team in the NFL, he remains a staunch supporter of the concept that any press is good press. With the game having just started, it's quiet in The Perch, nothing like the scene directly below in the owner's suite. Jerry is quiet, as are his two sons.

Both of the sons have duties and responsibilities with the team, but Stephen has been tapped to replace the king whenever that sad day comes. At work, Jerry is "Jerry" to his children that work for the team. Outside of the office, Jerry is "Dad." This father-and-son duo is exceptionally close, but Stephen does not have his dad's personality, and has made it known that replacing his father is not something he wants, for the obvious implication. Jerry is in good health, and not close to stepping down from The Perch anytime soon.

FIRST QUARTER, 10:05

Patriots' ball

The Patriots are favored to win by seven and a half points, but there is an added level of intrigue that no handicapper can determine. For the first time this season, one of the NFL's best defensive talents will play. He also happens to be its most controversial. Defensive end Greg Hardy has finished his four-game suspension for violating the NFL's conduct policy, and is wearing the star on his helmet and standing on the Cowboys' sideline for the first time.

There is no player in the NFL more reviled than Hardy; the why on this is complicated. Hardy was convicted by a judge in North Carolina the previous year for brutally assaulting his ex-girlfriend, including details of how he threw her on a bed full of guns. Hardy's case was to be tried by a jury, but the charges were dropped when the accuser opted to no longer cooperate with prosecutors after a settlement had been reached between the two parties.

There is no player in the NFL more reviled than Hardy; the why on this is complicated.

The Panthers released him, and the only man willing to step out and sign Hardy—and take the accompanying criticism—was Jerry Jones. Hardy signed a one-year contract in March of 2015, and as expected, both he and the Cowboys were on the receiving end of local and national condemnation. A noted critic of the signing was one of the cherished men of this organization, Hall of Fame quarterback Roger Staubach.

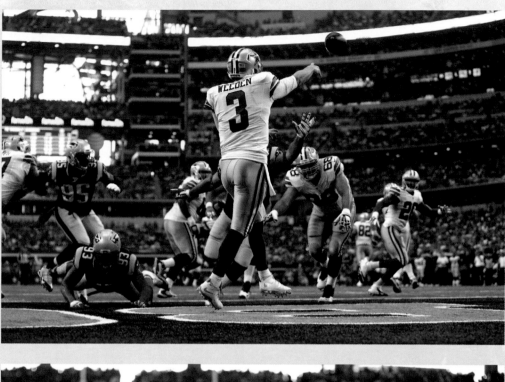

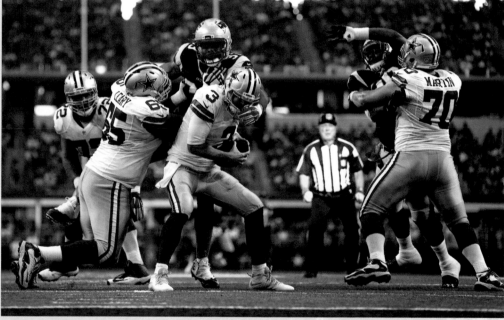

The criticism was that Jerry "doesn't care"—that he's an enabler with a track record of signing controversial players, such as Adam "Pacman" Jones, Tank Johnson, Dez Bryant, Josh Brent, and Terrell Owens, among others.

The issue of domestic violence was pushed to the forefront of the NFL because of high-profile cases involving former Ravens running back Ray Rice and Hardy. Jerry signed Hardy because he is one of the best defensive ends in football, and should be second only to the guy in Houston—J. J. Watt.

The reaction among most Cowboys fans was that Hardy was not convicted by a jury, and that he is a welcome addition to the team. They want a good player, and the rest is white noise.

Hardy met with the media this week for the first time since he signed with the Cowboys, and almost immediately stuck his foot in his mouth. He said his intention was to come out with "guns blazin' " against the Patriots, and that he hoped that Brady's wife, supermodel Gisele Bündchen, would bring her sister to the game. It was not awful, but it was far from a mea culpa or a sliver of contrition.

The issue of domestic violence was pushed to the forefront of the NFL because of high-profile cases involving former Ravens running back Ray Rice and Hardy.

He is not here to say he's sorry; instead, he's here for moments like this: The Patriots have the ball at the Cowboys' 31-yard line, and Brady stands in the shotgun, ready to take the snap. Lined up at right defensive end is Hardy, who looks like he's been shot out of a cannon as he easily beats Patriots left tackle Nate Solder to drill Brady and pin him to the turf. It's the first time in Brady's career that he is sacked five times in one half.

On the Cowboys bench, Hardy sits next to teammate Demarcus Lawrence.

"I'm going to keep trying everything," Hardy says. "I'm going to let ya'll know what I've got over there." He screams toward teammates Nick Hayden and Jeremy Mincey: "More, son! More, son! More, son! Take everything they've got, dog! Everything they've got!" Hardy stands up and claps his hands, shouting, "We've gotta keep comin'! We've gotta keep comin'!"

For the fans, this is the priority. As long as he wears the star and sacks quarterbacks, all is forgiven, or maybe there's nothing to forgive at all.

SECOND QUARTER, 3:58

Patriots' ball

The addition of Greg Hardy and linebacker Rolando McClain, who also had served a four-game suspension, has made this an interesting afternoon. McClain was another troubled player before he came to the Cowboys, and missed the first four games because of taking a banned substance. Late in the first half, the score is 3–3, and the most popular cheerleading group in the world has something to cheer about—not that it matters.

Created by Schramm, the Dallas Cowboys cheerleaders have retained their brand, image, and place as the leaders in the entertainment category.

Created by Schramm, the Dallas Cowboys cheerleaders have retained their brand, image, and place as the leaders in the entertainment category. Little girls routinely dress up as Cowboys cheerleaders, and all of those young women who cheer at Odessa Permian, the University of Houston, and the University of Texas aspire to be in this group. The Cowboys were essentially the first, and they remain iconic.

With her blue-and-silver pom-poms on her hips, Jinelle waits for the cue to break into one of this crew's series of routines that are rehearsed every night of the week during the season, beginning around five p.m. and lasting until as late as one a.m.

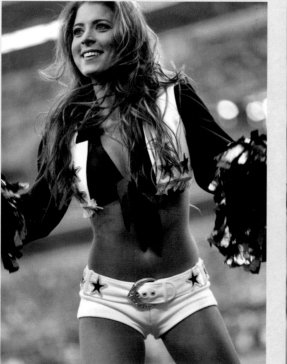
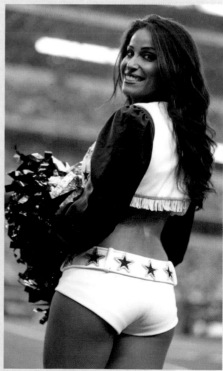

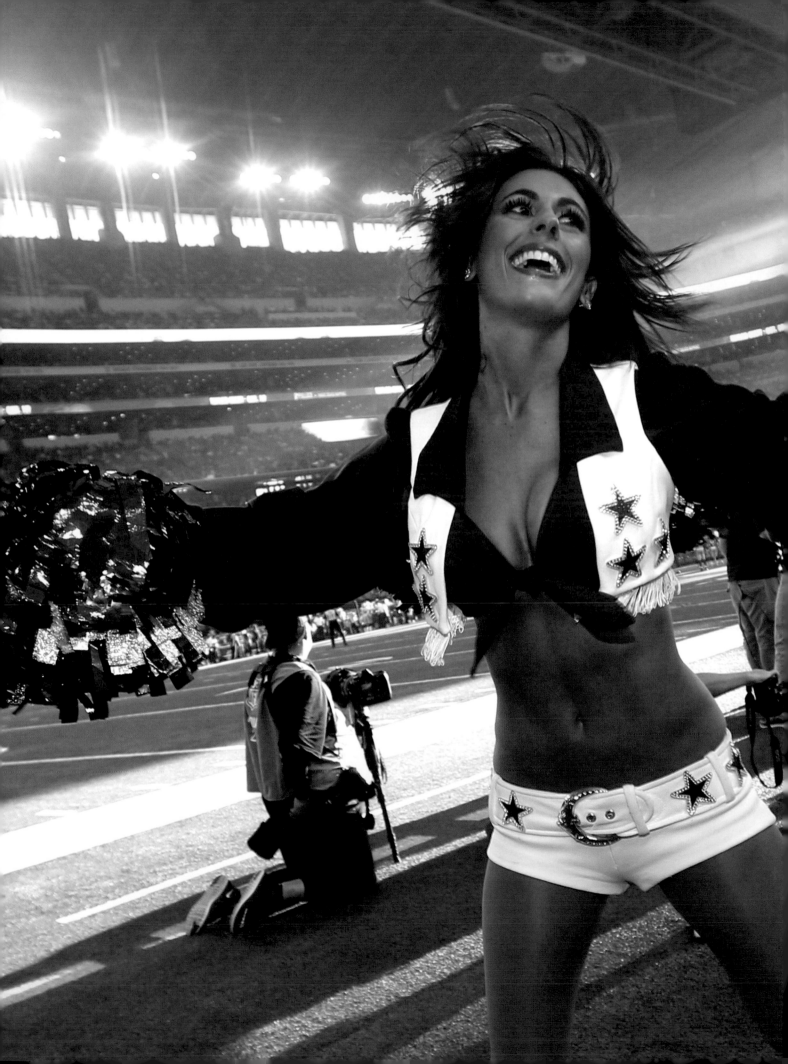

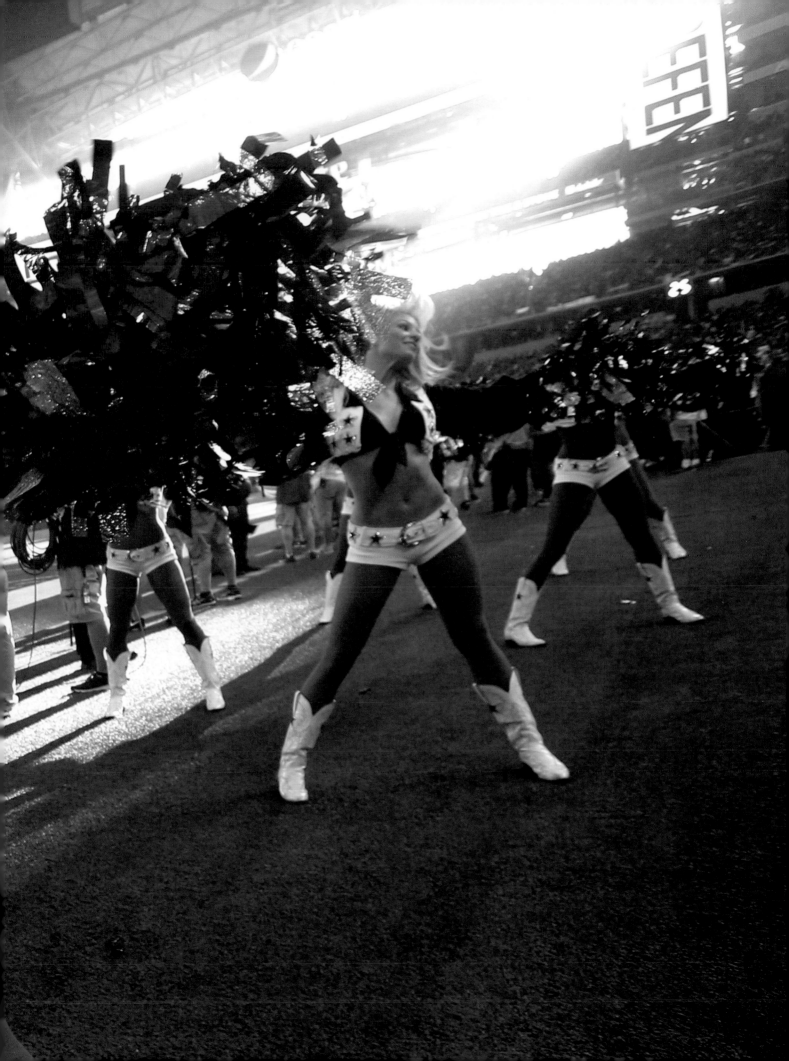

With her long black hair and giant smile, Jinelle is another in a long line of pretty young women on the squad. What separates Jinelle from the rest is that she is Australian. She had never seen an NFL game in person before she came over from Melbourne to try out for this squad, two days before the audition. She saved her money with the intention of cheering her way onto the team.

"I booked that flight, and I had everything packed to stay for one week, for that first week of auditions, and that was it," she says. "Then I stayed for the whole training camp and I made it, so I stayed."

She was a cheerleader for a rugby team in Australia, so is familiar with Aussie-rules football, but didn't have a clue about the particulars of the American version.

The NFL's popularity remains mostly a North American venture, but "everyone in Australia knows the Dallas Cowboys, and everyone knows who the Dallas Cowboys cheerleaders are," she says.

"It's different in every single way. It is really complicated and confusing," she says. "It was really hard to pick up at first."

The NFL's popularity remains mostly a North American venture, but "everyone in Australia knows the Dallas Cowboys, and everyone knows who the Dallas Cowboys cheerleaders are," she says.

The Cowboys cheerleaders are the only cheerleading team to have its own TV show. Country Music Television's *Making the Team* remains a wildly popular program among moms and daughters. It annually follows the group of women in their attempts to survive the insane standards strictly enforced by the group's leaders—director Kelli McGonagill

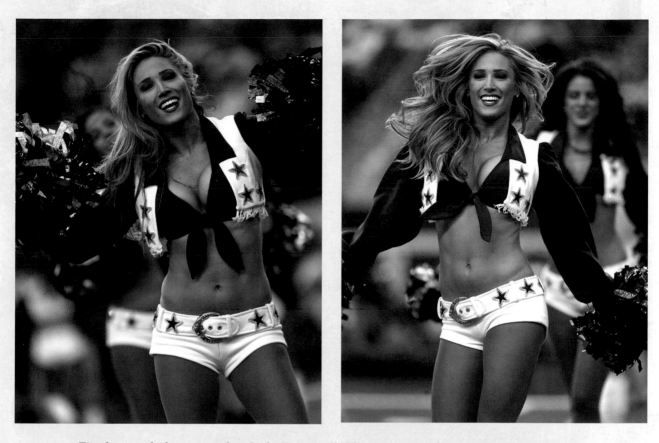

Finglass and choreographer Judy Trammell. These women don't screw around, they have no filter, and they often sound more like football coaches than actual coaches do.

When Dave Campo was the head coach of the Cowboys in 2002, the HBO behind-the-scenes series *Hard Knocks* included Trammell and Finglass, who became celebrities and were often hailed as coaches more than the actual head coach himself. Judy is renowned for her brutal honesty, which has included telling a cheerleader to her face in front of the squad that she was not "fat, but just looked old."

To be a cheerleader on this team requires peak fitness. Each cheerleader signs a contract to maintain their original weight at the first weigh-in of their career with the squad. If not, they are placed on "weight probation." If a girl weighs too much she will not cheer for the next game. Each woman's uniform is custom-made, and she must fit into that exact same one throughout. When Jerry bought the team, he famously wanted to change the uniforms to make them a bit skimpier, but on that one he was overruled by tradition.

"It's so much more than I thought it could ever be," Jinelle says. "In terms of what we do, we dance for about three hours straight, so it's physically more demanding than I thought. There is so much."

To be a cheerleader on this team requires peak fitness. Each cheerleader signs a contract to maintain their original weight at the first weigh-in of their career with the squad.

She's not complaining; few of them ever do. The life span for these cheerleaders is only a few years. The demands are extensive, and range from calendar shoots and hospital visits to USO tours. Oftentimes when Dallas Cowboys players and cheerleaders visit hospitals or the Salvation Army, the cheerleaders are the far bigger draw. Their schedule normally requires about forty hours a week. Each woman makes about $150 per game, and is paid for team-oriented functions, but this is all about the stature and cachet that comes with being a Dallas Cowboys cheerleader. They are not that much different from the football players: They are famous, and young people from all over the world want to be a part of the squad.

The irony is that unlike the Cowboys players, no one ever really knows the cheerleaders' names. For security purposes, only first names are released.

The irony is that unlike the Cowboys players, no one ever really knows the cheerleaders' names. For security purposes, only first names are released. There is no Cheerleader Ring of Honor. Careers are short, and this is an exclusive sorority that sometimes includes sorority-ish behaviors. The hours are long, there is pain and savage competition, but the trade-off is that they become part of the most famous cheerleading group in the world, which is why all of them, including Jinelle, do so eagerly.

HALFTIME

AT&T Stadium Press Box

The large media contingent here gathers around a buffet line and the wall of televisions that show highlights of the "early" games, or a current game between the Denver Broncos and Oakland Raiders. Among this group is the last surviving member of the early days of the Dallas Cowboys, a walking encyclopedia of football stories and knowledge, and a man who remains a football addict: Gil Brandt. He is a regular at nearly every Dallas Cowboys home game, as well as any other big games in the area. Yesterday, he was at the Cotton Bowl to watch Texas upset Oklahoma.

His black sport coat is a bit loose, but he still has most of his hair, and despite the fact that he's eighty-two years old, Brandt's memory is nearly spot-on. It's one of the reasons he remains so popular among the media, and why he remains on staff with the NFL as a contributor to its media platforms.

Brandt could and should have written a book by now. He has repeatedly said no, mostly because he knows the types of stories that would make a Gil Brandt book

a must-read are exactly the same ones he does not want to tell. He actually photographed babies before he became a part-time scout for the Rams in the 1950s. Schramm gave him a job as a scout when the franchise began in 1960. Brandt was the first one to keep a file on potential draft prospects. His efforts with computers, testing, and filing revolutionized the player-evaluation process in pro football. Brandt and the Cowboys were the first to hold "Pro Days" at college campuses, to test players. Now practically every college football program in America has its own such event each spring.

Of the three men who were considered the "brains of the Cowboys" from 1960 to 1989, Brandt is the only one not to be included in the Cowboys' Ring of Honor.

Of the three men who were considered the "brains of the Cowboys" from 1960 to 1989, Brandt is the only one not to be included in the Cowboys' Ring of Honor. The Cowboys belong to Jerry Jones, and he approves all Ring of Honor inductees. This Ring is his decision. A lot of feelings were hurt when Jerry bought the team and subsequently fired Landry. Tex

and Brandt quickly followed Tom out the door. Firing Landry was an offense that was not forgotten for many years. It took a while, and eventually feelings changed; Landry and Tex both went up in the Ring of Honor at the old Texas Stadium before they died.

Brandt is often credited as being the most important executive not named Schramm or Tex in the early years of the Cowboys. Since the Pro Football Hall of Fame added a "Contributors" category two years ago, it is widely believed Brandt will be inducted into Canton, joining Tom and Tex.

Today, he just watches the games and spits out stats and facts like the computers he used when evaluating players thirty years ago.

THIRD QUARTER, 10:11

Patriots' ball

For the entire first half, the most difficult player to cover the NFL was held to one reception. Cowboys rookie first-round draft Byron Jones is covering New England Patriots tight end Rob Gronkowski. To start the second half, Gronk catches one pass for 33 yards with Jones in good coverage, and it requires Brady to make a perfect throw from his own end zone. A few plays later, Gronk catches another pass on a third-and-five to extend the drive.

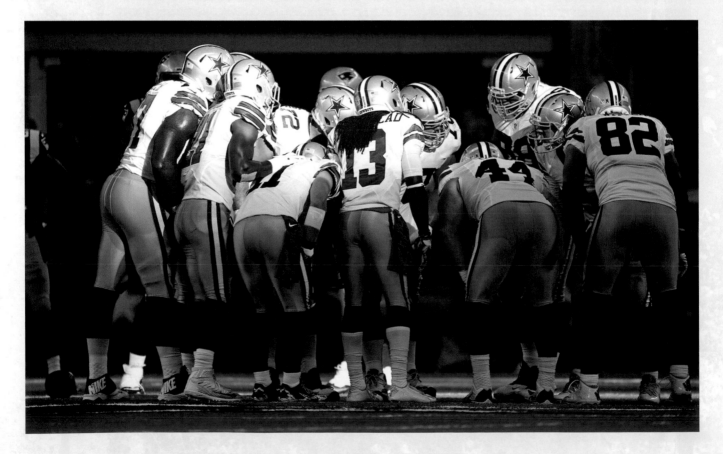

"There's nobody else like him," Jones says. "He's just so long."

All of it looks perfect, and so do Brady and Belichick. This pair has made advancing a football so easy for more than a decade.

The drive reaches the Cowboys' 10-yard line. A touchdown here will likely finish the game. The Cowboys offense is not sufficient with Weeden to score enough to catch up. Brady throws a quick pass to running back Dion Lewis, who catches the ball at the 10 with one hand. Lewis ducks under a tackle from Cowboys safety Barry Church, dodges a tackle from defensive lineman Jack Crawford, runs through a tackle

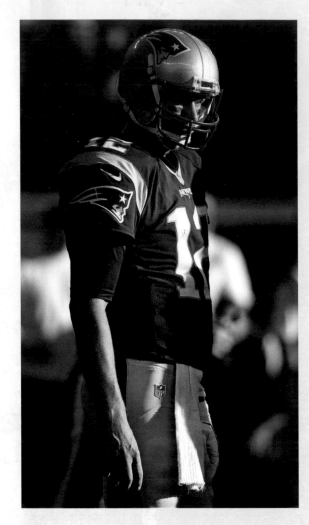

The New England Patriots are the NFL dynasty of this new century, and everything the Dallas Cowboys used to be. Brady/Belichick is an updated version of Staubach/Landry, or the 1990s edition of Troy Aikman / Jimmy Johnson.

by defensive back Kevin White, and bounces off a tackle by safety J. J. Wilcox into the end zone, for what feels like the game-ending touchdown.

"I was just trying not to get hit," Lewis says.

The score is 20–3, and Cowboys–Patriots feels like just another Patriots' beating without Romo and Dez. Not that it would have been easy even with that pair.

The New England Patriots are the NFL dynasty of this new century, and everything the Dallas Cowboys used to be. Brady/Belichick is an updated version of Staubach/Landry, or the 1990s edition of Troy Aikman / Jimmy Johnson.

Jerry Jones would likely spend all of his net worth, which exceeds $1 billion, if he could somehow switch these teams. Ironically, he is partly to blame for the success of the New England Patriots. Since he bought the Cowboys in 1989, no owner has had as much influence on the NFL as Jerry Jones, including a measure that has worked to the benefit of the league, but to the detriment of his team. Early in Jerry's tenure as owner, he was at the forefront of pressuring NFL commissioner Paul Tagliabue for a salary cap. As a businessman, Jerry saw the need to try to keep the costs of player salaries fixed, which would protect owners against themselves and prevent them from spending too much. It also helped small-market teams and negated the advantage of the wealthier franchises. Franchises like the Cowboys.

Had Jerry not pressured the league for a cap, he could have been the George Steinbrenner of the NFL and bought off his mistakes, signed the biggest and best names available, and hoarded talent. The cap changed the NFL.

It was supposed to make dynasties—such as the ones the Cowboys had in the '70s and the '90s—impossible. It mostly accomplished this, until the Patriots figured it out. No team handles the draft or player evaluation any better these days than the Patriots. They are this century's Cowboys, in large part because of Jerry's salary cap.

FOURTH QUARTER 1:26

Cowboys' ball

Today's game is long gone, and thousands of fans have exited AT&T Stadium well before the clock hits zero. Wearing a gray suit with a pink tie, Patriots owner Bob Kraft stands on the sidelines to watch the final few minutes of his team's fourth straight win to start the season.

Kraft watches as the Cowboys have the ball at the Patriots' 6-yard line, having failed on four previous plays to score a touchdown from inside the 20-yard line. The Patriots are going to win, and yet the team calls a timeout just to make sure their defense is right on this play—a Cowboys' fourth-down attempt.

It's a throwaway play, but one that Weeden desperately needs, not to mention his "top" receiver, Terrance Williams. The Cowboys have not scored a touchdown today, and Weeden must have this if he has any prayer of keeping his job over veteran Matt Cassel.

Weeden stands on the sidelines talking to head coach Jason Garrett and Tony Romo. The normal starting quarterback of the Cowboys wears a blue sweatshirt and a hat, has a day or two's worth of facial hair, and a sling for his left arm. Romo had dinner with Weeden on Thursday night. Few have been as helpful or as supportive of the backup quarterback as the starting quarterback. Romo is thirty-five, and he needs Weeden.

Romo is scheduled to return to the team on November 22, and if the team can win a couple of games in his absence, then a season with Super Bowl hopes is in play.

"It doesn't look good right now, but this season is only a quarter of the way over," Dallas Cowboys veteran radio play-by-play man Brad Sham tells his listeners. "There is a lot left to do, and there is time to do everything they want."

One of the best—and worst—parts of football in Texas for players is the talk. Plays are not just

Romo is scheduled to return to the team on November 22, and if the team can win a couple of games in his absence, then a season with Super Bowl hopes is in play.

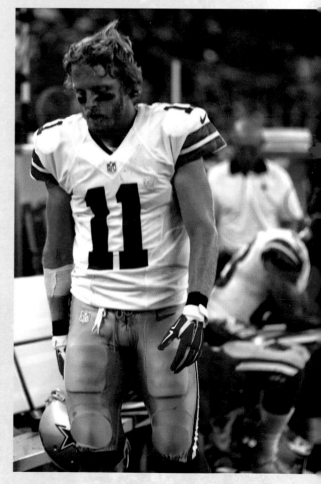

cheered or booed, but dissected, lamented, and ridiculed by damn near everyone. Texans don't just watch football; they study it and break it down and talk and talk and talk and talk about it. Despite the presence of the Texas Rangers, Dallas Mavericks, Dallas Stars, TCU, University of Texas, and Texas A&M, Cowboys talk dominates this market as if those other teams were playing junior high school volleyball.

Weeden has one last chance; on the play, he lines up in the shotgun and is aware of his tenuous hold on his job as the starter. One touchdown may not buy him another start, but he needs it nonetheless.

Tight end Gavin Escobar is lined up as the wide receiver to the right, with Cole Beasley in the slot. On the opposite side is Terrance Williams, and in the left slot is rookie Lucky Whitehead, with veteran tight end Jason Witten standing a few feet to the left of Pro Bowl left tackle Tyron Smith.

Since Dez suffered his broken foot in week one, Williams has tried to prove he is worthy of replacing one of the NFL's best wide receivers. The fourth-year player from Baylor University has so far struggled without Romo throwing him passes and Dez Bryant drawing the other team's top defenders. Williams needs a touchdown as much as Weeden.

Weeden takes the snap and retreats to the 14-yard line and Williams runs a perfect route. At the 3-yard line he makes a hard dig as if he is going to run into the middle of the end zone; instead, he breaks immediately to his left for the end zone. Patriots cornerback Malcolm Butler bites on the fake. Williams is wide open. With no immediate pressure from the Patriots, Weeden throws a nice, arching spiral in Williams's

direction. The touchdown is there. The ball sails high over Williams's head and lands out of bounds; he had no chance to catch it.

"Obviously the game was out of reach, but you just want to hit those, for a confidence factor, and to take advantage of receivers running good routes," Weeden says. "Of course I am going to take a lot of the blame. That is just part of playing this position. Right, wrong, or indifferent, that's just the way it works."

With his head down Weeden snaps his chin straps from his helmet in disgust; Williams is clearly upset, and he and Butler exchange a few words. Standing in the CBS booth, Simms offers Weeden the following advice: "Don't read the papers, and don't listen to talk radio."

> **"Of course I am going to take a lot of the blame. That is just part of playing this position. Right, wrong, or indifferent, that's just the way it works."**

The Cowboys lose 30–6, and it's the first time since 2011 the Cowboys do not score a touchdown.

This is the pass Cowboys fans will use to ridicule Weeden. There is a good chance this will be his final play as a Cowboy.

6:03 P.M.

Cowboys locker room

Jerry Jones walks out of the Cowboys locker room in the bowels of AT&T Stadium and is immediately swarmed by a throng of media. He squints to shield his eyes from the white lights of the news cameras. He does this nearly every game. Jerry will stand here for sometimes as much as thirty minutes, often longer, and field every question from anybody that has a pen, a recorder, or can draw a breath. Whatever he says are the most important words uttered today, and the most candid.

"We're not a good team right now," Jerry says. "Lesser teams win ball games. But they're just a better team. I think what we saw out there today was that New England was more than Dallas was not."

This is typical Jerry-speak. His words often don't flow properly, and he's known to laugh at himself for murdering proper English.

"We've got to get to be a better team overall, a better football team, a better everything," Jones says.

That makes perfect sense.

Unlike when Jimmy Johnson was his head coach, or Bill Parcells, Jerry's voice trumps all with the Cowboys, including Garrett. While Jerry doesn't mean to, he often usurps his latest head coach because he wants to be accommodating, and he loves talking football. It's why the media loves Jerry Jones: He will fumble with his words

and use funny colloquialisms; he'll be impossibly charming, candid, and polite; and he'll provide endless amounts of content.

As Jerry talks, the players slowly shower and walk to their individual lockers to dress. The layout of this locker room is grouped by position: The offensive line is in one area, the defensive line in another, and so on. Defensive backs Morris Claiborne and Brandon Carr sit next to each other and talk about the game. Most of the guys in here quickly dress and walk to their cars.

Defensive end Jeremy Mincey speaks for the entire team when he says, "I definitely didn't see this coming."

The Cowboys are 2-3 and now on the bye week. When Romo broke his clavicle, his teammates had hoped that they would be no worse than a game under .500. The team has seven games remaining when he returns on November 22 for the game against the Miami Dolphins.

Defensive end Jeremy Mincey speaks for the entire team when he says, "I definitely didn't see this coming."

6:58 P.M.

Jason Garrett's press conference

Wearing a golf shirt with a blue star on the left pocket, Jason Garrett walks to the podium to address the media, just as he does after every game. Since replacing Wade Phillips midway through the 2010 season, Garrett always looks the same. He does not look a day older, and his appearance never seems to change. The same can be said for his mood.

Reporters sit near the front of the room while the cameras are at the back, and a handful of fans watch this press conference through the glass windows at the Miller Lite Club. It's the only place in the NFL where fans can drink a beer and watch a live press conference after a football game.

Today's game features two of the brightest—Garrett is a Princeton grad, and Belichick, from Wesleyan—yet deliberately dull men the NFL ever put behind a microphone. The only difference between Garrett and Belichick, other than their respective records, is that the redheaded former Cowboys backup quarterback is unfailingly polite and professional. He doesn't say a single thing but has a smile on his face. Belichick is notoriously grouchy, and today is no different. Garrett is just a businessman doing business with a client he knows he must address, but would rather not.

At the podium Garrett is nearly lost amid all of the sponsorship. Behind him on the wall are the logos for AT&T Stadium and Reliant, the latter the same company that is owned by NRG, which has the naming rights for the football stadium in Houston. At Garrett's lectern are three plastic bottles of Gatorade, each positioned just right so the cameras catch the logo.

If Jerry Jones offers the most entertaining and lively sound bite or quote in the NFL, Jason Garrett is the antithesis. Unlike most coaches during a presser, Garrett does not stammer in his search for words, nor does he use "Uhh" as a verbal crutch. Unlike Jerry, Garrett is vanilla, mundane, and uninformative.

He is asked seventeen questions during this press conference and in response he uses a little bit more than 1,500 words. He uses words like "impact," "significant," "energy," "battling," "process," and expressions like "get better" and "watch the tape." Seldom does he answer a question directly. When asked about a certain player who had a bad game, Garrett will acknowledge the obvious about the specific player while in the next clause include the entire roster.

"Brandon didn't play well enough. We didn't play well enough," Garrett says.

Unlike Jerry, Garrett is vanilla, mundane, and uninformative.

The Cowboys have lost three straight games, and what Jason Garrett will not reveal is whether Matt Cassel will be the new starting quarterback.

"We're going to watch the tape and evaluate each guy and each unit to see how we can play better," he says. "That's just the process we go through each week. Ultimately we didn't score enough points. Brandon was a part of that, but everybody else was a part of it, too."

Garrett does say they will evaluate the quarterback position, which is all the media needs to voice their opinion that Cassel will be the team's starting quarterback when the Cowboys play their next game against the New York Giants.

It all takes approximately one hour, after which the media heads up to the press box, the players head home or out to dinner, and the coaches return to the practice facility at Valley Ranch to start preparing for their next opponent.

TRAVEL LOG, DAY 4

Because the NFL owns Sunday, there was only going to be one game to cover. The chance at a regular night's sleep made Day 4 the easiest of this project. The problem was always going to be the traffic, and parking. Once the Texas Rangers made the postseason and the schedule was released, there was no way to do anything other than arrive earlier than usual.

The weather was spectacular. These are the days that make the typical 105-degree temperatures in Texas during late July and seemingly all of August worth it.

The game was not great, but, overall, the four days were perfect.

8:20 P.M.

AT&T Stadium, lot 10

Texas's relationships with football and religion are rivaled only by its relationship with guns. As a rule Texans love their guns and are fiercely protective of their Second Amendment right to bear arms. In May of 2015, Texas lawmakers approved "Open Carry" legislation signed by Governor Greg Abbott, allowing Texans to carry handguns in plain view in a belt or a shoulder holster.

Texans are usually painted as gun-toting citizens that settle their differences the way it was done in a Western—with a six-shooter. These are hyperbolized and inaccurate perceptions, but gun violence does happen, including tonight.

The Cowboys game has been over for more than two hours, and the Texas Rangers American League Division Series game against the Toronto Blue Jays is more than an hour old when a tragic event occurs in the parking lot outside of the AT&T Stadium. Twenty-eight-year-old Marvin Rodriguez gets into a fight, at which point he threatens a fellow fan by pointing a handgun to the temple of another man's head. During this altercation, forty-three-year-old Rick Sells tries to break up the fight, and Rodriguez shoots him in the neck.

Rodriguez drives away, but is stopped by the police and arrested. More police cars appear, along with emergency crews, and Sells, recently engaged and an expectant father, is taken to the emergency room.

The tragic scene mars an otherwise pleasant afternoon, and weekend, of football.

DINING LOG, DAY 4

We stayed in the same region, and, fortunately, there are more than enough good options all over Dallas–Fort Worth.

Bird Café. Located in the underrated Sundance Square in downtown Fort Worth, the Bird Café offers a top-tier Sunday brunch. Order the Bird Creole Benedict, a split biscuit with fried green tomatoes, poached eggs, and crawfish étouffée. The "BadAss Bacon Waffle" and scrambled duck eggs are good choices, too. (155 East Fourth St., Fort Worth; birdinthe.net)

Babe's Chicken Dinner House. Expect to wait, and expect to enjoy the family-style dining experience, with some of the best fried chicken and chicken-fried steak ever made. (104 North Oak St., Roanoke; babeschicken .com)

GAME RECAP

B y the end of January 2016, every team that was covered from October 8 to October 11, 2015, had finished its season. How certain players, or teams, looked in the respective games during this weekend was not necessarily reflective of how their seasons would finish.

OCTOBER 8, 2015

Baytown Sterling. The team began 4-0 but finished with a six-game losing streak, and did not win a district game or make the playoffs.

Houston Stratford. The team won its game on October 9 at Brenham and finished the regular season with nine wins and a district title. Stratford won one playoff game before its season ended with a 14–6 loss against Temple. It finished 10-2.

Houston Yates. After defeating rival Lee by 51 points, Yates lost three of its final four games, including one in overtime, and missed the playoffs.

SMU. In the first year of head coach Chad Morris's tenure, the Mustangs finished 2-8.

University of Houston. The Cougars were the biggest surprise in college football in 2015. Under first-year head coach Tom Herman, the Cougars finished eighth in the final Associated Press poll, with a 13-1 record. They were the second-highest-ranked team in the state of Texas, one spot behind TCU. Houston finished the season by upsetting the 7-point favorite Florida State Seminoles, 38–24, in the Peach Bowl.

After winning thirteen games for only the second time in school history, the Cougars celebrated by giving Herman a contract extension through 2019, with a salary of $2.8 million. They also received good news when former Texas A&M quarterback Kyle Allen, a five-star recruit coming out of high school, announced he was transferring to Houston.

Houston Astros. No team provided more highs and yet more pain to this city than this team during this season. With a chance to close out their best-of-five American League Divisional Series at home, the Astros led the Kansas City Royals 6–2 in the top of the eighth inning. But the Royals scored seven runs in the final two innings to force a decisive Game 5, which they won to end the Astros' season. The Royals went on to win their first World Series in thirty years.

Houston Texans. If the Houston Cougars were the biggest surprise in college football, the Houston Texans equaled that feat in the NFL. After falling to 1-4 with their loss at home to the Colts, the Texans won eight of their final ten games to win the AFC South and reach the playoffs.

OWN SEASON
Rebel Day Criteria

<u>Criteria</u>
- Players workouts - 100% accountable
- No discipline issues - classroom included
- IN-Season Grooming policy followed

<u>Outcome</u>
- Learn to care more about teammates than yourself
- How My ACTIONS and thoughts affect our program

CHAMP
San Antoni

Two weeks after starting quarterback Ryan Mallett was benched in that loss to the Colts, he was late for a team flight to Miami and had to buy his own ticket to join his teammates on the sidelines. He was cut two days after the Texans' game in Miami. It was later reported that head coach Bill O'Brien apologized to the team that he'd benched week-one starting quarterback Brian Hoyer at all.

Included in the Texans' run to a division title was a 16–10 win at Indianapolis. Hoyer started that game but was knocked out with a concussion and replaced by former Cowboys backup quarterback Brandon Weeden, who had been released by that team on November 18. The Texans' win in Indianapolis was their first there in thirteen tries.

Alas, the Texans third-ever home playoff game was a flop. Hoyer had returned from his concussion, but the Texans lost 30–0 to the Kansas City Chiefs.

OCTOBER 9, 2015

Midland Lee. After its 45–0 loss at Odessa Permian, the team split its final four games of the season and finished 4-6, missing the playoffs.

Stanton High School. The Buffaloes lost their game to Colorado City 35–21 and finished the season with a three-game losing streak to miss the postseason.

Odessa Permian. The Panthers started 9-0 and lost their only district game to San Angelo at the end of the regular season. Permian defeated Arlington Bowie in a playoff game before its season ended with a 17–10 loss to Amarillo Tascosa in the area round of the Class 6A playoffs. The 10-2 record was the best season for the Panthers since 2008, and coach Blake Feldt was named Coach of the Year in the district. The team had seven first-team all-district players. In November, defensive back Desmon Smith committed to play at Texas Tech.

OCTOBER 10, 2015

Texas Longhorns. The trajectory for the Longhorns did not dramatically change despite their upset win against Oklahoma. The Longhorns were 2-3 in their next five games, which included a 24–0 loss at Iowa State; this stretch of games eliminated them from bowl contention.

The final game of their season did improve the way people viewed head coach Charlie Strong. UT upset number twelve Baylor on December 5 in Waco. Because of injury, Baylor was down to its fourth-string quarterback, and Texas won, 23–17.

The team finished 5-7, the second consecutive losing season under Strong.

While practicing at the College Gridiron Showcase & Symposium in Bedford, Texas, in January, running back Johnathan Gray suffered a torn left Achilles'. He had suffered a torn Achilles' in 2013. Linebacker Malik Jefferson was named the Big 12's Defensive Freshman of the Year.

Oklahoma Sooners. After their loss to the Longhorns, Oklahoma went on a seven-game winning streak to win the Big 12 championship and a spot in the College Football Playoff. The Sooners' only game decided by less than 10 points after their loss to Texas was a 30–29 win at home against TCU on November 21. OU hung on to defeat TCU, when on a 2-point conversion attempt, with fifty-one seconds remaining, safety Steven Parker batted away backup quarterback Bram Kohlhausen's pass.

Sooners quarterback Baker Mayfield finished fourth in the Heisman voting.

The Sooners lost in the national semifinal game 37–27 to Clemson and finished fifth in the final AP poll.

TCU Horned Frogs. Injuries to several defensive starters, as well as All-American wide receiver Josh Doctson and quarterback Trevone Boykin, killed their chances at reaching the playoffs, but it was one of the most memorable seasons in school history.

TCU won five of the six games it played that were decided by a touchdown or less, including its final two games of the year. In a driving rainstorm against rival Baylor, TCU won in double overtime in the final game of its regular season.

Two days before its game against Oregon in the Alamo Bowl, Boykin skipped curfew and was arrested after he got into a fight in a local bar. He was suspended for the game. Taking his place was Bram Kohlhausen. In the final game of his final season, Kohlhausen made the only start of his career as a Football Bowl Subdivision (FBS) level player. TCU fell behind 31–0 before Kohlhausen led a comeback that ended with a win in the third overtime. It tied for the largest comeback in a bowl game. TCU finished the season 11-2, and ranked seventh in the final AP poll.

OCTOBER 11, 2015

Marvin Rodriguez and Rick Sells. These are the two men who were involved in the fight in the AT&T Stadium parking lot after the Cowboys' game. The fight ended with Rodriguez shooting Sells in the neck; Rodriguez was arrested and Sells was taken to a local hospital. Three days after the shooting, Sells was taken off life support and died in a hospital in Fort Worth. Marvin Rodriguez was charged with murder and aggravated assault. Less than one month later he was released from jail after his bond was lowered by nearly half. As of publication, no definitive punishment has been set, but he has a plea bargain for a potential forty-year jail sentence.

Texas Rangers. The Rangers lost on Sunday, and the Blue Jays won the final three games of the American League Divisional Series to advance.

New England Patriots. The machine kept winning. Tom Brady won another AFC East title and the Patriots finished 12-4, reaching the AFC title game before losing against the Denver Broncos. After forty years in pro football, it was the first Super Bowl win for Broncos defensive coordinator Wade Phillips, who is the former Cowboys head coach and the son of Bum Phillips.

Dallas Cowboys. Following their loss to the Patriots, the Cowboys benched Brandon Weeden in favor of Matt Cassel. The team lost their next four games with Cassel starting, including a painful loss in New York against the Giants on October 25, when late in the game, defensive end Greg Hardy slapped a clipboard out of special teams coach Rich Bisaccia's hands on the sidelines in an effort to inspire his teammates.

The Cowboys were 0-7 without Tony Romo, who did return as promised on November 22 to play the Miami Dolphins. By that point, receiver Dez Bryant was also back from a broken foot injury that he'd suffered in week one, knocking him out for two months. Four days later, on Thanksgiving Day, Romo suffered another broken clavicle. This injury ended his season in a blowout loss to Cam Newton and the Carolina Panthers.

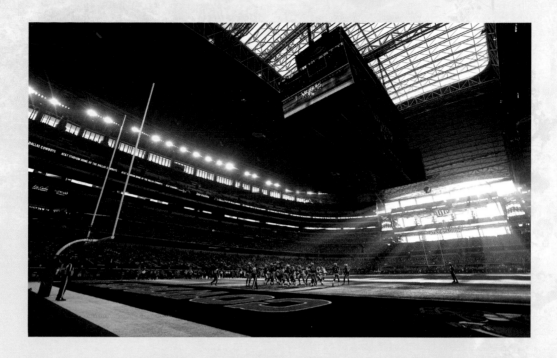

The Cowboys finished 4-12, arguably their worst season since Jerry Jones bought the team in 1989. They earned the number-four overall pick in the 2016 NFL Draft.

Jerry Jones said after the season that it ranked as one of the most disappointing of his tenure. He also said he believes Tony Romo can play at a high level for another four to five seasons.

POST-GAME WRAP

The four days were both routine and routinely exceptional. The lure remains the chance of something memorable happening—like Texas upsetting Oklahoma, or TCU's comeback at Kansas State—but the true hook of Texas football is not its size or the chance to watch a momentous game, but the people's connection to the sport. Everybody in Texas has some direct or peripheral attachment to football, from the Cowboys or Texans down to the 'Horns or Aggies, or the high school teams.

The game of football is a language every Texan speaks, and it connects El Paso to Brownsville to Tyler to Sherman. The game becomes the dominating point of conversation in church, at lunch, at work, or a thousand other places all over the state. A player's ability or talent may make him exclusive, but football's inclusiveness allows men and women of all races, ages, colors, and regions to be able to participate and share in the communal experience of the game. Football bonds millions of Texans over multiple generations, and that's how it makes any weekend special, eternal, and vital for every town.

> **The game of football is a language every Texan speaks, and it connects El Paso to Brownsville to Tyler to Sherman.**

Texans celebrate their love of football as much as they do their own history—from the Alamo and The Republic of Texas to the "Great Hurricane" in Galveston and the

When January hits and football season is over, there is a tangible lull, a sadness that another year is over.

soldiers at Goliad, from the creation of NASA in Houston and "Who Shot J. R.?" to the embarrassment of Lance Armstrong, Enron, or the raid on the Branch Davidian Compound in Waco. Texans mention those moments in the same breath as a Cowboys Super Bowl, Vince Young's run to the national title for Texas, The Pirate Mike Leach at Texas Tech, SMU's Pony Express, Johnny Manziel winning the Heisman Trophy for the Aggies, TCU's Rose Bowl win, or Robert Griffin's touchdowns for Baylor in the Alamo Dome.

When January hits and football season is over, there is a tangible lull, a sadness that another year is over. Then there is National Signing Day. Then spring practice for college, and seven-on-seven in high school. The NFL Draft is in May. Before too long it's time for two-a-days in the summer, training camp in August, and then it all starts again for real around the first of September.

Soon enough, every weekend, millions of Texans will gather together to watch, cheer, perform, or play in the game that is permanently part of this state like no other.

And then it will be Thursday, and Four Days in Texas Football begins again.

ACKNOWLEDGMENTS

I wish I could take credit for this concept, but the idea for this book was all Rick Rinehart's, editor at Taylor Trade. He gave me this project without ever having met me, offering me a blank canvas and all of the latitude I could ask for.

I'm personally thankful for Mr. Terry Frei, a longtime writer for *The Denver Post*, someone I have always respected for his kindness, professionalism, and considerable talent. Terry gave my name to Rick, and that is how this project began.

I had known Ron Jenkins and admired his work for many years, but after traveling and working closely with him, my appreciation and respect for his talents grew exponentially. Capturing a moment in time is not a point-and-shoot act; taking a picture is both a talent and a craft. Both Ron and his assistant, Michael Ainsworth, did a fantastic job of capturing the colors and culture of Texas football during these four days. Their pictures bring this book to life and give it brilliant imagery. They were completely on board with the relentlessness this book required—little sleep, just go for four days.

The stars of this book are the people. I had some idea of how to approach this project logistically, but after touching down in Houston, it was simply a go-go-go mentality. I wanted to pack in as much of Texas and football as possible in ninety-six hours, and the only way this was possible was because the people were helpful and cooperative in a way that I was not expecting.

In a handful of instances we showed up unannounced.

The following people made this book successful with their cooperation and patience:

- A giant thank-you to my daughter, Vivian, and my spouse, Jennifer. She is the superior writer, and her editing helped to make this book so much better than its initial drafts. Had it not been for Jennifer, the word *massive* would have been in this book no less than eight hundred times, not to mention four hundred other mistakes.

- Thank you to former Dallas Cowboys quarterback and Fox analyst Troy Aikman, for graciously providing the foreword.

- The people at the Houston Astrodome. I walked in without asking, and no one was the wiser.

- Rice University athletic media relations director Chuck Pool, and the Rice University English Department.

- Houston Yates high school football coach Jeffrey Caesar and his entire team.

- Baytown Sterling head football coach Pete Gareri.

- The front office staff at Stratford High School, for allowing us to barge in.

- The University of Houston spirit staff and spirit squad, for not minding that I walked in during their preparation before their home football game against SMU. A special thanks to U of H cheerleader Chelsea Villars.

- The Houston Texans and public relations staffer Amy Palcic.

- Midland Lee and head football coach James Morton.

- All of Stanton High School, for allowing us so much access on no notice.

- Odessa Permian, for once again being so polite, gracious, and welcoming.

- The media relations staff at the University of Texas and University of Oklahoma.

- Buffalo Bros. restaurant in Fort Worth.

- TCU director of athletics Chris Del Conte.

- Chef Tim Love.

- Jim Nantz and Phil Simms, for inviting me to chat in the CBS booth before the Cowboys game.

- Thank you to Melissa Miller for your assistance.

- Dallas Cowboys public relations staffers Rich Dalrymple, Scott Agulnek, Joe Trahan, and Whitney Brandon. A giant thanks to Rich, for allowing Ron Jenkins to shoot from inside the owner's suite, as well as Jerry Jones's Perch.

- Thanks to Gene Jones, for giving me so much time.

- Thanks to editor Melissa Hayes, production editor Meredith Dias, designers Piper Wallis and Sheryl Kober, layout artist Melissa Evarts, and proofreader Kris Patenaude.